InstaTravel

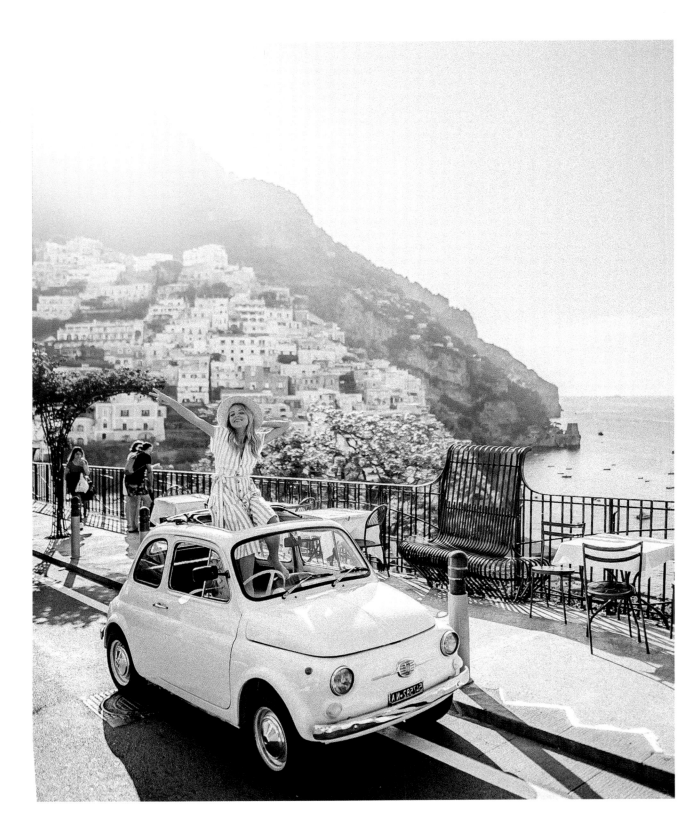

InstaTravel

DISCOVER BREATHTAKING DESTINATIONS

EXPERIENCE AMAZING ADVENTURES

CAPTURE STUNNING PHOTOS

Aggie Lal

ALPHA

Contents

Beach & Water Experiences18

Adventures52

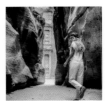

Cultural Experiences98

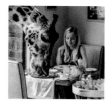

Animal Encounters114

Festivals174

Index188

City Experiences146

Dedication

I dedicate this book to two people: First, to my younger self—a girl with big travel dreams and little resources. Thank you for not giving up on yourself. Second, to Michael Moretti—I don't know anyone who would be so supportive of my vision, unrealistic dreams, impossible travel itineraries, and never-ending photo editing. I'm forever grateful for every trip taken together.

Who Am I?

They say life is about the journey, not the destination. It's about the "why": the people you'll meet, the places you'll see, and the lessons you'll learn along the way. Of course, the beaches and fancy hotels are incredible bookmarks in your story, but it's those in-between moments that will truly shape who you are. How do I know all this? I've made it my mission to live it every single day.

My name is Aggie Lal, and for more than a decade, I've been living a travel-oriented life as the adventurer behind Travel in Her Shoes, a blog and Instagram page with nearly 1 million followers. I've managed to turn travel into my full-time job, working hard every day with the clear purpose of making my way to the next destination. I've visited more countries than I've had boyfriends by tenfold and I spend more time on the road than I do at home in Los Angeles. Why? Because travel has always been *it* for me. My guilty pleasure, my therapy, my most patient teacher. Travel—the act of getting out, exploring, and really discovering something new—has always been there to celebrate my victories, soothe my sorrows, and help make the world around me make sense. In travel I trust.

So how did I get here? You might think I grew up jet-setting with my family, but that would be far from the truth. I had a modest upbringing in Warsaw, Poland, where the only traveling my family did was to my grandfather's tiny hometown of Zwierzyniec or the mountains of Zakopane. I was the last of my friends to see the ocean and I still remember the aching I'd feel in my chest every time a classmate talked about the endless horizon at the edge of the sea. I didn't leave Poland until I was 14, when I begged my parents to let me go on a summer trip to the south of France and I finally got to see the Mediterranean. Three years later, a few chance encounters with some friendly Australians led to an invitation to spend a gap year after college in Sydney. I saved all my pocket change, worked countless hours as a waitress, and managed to set aside the value of a small car to cover my trip. After a year of telling everyone I met that I'd be getting on a plane to Australia, one day, I finally did it. I was off.

Since then, I've never stopped traveling. I'd settle down for a few months at a time, working for MTV in Poland, moving to Los Angeles, and returning to Sydney to get a master's degree at the University of Sydney—and I even convinced one of those Australians, an old love who'd encouraged me to make my trip Down Under a priority, to join in my journeys around the world. In fact, he was the one who jumped onboard with me in 2013 when I decided to do something crazy— something that would solidify travel as my truest passion: We sold everything, quit our jobs, and bought a sailboat in Puerto Vallarta, Mexico, making plans to sail it across the Pacific and then back to Australia.

The Pacific

There are some events in life that define you forever. It can be a moment, a trip, or meeting someone for the first time. And nothing on Earth has shaped me more than the eight months I spent sailing across the Pacific Ocean.

As my 25th birthday approached in 2013, I was having a quarter-life crisis. Daily routines had left me drained and uninspired, and I needed a big challenge to face that would give me some direction. And what could be more challenging— or in more need of direction—than months at sea, traversing thousands of nautical miles from Mexico to Australia?

To say I was naïve would be an understatement. The aforementioned old love and I did our best to prepare, but it wasn't until we were out on the water that we realized how ill-equipped we were. Our desperation for a change had outweighed any of those gut feelings we should have gotten about the dangers that lay ahead. We'd envisioned days dictated by the sun and the waves, a chance to connect with nature and see it at its best. But nature is a cruel mistress: Even the most experienced sailors can be lost at sea—and there we were, hundreds of miles from land, working harder than we'd ever worked just to stay alive.

We departed from Puerto Vallarta on my birthday, September 23, 2013. The first leg of the journey, from Mexico to Nuku Hiva in French Polynesia, was supposed to take three weeks. It took us almost eight. We ran out of food, eating plain rice

cooked in salt water for every meal. We had no autopilot on our boat, which meant someone had to be steering at all times. So instead of enjoying the sun or facing the daily struggles together, one of us slept while the other kept the course.

Being on a boat at sea with one other person can be isolating as it is, but it's even more so when you never see one another. It's a lot of time to spend alone with your thoughts and it can drive you to the edge. I worked hard to keep myself calm and sane, journaling daily as a way to reconnect and process everything I was thinking and feeling. When I wasn't feeling seasick and lonely, I was meditating to try to keep my wits about me. I was in awe of how powerful nature really is. On some sunny and peaceful days, pods of dolphins would swim along the boat to give us a bit of company. But on other days, storm clouds would roll in and the risk of imminent danger caused our survival instincts to kick in. This was a far cry from a romantic pleasure cruise.

We made a number of stops on our journey and were rewarded with the incredible kindness of island locals who were shocked to see a boat pull into their harbor in the height of hurricane season. We enjoyed fresh fruit in Nuku Hiva after weeks at sea and were cared for by the locals of Tubuai after surviving near-cyclone conditions. In fact, I was so excited to not be eating rice anymore that I ate enough fruit to make my stomach hurt!

We were the first sailors they'd seen in months and they extended the warmest hospitality to two seaworn sailors who were, in so many ways, out of their depth. We'd wander the villages to get supplies and return to the boat to find food left on the deck. We'd be recognized in town as "the sailors" because, well, we were the only ones there. That generosity is something I'll forever be grateful for—a contrast to how harsh the open ocean could be.

During Christmas, we spent some time in Bora Bora—although it wasn't the luxury island experience I'd have when I returned six years later. Instead of overwater bungalows and chilled champagne, we sat on the beach near our boat, eating rice and beans to celebrate the holiday. Even now, it's humbling to look back and acknowledge that contrast. The journey I took at the age of 25 is one I'll carry with me for the rest of my life and I'll never be able to wander a marina or sit on a beach without remembering how different it felt after weeks at sea.

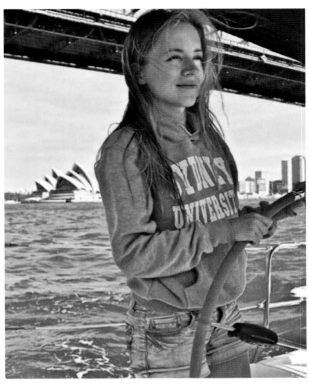

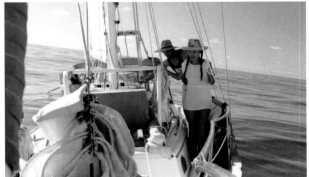

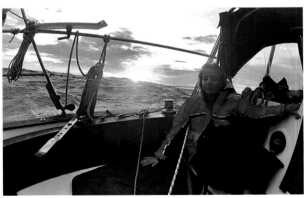

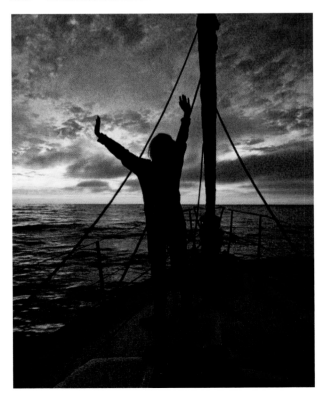

The final days of our journey were hopeful, but again, a challenge awaited us. After leaving New Zealand for the final sail to Sydney, we found ourselves stuck less than 15 miles off the Australian coast. What should have been a short trip to land turned into four incredibly difficult days. The wind had died, but a gale was on the radar that we hoped would help push us to shore. Instead, it changed directions and we had to head back out to sea to allow the storm to pass. Hungry, exhausted, and physically and emotionally drained, we had to muster what little strength we had to endure until we could sail safely to Sydney, finally arriving on May 5, 2014. Up until the very last moment, the ocean tested our limits. We didn't realize it then, but we were actually incredibly lucky: Two days after we'd left New Zealand, a group of six sailors departed to make the same journey to Australia, but they never made it back to land. The ocean takes so many people, and no matter how prepared you are or how much you train, you can't escape the fact that it's a dangerous and unpredictable place.

This experience was 10% fun and 90% hard work. It taught me gratitude, perseverance, and that I'm stronger than I ever imagined I could be. We were rewarded for our hard work with the feeling of being one with the ocean, with the most spectacular sunrises and sunsets and with skies full of more stars than you've ever imagined. But it's important to remember that a journey like this one is far from easy. It was the hardest thing I will ever do in my life. It isn't a bucket list adventure to simply check off your list, but instead, it's an incredible challenge that should be carefully considered, expertly planned, and painstakingly prepared for. In exchange, you'll return as a new, stronger, and more capable version of yourself.

Life as a Traveler

I was once a girl who dreamed of traveling—one who didn't know where to start or whom to ask. Today, I get to live that dream every moment. Instead of waiting for a big occasion or the right moment, I've turned travel into my profession as well as my passion and I've been blessed with the opportunity to share that with people all over the world. I've made it my mission to spoil myself with adventures—whether for my birthday or "just

because"—because it's those adventures that make me feel alive. And I hope that's what you'll get out of this book: the motivation and inspiration you need to spoil yourself. Traveling is an act of self-love as well as an act of self-discovery because as we ask the world around us to open up and let us in, we're also opening ourselves up to being changed and transformed by what we find.

Why Travel?

"Normal" Is Just a Perspective

Travel has introduced me to a world full of people and cultures different from my own. Anytime I've felt a judgment in my heart about someone or something other than what I know, I've made the choice to get on an airplane and go see things firsthand. It's opened my eyes and shifted my perspective and taught me to admit I was wrong. I've never once regretted the new experiences and understanding that has come from this quest to rid myself of that judgment. It's always worked out for the better!

Through this exploration of the world around me, I've been able to redefine what "normal" means for me. I'll never be a member of a tribe in the jungles of Brazil, a young mother in a Zulu village, or a woman in one of Dubai's towering skyscrapers, but by meeting these people and making an effort to learn about and understand their culture and their way of life, I now have the license to live my life on my own terms—by design, not by default. These women might all follow different religions and practice different cultural norms, but we're all part of something bigger—a global community where there's space for all our differences to coexist, even if we don't always understand or agree with one another. Seeking out other people's cultures will fundamentally shift your own perspective, helping us all realize that life isn't as limited as we might think it is from within our own bubble.

Even though this book is called *InstaTravel,* there's nothing instant about traveling. It's a journey—physically and emotionally. Take your time, be patient with yourself, and really enjoy the adventure you're on. Instagram is an incredible source of inspiration. It's led me to so many new destinations and I hope it will have that same effect on you. But once you've arrived, remember that that's where the "instant" part of it ends and it's time to put down your phone and immerse yourself in the experience!

Face More Than Your Fears

No one wakes up one day and is suddenly a world traveler. That title comes with practice and is something you have to earn as you go out and explore, gaining confidence in yourself as you open up to new experiences.

Facing the unknown isn't easy. I've heard followers tell me they aren't as brave as I am, but I wouldn't ever consider myself "brave." Instead, I see myself as open-minded and eager to try something new, even if that takes me out of my comfort zone and pushes my own boundaries. Remember, it's okay to start small! Be patient with yourself and begin with a trip that will help instill confidence in your curiosity, then build on that feeling. Travel at your own pace, progressing on your own terms from a relaxing weekend getaway to a more drawn-out, once-in-a-lifetime kind of voyage.

On every trip you take, try to do one thing that scares you. Brave isn't about not feeling fear. It's about fearing the unknown and doing it anyway. You might not be ready to spend days in a hut in Africa, but if you're heading to an island resort, plan to spend an afternoon in a nearby town where you can meet locals and get an authentic taste of the culture and community. That first visit might make you feel like a tourist, but with time and repetition—more traveling and more immersive experiences!—you'll feel yourself shift from a tourist to a traveler.

Find Your Bucket List

Everyone has those places they've always wanted to visit—the destinations that call across the miles. You might not know why you're drawn there, but that's just as good a reason to get on a plane as any. Now's your chance to go and find out why this place has been speaking to you! A surfer might travel the world in search of a perfect wave, foodies might make the trek for an incredible cooking class or a dish they simply can't eat anywhere else, and language buffs might go somewhere new to learn a local dialect. It's these reasons that create a feeling of connection between travelers and their destination, making the experience all the more valuable.

For me, my bucket list started with a map in my aunt's office. She'd covered the wall with a map, sticking pins in the paper to mark every destination she'd visited. When I was young, I would spend hours daydreaming about those pins. What were the people like beneath that pin? What did their town look like? What did they do for fun and eat for dinner? I realized that I was also a little pin and that the experience behind every one of those pins was going to be completely unique—whether it was in a different part of Poland or on the other side of the world. That's how I wound up in Australia: It was as far as I could get from Poland and the journey made me feel like an explorer from hundreds of years ago, making my way around the world so I could report back and tell everyone what I'd found.

These days, it's the places on the map that don't have pins that are intriguing to me. Whenever I realize there's an area without a pin, it jumps to the top of my list and I get ready to explore something new.

Ready to get out and see the world? This book is here to help you make it happen! Start your own list, make your own map, and check off countries and experiences as you go. The best way to build a bucket list is to cover three categories. First, make a list of the top five places you've always wanted to go. These could be exotic adventures or popular tourist destinations—whatever it takes to get you traveling! Next, talk to your friends and add five places they've visited and loved. A good recommendation will never steer you wrong.

Finally, round out your bucket list with five places that are a bit more under the radar. These are the unique and unexpected destinations that might be a bit harder to get to or come with fewer guidebooks and posts on travel blogs. These last five destinations will give you a chance to feel like you're really discovering something new—just don't forget to report back on what you find!

What This Book Is

This book is a collection of some of my favorite destinations and experiences—from the relaxing (Search for Black Sand Beaches Around the World, pages 44–54) to the indulgent (Eat Pray Love in Rome, pages 60–61) to the über adventurous (Climb Mount Kilimanjaro in Africa, pages 62–67). These are the places I go back to time and again, the bucket list locations you can't miss, and the unique trips you might not have even considered.

I've designed each page to help you make the most of your trip, with tips for when to go, what to pack, and, of course, how to get the best photos! And since you're already hopping on a plane to get somewhere new, I've also included some of my favorite nearby destinations so you can make the most of that plane ticket.

Use these experiences as a starting point, but remember to make each journey your own. Seek out things that are exciting to you, even if they didn't make my list. You might be a foodie in search of the most authentic meal, an adrenaline junkie looking for a mountain to climb or a cliff to dive off of, or an art lover dreaming of touring local museums and galleries. Add in the moments and destinations that will make your trip feel like you—the things you'll value and cherish for years yet to come.

How to Make It Happen

Safety and Security

Adventures like these are designed to get you out of your comfort zone, but that doesn't mean you should throw caution to the wind. The world is an ever-changing place, and the best way to stay safe when traveling is to be mindful and do your research. Travel with a friend, visit populated areas, and stay up to date on current events so you'll have a better understanding of what to expect when arriving in a destination where safety might be more of a concern.

And remember, what makes one person feel safe might not be the same for someone else, so trust your instincts and take the necessary precautions that will make you feel most at ease. Taking the proper steps to ensure your personal safety as you head abroad will give you peace of mind, resulting in a more positive experience and lots of amazing memories!

As you begin to plan your itinerary, there are a few fantastic resources that will help you check whether your chosen destination is safe to visit.

The US Department of State (travel.state.gov) provides up-to-date safety information sorted by country and type of traveler—whether you're heading to a high-risk area, you're traveling as a group of women, you're LGBTQI+, or you're traveling with disabilities. They've also assembled a list of tips to help you should you encounter a crisis while abroad—from a stolen passport to a natural disaster to everything in between.

I also recommend visiting www.gov.uk/foreign-travel-advice for additional travel information from the British government. Countries are sorted alphabetically and each features specifics about local laws and customs, health and weather advisories, and maps of local regions that should be avoided for safety reasons.

Use this information to plan a trip that makes you feel safe and excited. You might opt to travel with friends instead of alone or even consider joining a formal tour group that can provide additional resources and support in a more remote country or less stable region. Every traveler's "comfort zone" will be different, so it's up to you to do your research and take the steps that will help you ensure a fulfilling and safe journey!

Documentation

Crossing borders and going through customs and immigration means you'll need the proper documentation to get you from one country to another. Do this research well in advance, even turning to a travel agent or another professional for assistance (especially if you'll need visas or other permits to enter a country on your itinerary). And do what I say, not what I do! It only takes one time being stopped at the border because you've forgotten to get a visa or one missed flight because you didn't apply early enough for you to learn your lesson—you might as well learn from my not-so-rookie mistakes!

Health and Well-Being

There's nothing worse than getting sick on vacation. Before you hop on the plane, be sure to check the CDC website (wwwnc.cdc.gov/travel) for any required or suggested vaccines as well as tips for staying healthy while on the road.

Make sure you're up to date on routine vaccines (such as influenza as well as measles, mumps, and rubella), then talk to your healthcare provider about additional vaccines you might need based on your destination. Discuss your options—including shots vs. pills and the side effects of different formulas—and come up with a plan that best fits your travel style, your personal health, and any pre-existing conditions you might have. Don't forget to get all the necessary documentation proving you've been vaccinated! Keep this with your passport, as you might need to show proof of your vaccinations upon entry into a new country.

The most common travel documents are:

- A driver's license or photo ID, issued by your state of residence.

- A passport from the country of which you are a citizen. This will allow you into most other countries as well as back home at the end of your trip.

- A visa, which might be required for entry into and exit from the country you plan to visit. Visas aren't required for all destinations, but be sure to check the US Department of State's website (travel.state.gov) for an updated list of countries that require American travelers to obtain visas before visiting. Not a US citizen? The country of which you are a citizen (including your nearest embassy) will be able to provide information about whether you'll need a visa for your trip.

Beyond vaccines, there are a number of travel tips that will help keep you feeling good and safe while you're drinking foreign water, eating new foods, and being out in nature. Your toiletry bag should include the following:

- Any prescription medications you're taking (enough to last your whole trip, plus a few extra). This includes insulin, inhalers, and EpiPens.

- Over-the-counter basics, such as ibuprofen, allergy medicine, motion sickness medicine, cough drops, and antacid.

- Hand sanitizer or antibacterial wipes.

- Insect repellent.

- Sunscreen with an SPF of at least 15. Look for reef-safe varieties to ensure the product you're wearing won't harm local waterways, especially if you'll be doing a lot of swimming!

- A mini first-aid kit that includes a few bandages and hydrocortisone cream.

- Water purification tablets.

- Travelers' diarrhea antibiotics.

Responsible and Sustainable Tourism

As travelers, it's our responsibility to ensure we're taking care of the places we visit and respecting the cultures that surround us. It might be easier to head to the biggest tourist hotspot to "get a taste of the culture," but these attractions are often watering down the culture, skipping crucial (and often controversial) parts of an area's history or exploiting indigenous people, lands, and animals. Instead, it's important to seek authenticity. Look for companies that employ locals and give back to the community (such as the Original Maasai Hotel, pages 106–109) and ones that emphasize their commitment to maintaining and respecting the local culture, not just monetizing it. Search for sustainable, preservation-oriented, and eco-friendly experiences because the places that top our travel bucket lists will only continue to be there if we make an effort to care for them.

The same applies to animal experiences. You might have dreamed of petting a lion cub or riding an elephant, but be sure to do your research before you buy your tickets. Remember, these are wild animals that should be roaming their natural habitat instead of on display for tourists! One important thing I've learned in my travels is that a "sanctuary" isn't necessarily a facility that's rescuing and rehabilitating animals. Instead, many are taking advantage of orphaned young and domesticating them for the sake of a profit. That isn't to say that animal experiences should be avoided but just that they should be well researched. Look for rescue organizations and rehabilitation centers where you can see the animals up close—although you likely won't be able to touch them—and take a good look at the type of work the employees and volunteers are doing to help the animals survive and thrive.

If your chosen destination is home to something that you're passionate about—whether it's your favorite animal or a charity that's building schools for local children—consider using some of your time to volunteer or bringing requested donations in your suitcase. When you add a humanitarian element to your travels, you'll leave your destination a better place than when you arrived and you'll form an even deeper connection to the people you meet and the places you see.

Get Out There!
A Good "Why" Makes the "How" a Formality

A wise traveler once told me that a good "why" makes the "how" a formality. If you make it your life's priority to find out what inspires you to live your life to the fullest, the steps it will take to get you there will find meaning in their own right—and even the hardest moments or steepest climbs will always feel like you're working toward an all-encompassing goal. Travel isn't about Instagram or about getting the perfect photo to share with your followers. It takes time and costs money, but it's more profound than that. Travel changes you—but only if you let it.

In these pages, you'll find more than a bucket list of experiences to check off and post on your own Instagram. You'll find more than 50 opportunities to get to know the world and yourself a little better, to grow, to be inspired, and to fill your days—and your memories—with moments that will give your life new meaning.

What are you waiting for? I'll see you on the road!

xoxo,
Aggie

beach
+ water

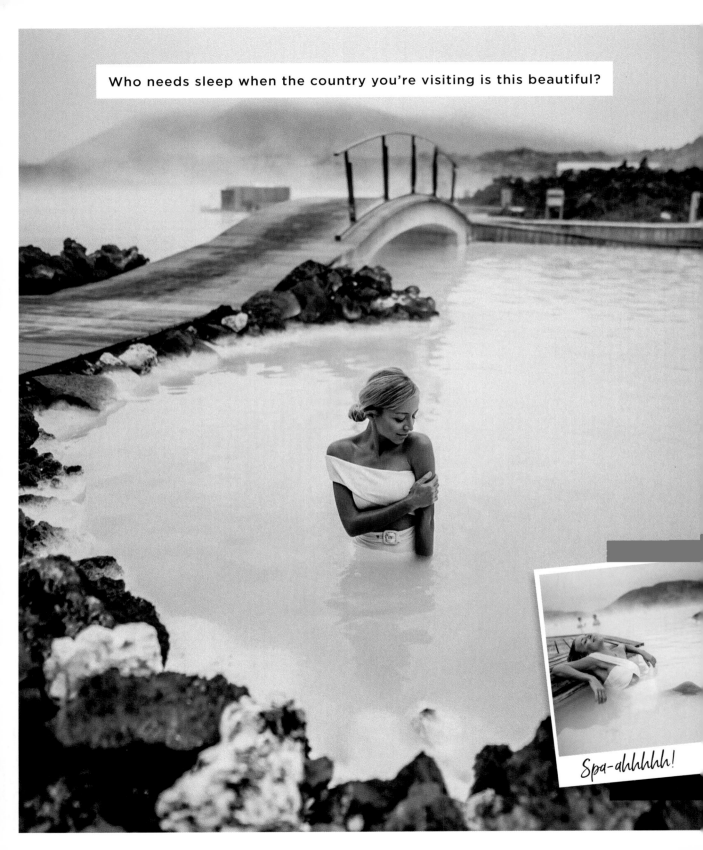

Who needs sleep when the country you're visiting is this beautiful?

Spa-ahhhhh!

Whether it's winter's short daylight hours or the endless days of summer, visit in the morning or late in the afternoon for smaller crowds.

Where to go

THE BLUE LAGOON might look like a wild and remote oasis, but I was shocked to discover that the Blue Lagoon is actually man-made! The nearby Svartsengi Power Station uses water that runs over an underground lava flow to power the turbines, then that water is directed into the lagoon to maintain a totally relaxing 100°F at all times. You can access the warm water, algae-rich clay, and luxe spa treatments at the Blue Lagoon Iceland Geothermal Spa.

Nearby places

While many airlines feature long layovers in Keflavik specifically so you can visit the Blue Lagoon (and the spa itself has shuttles that run to and from the airport), it's worth spending a few days exploring the country. **REYKJAVÍK** is an incredible place to rent a car for a daylong road trip on the Golden Circle, where you can see the Strokkur geyser, the multilevel Gullfoss waterfall, and Thingvellir National Park. For something cooler (literally!), book a tour and hike one of Iceland's five major glaciers, including Vatnajökull.

Swim in the
Blue Lagoon
IN ICELAND

A visit to Iceland feels like going to another planet because it's almost impossible to know what time it is: In summer, it never gets dark, and in the winter, there are just five hours of daylight.

I visited in June and immediately noticed two things: First, it was cold. Temperatures rarely rise above the mid-50s and here I was expecting summer! Second, it was so, so bright. All that daylight messes with your mind, plus figuring out when to eat and sleep was a huge challenge. The upside, though, was that it felt like we never saw a crowd. We visited waterfalls after midnight, saw glaciers in the wee hours of the morning, and hit the spa when we should have been eating dinner.

The Blue Lagoon is a dramatic lava field full of pale blue water, craggy rocks, and relaxing inlets. The water gets its color from silica and algae, the basis of the spa's products and treatments. Slather on that white mud mask and enjoy—it really does wonders for your skin! You could spend the whole day there, indulging in massages and facials before dining at the restaurant or getting a cocktail at the bar. All the extremes that come together in one place will make a trip to Iceland one of your most memorable adventures!

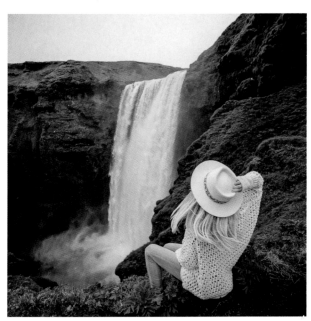

🧳 What to bring

Do what I say, not what I do! I had a vision of myself floating in the pale blue water, but I quickly learned that the silica and algae that are great for your skin will actually wreak havoc on your hair. Oops!

Keep your head above water and pack a rich conditioner to use after your swim. Better yet, pick one up from the spa for the softest hair of your life!

You'll also want to bring layers, even if you're visiting in the summer. Even in June, the temps in Iceland hover in the 50s, so you'll want to wear a sweater when you're not in the water.

PHOTO TIPS

If you visit in the summer, you won't have to worry about it getting dark. Iceland has more than 20 hours of sunlight a day in June, so a 7 p.m. photo shoot is still broad daylight! But don't worry if that doesn't line up with your schedule. Most people spend a few hours at the lagoon and spa and are so relaxed that they're happy to move over so you can snap a photo.

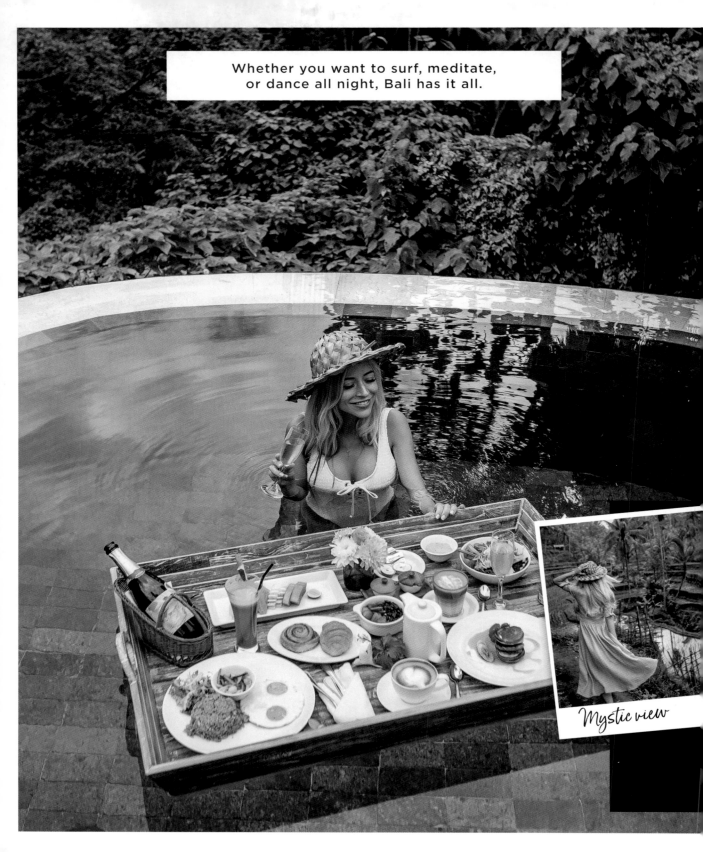

Whether you want to surf, meditate,
or dance all night, Bali has it all.

Mystic view

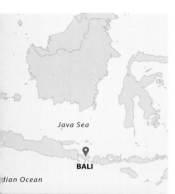

Java Sea

BALI

dian Ocean

🧳 *What to bring*

The packing list will vary depending on the experience you want to have. In Ubud, it's all about easy sundresses and yoga pants. For Kuta, pack your favorite beachy mini or cutoff shorts. Heading to Canggu? Don't forget your rashguard! No matter where you go, a few bikinis are an absolute must.

PHOTO TIPS

It gets hot quickly in Bali, so breakfast is delivered at 7 a.m. Get in the pool ASAP so you (and your food!) don't fry. Sit on the steps with your legs under water alongside the floating tray—you'll want your torso and arms visible for the perfect action shot.

Try to get your shots all in one morning. That way, you can spend the rest of your mornings enjoying the fresh fruit and Balinese coffee instead of trying to photograph it!

LOCATION: **BALI**
COUNTRY: **INDONESIA**
Aim for April to June or September and October to avoid the daily rain, higher humidity, larger crowds, and *a lot* of mosquitoes.

Where to go

UBUD is for yoga lovers looking for a laid-back getaway. Head to the jungly center of the island to reconnect with nature and indulge in some major "me" time. This is the perfect place to go on a girls' getaway with your BFFs!
KUTA is the perfect destination if your dream is to party in the sand. It's cheap and full of fun but won't be a relaxing or romantic retreat.
CANGGU is for the spiritual junkies in search of a good vegan meal, a nice hotel, and a gorgeous sunset. Spend the morning surfing, then tour the temples in the afternoon.

Nearby places

Bali perfectly balances a remote getaway and an Instagrammer's paradise. Escape to the jungle or hit every blogger hotspot—it's totally up to you! Ubud has two experiences I love: the **BALI SWING** is a dramatic wood and rope swing that goes out over the treetops. For a different experience, the **SACRED MONKEY FOREST SANCTUARY** is home to hundreds of monkeys as well as a few Hindu temples. Watch your pockets—the monkeys are fearless and will come looking for snacks. And if you're surfing with all the cool kids in Canggu, be sure to visit the **SHADY SHACK** for super yummy vegan food!

Eat a Floating Breakfast
IN BALI

Bali isn't a very big island, but it's incredibly diverse. It has a special energy that attracts all types of people—from hippies and yogis to hardcore partiers—and each group can find their niche between the soft sand and dense jungle. There's also a destination for every price point— whether you want to stay in a no-frills guesthouse or plan to check in to one of the world's most luxurious resorts.

The thing I'll always remember about a recent girls' trip to Kamandalu in Ubud was our daily floating breakfast. Each villa had its own pool, and at 7 a.m., the staff would arrive to deliver fresh fruit, smoothies, and rich coffee—all arranged on a tray and left to float in the water so you could enjoy the serenity while you dined.

Our trip was all about growth, self-care, and reflection. Every day, we would roll out of bed, put on our bathing suits, and settle in on the pool's steps to eat our fill as the sun shone over the water. It was the perfect laid-back morning ritual before the hotel's daily yoga classes or an open-air massage in the forest spa. We meditated, wrote in our journals, and made the most of every relaxing moment!

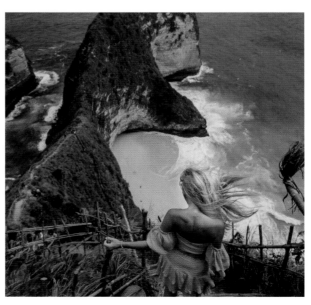

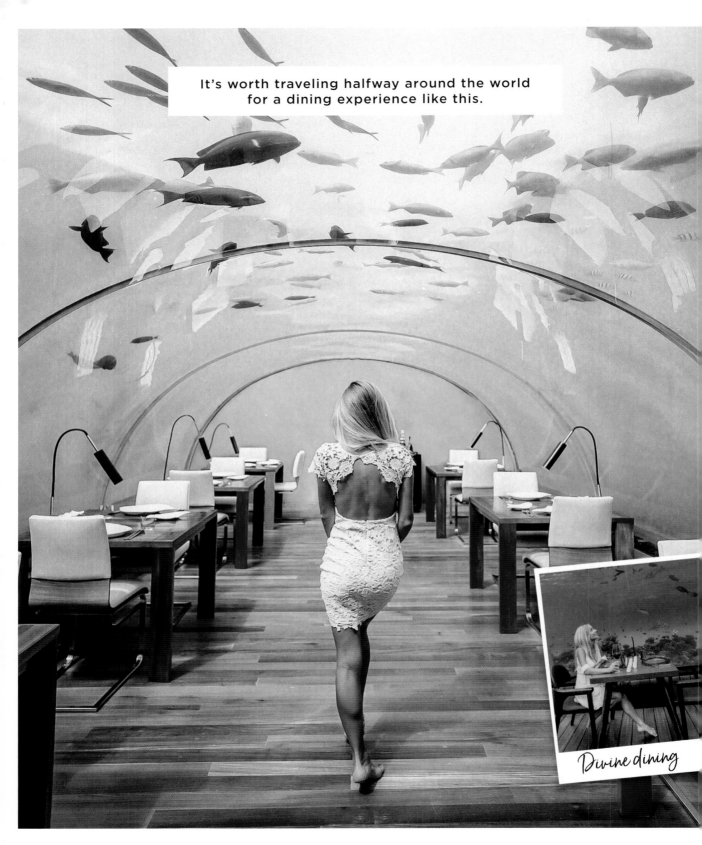

It's worth traveling halfway around the world for a dining experience like this.

Divine dining

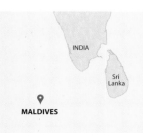

INDIA

Sri Lanka

MALDIVES

Indian Ocean

🧳 What to bring

These fine-dining experiences are more dressy than your standard beach resort, so bring a cute dress! However, don't worry about your shoes—you'll have to take them off once you reach the end of the dock and the entrance to the restaurant.

PHOTO TIPS

Turn off your flash! While it does get darker in the evening, the flash will reflect off the glass—and can be dangerous to the fish. Instead, use a longer exposure and consider turning on your camera's underwater settings to balance out the blue tone of the surrounding water against your skin.

LOCATIONS: **THREE DIFFERENT RESORTS**
COUNTRY: **MALDIVES**
November to April is ideal. You might get a better deal from May to October, but this time can be wet and windy.

Where to go

5.8 UNDERSEA RESTAURANT AT HURAWALHI MALDIVES is the largest all-glass undersea restaurant in the world, with a modern tasting menu to match. The 10-seat restaurant offers views like no other.
ITHAA UNDERSEA RESTAURANT AT CONRAD MALDIVES RANGALI ISLAND is the world's first undersea restaurant—an intimate place overlooking a coral garden. Enjoy a mid-morning glass of champagne or book a table for a locally inspired seafood feast. Not enough? The Muraka is the resort's two-level residence, which features an incredible undersea bedroom!
SEA AT ANANTARA KIHAVAH MALDIVES VILLAS has the world's first underwater wine cellar. You can admire different sea life as you enjoy your meal and a glass of vino.

Nearby places

Maldives is a series of 26 atolls and thousands of coral islands (and each resort is on its own island!). You might be tempted to spend your whole trip at your resort—and who could blame you!—but those looking for adventure will love spending a few days living on a boat for nonstop scuba diving, enjoying the glow-in-the-dark beaches of the **BAA ATOLL** (lit by bioluminescent plankton!), or sailing on a traditional Maldivian *dhoni*.

Dine Under Water
IN THE MALDIVES

Sure, you can find a luxurious overwater bungalow and an incredible spa at almost any resort destination from the Indian Ocean to the South Pacific, but the Maldives offer something extra special: a chance to dine *under* the ocean!

My first experience at an undersea restaurant was at the 5.8 Undersea Restaurant. Situated nearly 20 feet beneath the sea, 5.8 offers an experience you can't find anywhere else. You follow the jetty from the beach, arriving at a staircase that spirals down into the water. The water is so incredibly clear, you can see fish swimming around as the sun begins to set above you. They pair this already spectacular restaurant with a luxurious seven-course dinner and impeccable service—I was absolutely blown away. It's super romantic—the perfect place to go for a special occasion with someone you love. You can even hire a staff member to swim outside holding a sign that reads anything from "Happy Birthday!" to "Marry Me?"

Other hotels in the Maldives offer a similar dining opportunity, including Ithaa and SEA. Are they expensive? Yes. But they're worth every penny. How many people do you know can say they've dined at the bottom of the ocean?!?

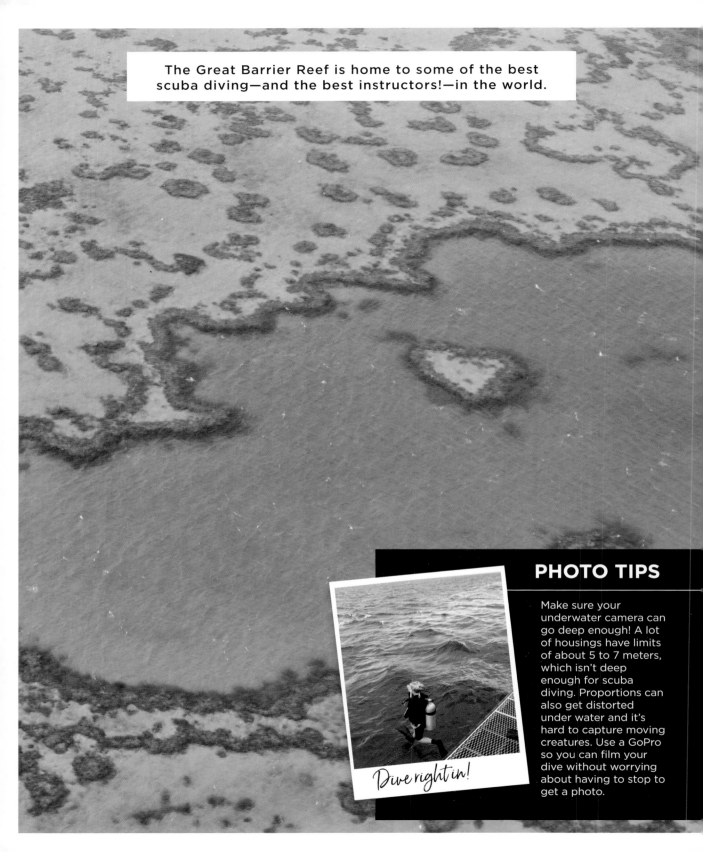

The Great Barrier Reef is home to some of the best scuba diving—and the best instructors!—in the world.

PHOTO TIPS

Make sure your underwater camera can go deep enough! A lot of housings have limits of about 5 to 7 meters, which isn't deep enough for scuba diving. Proportions can also get distorted under water and it's hard to capture moving creatures. Use a GoPro so you can film your dive without worrying about having to stop to get a photo.

Dive right in!

LOCATION: **GREAT BARRIER REEF**
COUNTRY: **AUSTRALIA**
Go between June and October to avoid rain that can cloud the water as well as the deadly box jellyfish.

What to bring

Reef-safe sunscreen is a must. Coral bleaching has damaged and killed significant parts of the Great Barrier Reef, so do your part to help protect this ecosystem by choosing products that won't harm the coral or wildlife.

Nearby places

The world's largest coral reef, the Great Barrier Reef is a must-visit for anyone who loves to dive. But if you've flown all the way to Australia, make the most of your time there! I studied in **SYDNEY** and the city is definitely worth checking out. (See pages 36–37 for my favorite spots near Bondi Beach!). On your way to the Great Barrier Reef, you'll most likely pass through **CAIRNS**. The nearby mountains are covered in rainforests—a stark contrast to the desert of central Australia—and it's an incredible place to learn about Aboriginal culture. **ULURU** (previously known as Ayers Rock) in central Australia is a sacred Aboriginal site that towers above the desert. Kangaroos and emus are plentiful, as are historic cave paintings. And the sunset over the red sandstone is totally breathtaking! You can also take a trip in a camper van along the eastern coast of Australia (pages 90–91).

Where to go

Climate change and pollution have started to cause irreparable damage to the coral, so now is the time to go to the Great Barrier Reef.
MICHAELMAS CAY is a small reef island that's popular for snorkeling and diving. Take a catamaran cruise from Cairns to visit the cay, where you can see green sea turtles, colorful tropical fish, and the thousands of birds that call the protected sanctuary home.
HEART REEF is best viewed from above, so hop on a seaplane to get a peek at this charming coral formation.
WHITSUNDAY ISLANDS are as close as you might ever get to a real-life paradise. These 74 islands are home to soft and secluded beaches, incredibly blue water, and friendly towns full of locals. It's another formation you'll want to see from above—whether on a seaplane or (for the more adventurous) while skydiving!

Scuba Dive
IN THE GREAT BARRIER REEF

I'd always dreamed about diving at the Great Barrier Reef and was so excited to finally make the trip. Knowing I wanted to really immerse myself in the experience, I booked a three-day dive trip: We lived on the boat and dove five times a day—and it was one of the coolest adventures I've had.

Diving is incredibly technical and I wasn't sure how I'd feel about it once I was there, but there's no better place in the world to learn how to dive or get advanced certification. The location is unbeatable and you're under water with some of the most accomplished and experienced trainers on the planet.

We headed out 50 miles offshore, filling our day with an easy rhythm: 2 hours of preparations, a 30-minute dive, 1 hour for a break and a snack, and then back to prepping for the next dive. You're wet and salty all day, so it's worth packing extra swimsuits so you can dry off between dives!

All that repetition did wonders for my confidence. By the end of our trip, we were diving nearly 100 feet under water and I found myself eager for every dive. I also loved the peace and solitude you feel at those depths. You're surrounded by turtles, whale sharks, and colorful fish—and the slower pace gives you a chance to really be present.

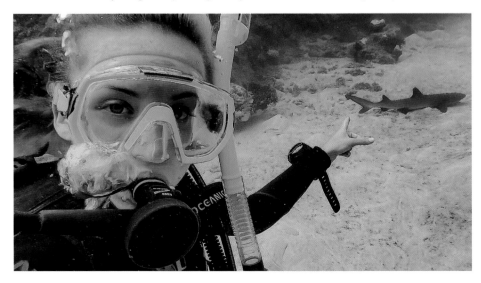

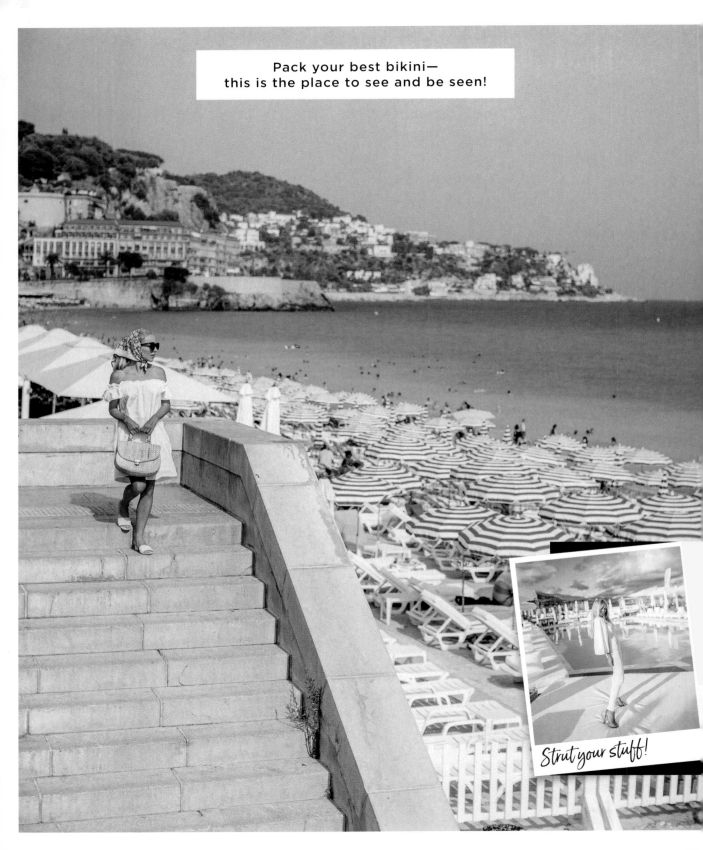

Pack your best bikini—
this is the place to see and be seen!

Strut your stuff!

LOCATION: **SOUTHERN COAST ON THE MEDITERRANEAN SEA**
COUNTRY: **FRANCE**
It's always sunny but it can be rainy in March, April, October, and November. July and August are the busiest.

Visit the *French Riviera* IN FRANCE

What to bring

On the French Riviera, it's all about the details. Leave your flip-flops at home—this is the time to wear your nicest sandals, even down to the beach. Bring a dramatic sunhat or pick one up at one of the local shops. And don't even think about packing your cutoffs! Your best bikinis should be worn under a chic sarong or flowy sundress. You'll even spot women wearing jewelry around the pool, so don't be afraid to accessorize!

PHOTO TIPS

Unless you're doing a photo shoot, it's best to leave large camera equipment in your hotel. A lot of places—especially the casino in Monte Carlo!—are sensitive to cameras because there are so many celebrities and high-rollers around, so stick to your phone if you want to snap a shot of the view.

Where to go

CANNES is worth visiting twice—once during the film festival for the glamour and celebrity sightings and once when it's not festival season to enjoy the beach and wander the coastal city with smaller crowds. I got to attend the festival to receive an award for Best Style in Travel from the World Blogger Awards and I loved seeing movie stars wandering the streets of the city in gowns and tuxedos!
NICE is more than just an airport. It features pebbly beaches (compared with the soft sand of Cannes), museums featuring Henri Matisse and Marc Chagall, and a lively market in the Old Town, or *Vieille Ville.*
SAINT-TROPEZ is a posh and high-end area—the perfect place to go if you want to spot mega-yachts.
MONTE CARLO is home to high-end casinos, the Formula 1 Monaco Grand Prix, and incredible ocean views. It's a place to feel like royalty as you rub shoulders with the rich and famous and ogle the sports cars parked in front of the Hôtel de Paris.

The French Riviera will always hold a special place in my heart. It was the first international destination I visited as a teenager, after begging my parents to let me go on a weeklong trip to Cannes. I'd never been surrounded by another language, been so far from home on my own, or been somewhere so warm! It's crazy to look back now and realize that it was on Cannes's sandy beaches that I was bitten by the travel bug and that I've visited more than 70 countries in the 15 years since that trip.

A trip to the French Riviera is a total luxury experience. I love spending the day at a beach club, where you can drink champagne on a daybed, enjoy a high-end meal (mind the dress code, of course!), and lay out and get a tan in between. Don't forget your biggest sunglasses—all the better for spying on the celebrity on the lounge chair next to you!

Even with so many international destinations under my belt, I keep going back to the French Riviera. Why? There's just something so cool about the lifestyle: French people along the Riviera have totally mastered the *je ne sais quoi* that the country is famous for! There's an easy and laid-back vibe as well as an understanding that life is worth celebrating—especially with a glass of rosé while overlooking the ocean!

Whether you have your toes in the sand in Cannes, are partying on a yacht in Saint-Tropez, or are gambling with high-rollers in Monte Carlo, the French Riviera is charming, fancy, and the perfect place for a fun and sunny holiday.

Nearby places

Stretching along the southeastern coast of France from Toulon to the Italian border, the French Riviera is the best place to people-watch as you work on your tan (and your French!). While the area is luxe and beachy, the rest of the south of France is pastoral and serene. Make time to visit these places to have other experiences. **PROVENCE** is home to olive groves, lavender fields, and everyone's favorite summer drink: rosé! Arrange a tour at the stunning Chateau d'Esclans, where Whispering Angel is produced. If perfume is more your speed, head to **GRASSE**, the world's perfume capital, to visit historic *parfumeries*. When it's time for your next destination, head back to Paris or Lyons to take the high-speed train to **MILAN**, getting you to Italy in mere hours—it's much more civilized than running through an airport!

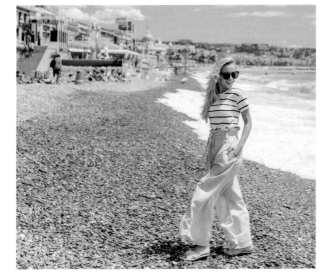

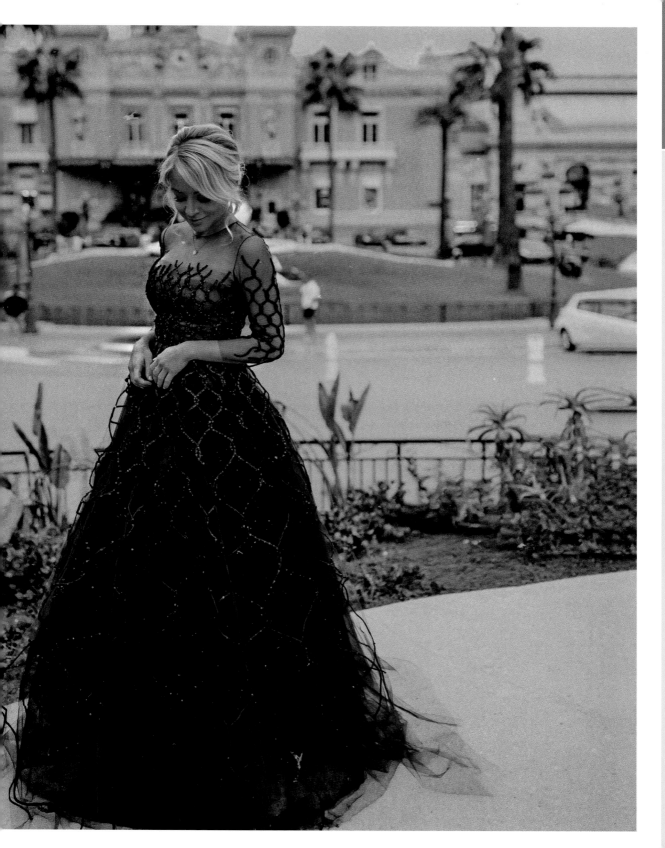

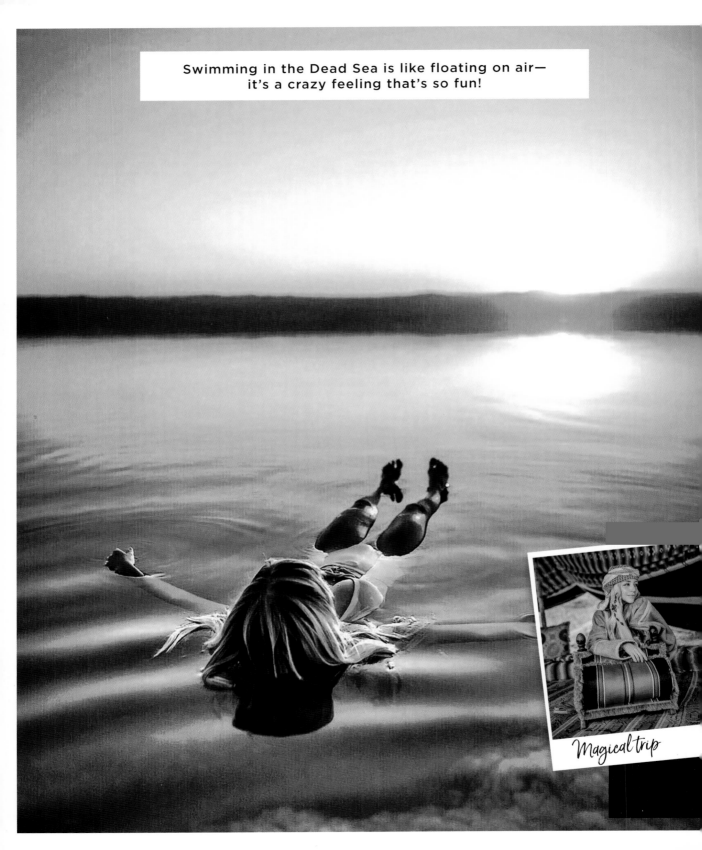

Swimming in the Dead Sea is like floating on air—
it's a crazy feeling that's so fun!

Magical trip

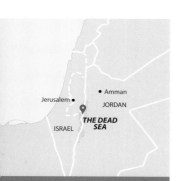

LOCATION: **THE DEAD SEA**
COUNTRIES: **ISRAEL & JORDAN**
March to May and September to November have the most comfortable temps. Don't go on Fridays and Saturdays if possible to avoid the crowds.

Swim in The Dead Sea

What to bring

Because the Dead Sea has high salinity levels and dark mud that can stain your clothes, it's best to pack a swimsuit in a dark color or one you won't mind throwing away after your trip. While bikinis are acceptable, you might feel more comfortable in a more modest style, especially if you'll be swimming on the Jordan side. On that note, you might also want to bring a pair of shorts and a T-shirt to wear over your bathing suit to and from the changing room. Also, pack lots of fresh water (to drink and for rinsing off!) and a few towels!

PHOTO TIPS

Don't point your camera at the locals taking a dip—especially women. Most people in Jordan are Muslim and women will remove their abayas and other coverings to swim. The men they're with can get very protective. Keep your camera away from the water. Take any photos on shore, then put your camera somewhere safe and dry. This isn't the place for any underwater photography—and the salty water isn't clear enough anyway!

Where to go

ISRAEL
EIN BOKEK is a resort area with hotels and spas offering Dead Sea mud treatments. If you're not staying at one of the hotels, you'll have to pay a beach access fee.
KALIA BEACH is on the northern coast, with great facilities and beautiful views.

JORDAN
AMMAN BEACH is a public beach south of the resort area with affordable access to the Dead Sea.
AL-WADI RESORT is a great spot if you're looking for more than a float and a mud bath. This water park has slides, a wave pool, and beach access.

Nearby places

In Jordan, **WADI MUJIB** is a river canyon formed during the last ice age that leads to the Dead Sea. The layered rock towers above a low riverbed, which you'll have to wade— and sometimes swim!— through on your hike. **PETRA**, also in Jordan, is an ancient city carved into the rock. You'll feel like you've traveled back to biblical times as you wander between the temples and tombs. (See pages 100–101 for more on Petra.) The **OLD CITY** of **JERUSALEM** in Israel is a walled central area filled with sites for Christians, Jews, and Muslims alike, including the Temple Mount, the Church of the Holy Sepulchre, and al-Aqsa Mosque.

Going for a swim in the Dead Sea is like floating on a cloud. There isn't much aquatic life because the water is so salty, but that high salinity means the water is extra dense—making swimming feel like you're in zero gravity.

I've visited the Dead Sea from Israel and from Jordan. Both coasts feature a mix of public beaches and luxe resorts, all geared toward the water and mud's healing properties—a practice that dates back thousands of years. As you approach the Dead Sea, the first thing you'll see are rocky cliffs over the turquoise water. You'll be tempted to dive right in, but the density makes going under water nearly impossible. Instead, walk into the water and lounge like you're on a beach chair! But the incredibly salty water will sting your eyes, so keep your face dry and get out to rinse off after about 10 minutes. For that same reason, don't shave for a few days before you go!

Resorts offer affordable indulgent packages, giving you extreme pampering in an extreme environment (you *are* more than 1,400 feet below sea level!). Take a cold shower, then head into the salty water for a float. Slather on the rich mineral mud and let it dry, then rinse. The rich minerals are supposed to do wonders for your skin and prevent aging and wrinkles—so you might want to repeat the whole thing again the next day!

Live near Icebergs IN THE ARCTIC

by Jacob Riglin (@jacob)

Along with a local Inuit guide and his son, I spent seven days living on the frozen Atlantic Ocean surrounded by towering icebergs and, of course, polar bears. Nothing can really prepare you for the first time you see a polar bear making its way toward you, the power in its body as it charges through the snow, confident and focused. We had been on the ice for two days, searching for tracks and signs of bears, and this was going to be our first encounter. We had to be completely silent so we wouldn't scare the bear. I expected this encounter to be a distant one, where the bear would walk past and keep its distance from us. But instead, it started to come directly toward us.

Behind the bear were two cubs, playful and clumsy as they tried to copy their mother. Even with the cute displays from the cubs, our guide was vigilant—eyes locked on the mother, who was now about 50 feet from us and still moving rapidly toward our group. It wasn't until I looked up from behind my camera lens that I realized they were now just 15 feet from us. The mother looked up and locked eyes with the guide before she began to bow her head in a dominating position. Our guide slapped the side of our skidoo and she returned her attention to her cubs—and they continued on their way.

I came to this remote area to see and hear about the negative impacts global warming has been having on the polar bear populations here. But I learned that the opposite's true: Polar bear populations are on the rise in that area, with more numbers seen here in recent years than ever before. On top of that, the fact we saw young healthy cubs (and some older cubs during the following days) meant that polar bear mating wasn't being affected. But polar bears are still a vulnerable species being affected daily by our carelessness for the planet. Do your part to help make a difference.

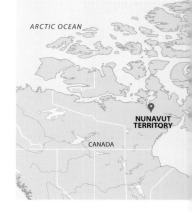

LOCATION: **NUNAVUT TERRITORY**
COUNTRY: **CANADA**
March and April are the ideal months to see polar bears as well as get great views of the Northern Lights.

Where to go

QIKIQTARJUAQ is an Inuit community just north of the Arctic Circle. The area offers many typical outdoor activities: hiking, skiing, climbing, and sledding. But the highlight of a trip to Qikiqtarjuaq is the Arctic life: narwhals, orca whales, walruses, seals, and, of course, the polar bears.

Nearby places

At the **GATHERING CENTRE** are several different kinds of events. You can have tea and bannock (a flat quick bread) with a local family, giving you a chance to interact with the locals and learn about their way of life. To learn more about the history, culture, and language of the Inuit, a local elder offers a two-hour experience through storytelling and conversation. Traditional clothes and traditional arts are demonstrated several times a week, including carving and toolmaking.

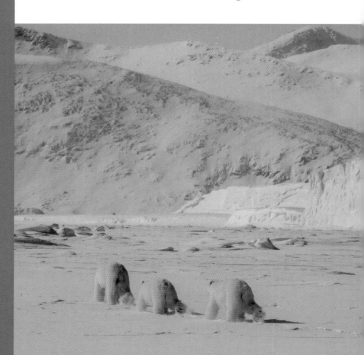

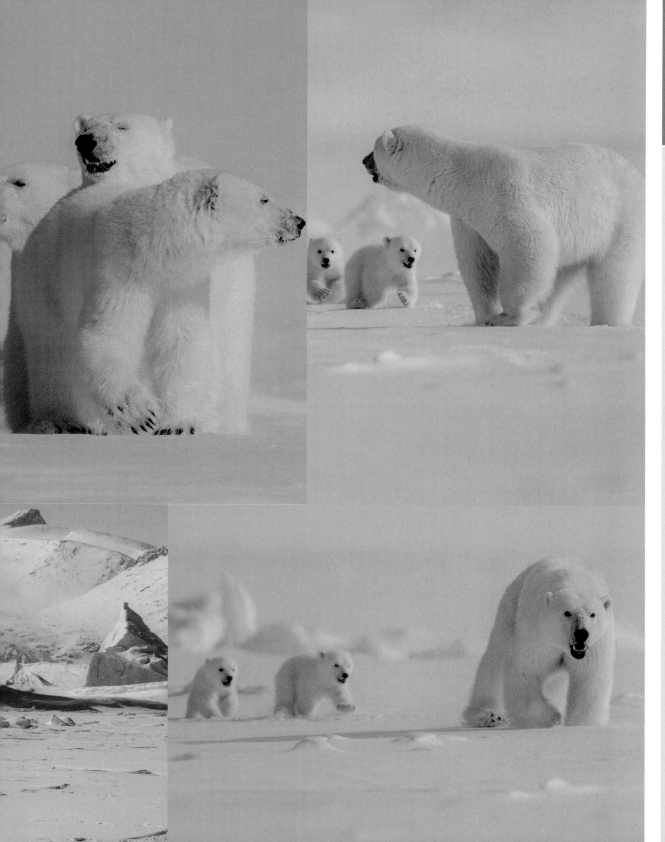

There's no better feeling than riding a wave in to the shore—no matter how many times you fall off your board first!

Sunlit beauty

**LOCATION: SYDNEY
COUNTRY: AUSTRALIA**
Nothing beats an Australian summer (from October to March). Sunny and warm days are perfect for a little time in the chilly ocean!

Where to go

BONDI BEACH is a beautiful white sand beach that's wide and shallow, with regular waves that make it the perfect place to learn to surf.
THE BONDI ICEBERGS CLUB is an iconic swim club and pool set right on the edge of the ocean, with waves crashing up into the pool itself. It's the perfect place to grab a drink and snap a photo with surfers in the background, although membership isn't for the faint of heart: The winter swimming club has outdoor swim meets every Sunday from May to September (the heart of Australia's winter and a very chilly proposition!).
SPEEDOS CAFÉ is the best place to get breakfast after watching the sunrise on the beach. The menu is fresh, colorful, and an Instagram foodie's dream!

Nearby places

When I lived in Sydney, one of my Sunday routines was to hike from Bondi to **BRONTE BEACH**, grab a coffee, and then hike back. It's a great way to get a feel for Sydney's hippie suburb! Head to one of the city's older neighborhoods, **MANLY BEACH**, by taking the ferry from the Opera House. The views are amazing! I also lived in **PERTH** for a year and a half and loved the contrast between Perth's laid-back, outdoorsy style and Sydney's cosmopolitan vibe. It's a great jumping-off point for a road trip. Check out my favorite route on pages 90–91!

What to bring

Bring a surfboard, sunscreen, and a smile. Australians are some of the friendliest people in the world! If you'll be surfing in the cooler months (May to September), you might want to put on a wetsuit to fend off the chill.

PHOTO TIPS

Sunrise photos over Bondi Beach are a must. Get there as early as possible—5:30 a.m. in the summer!—to capture surfers swimming out as the sky lightens. It might sound early, but it's worth it to get an epic shot before you get in the water.

Catch a Wave
ON BONDI BEACH

When I enrolled in my master's program at the University of Sydney, I was sure I'd be up and surfing every morning before class and a pro before I graduated, but studying took up a lot more time than I expected—and I realized surfing is a lot harder than it looks! However, being in Sydney put me just a few minutes away from the very best place to learn: Bondi Beach.

I had never surfed before and was happy to find that the beach is wide and shallow, with small, regular waves. It makes it easy to walk your board out instead of paddling, giving you a bit of a head start before you try to stand! The beach is also surrounded by surf shops offering rentals and group and private lessons so you can head out to catch a wave or sign up for a class to learn the finer points of the sport.

I was determined to learn myself, so I rented a board and headed out. The beauty of Aussie culture is that everyone is so incredibly friendly. Random people—from parents teaching their kids to lifelong surfers heading out for their daily waves—were happy to offer me a few pointers along the way. I might never have become a pro, but their guidance made a world of difference and ensured that I had fun even though I spent more time in the water than on my board!

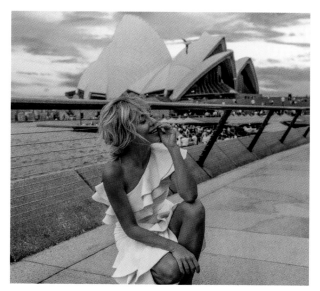

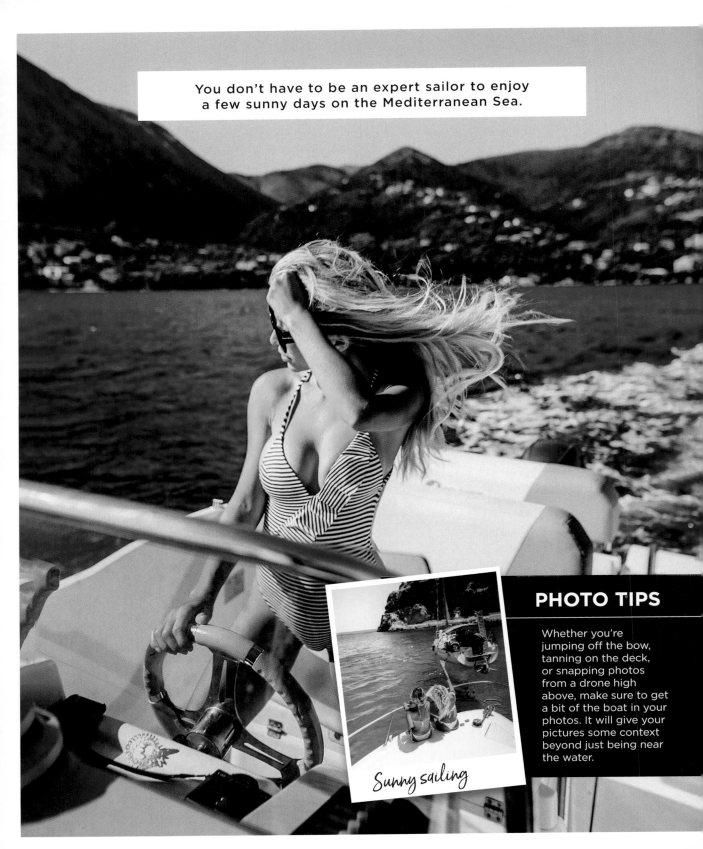

You don't have to be an expert sailor to enjoy a few sunny days on the Mediterranean Sea.

Sunny sailing

PHOTO TIPS

Whether you're jumping off the bow, tanning on the deck, or snapping photos from a drone high above, make sure to get a bit of the boat in your photos. It will give your pictures some context beyond just being near the water.

LOCATION: **MEDITERRANEAN**
COUNTRY: **GREECE**
June through September
are warm and sunny.
Expect Corfu to be slightly
cooler than Crete or Mykonos,
which are farther south.

Where to go

CORFU is off the northwestern coast of Greece, a gorgeous beach destination that's removed from Mykonos or Crete. The rocky, hilly island feels more like the Italian coast—a striking contrast to the soft sandy beaches.
VOLOS is on the eastern coast of Greece—just north of Athens. This historic town features a charming waterfront, ancient archaeological sites, and long, sandy beaches with shallow water perfect for wading.
CRETE has a little something for everyone: pristine beaches, high-end resorts, ancient ruins, spectacular hikes, and incredible food. Climb through the canyons, get a tan, and indulge in a tasting of local olive oils—all in the same day!
MYKONOS is a hotspot for travelers looking for a club feel in the sand. The sun shines all day, DJs play all night, and the white-and-blue architecture is a photographer's paradise!

🧳 What to bring

A white bikini and sunscreen! The best way to enjoy Greece's coastal cities and islands is on the water, so get ready to work on your tan. Top it off with a breezy sundress and you're ready for anything!

Nearby places

The Mediterranean is full of incredible places to visit and each will give you a taste of all the variety the region has to offer. On the Italian island of **SARDINIA**, colorful buildings cluster along the rocky coast and grottos open up to reveal crystal-blue water. Hike along cliff-top trails as you make your way to secluded beaches or take a Jeep tour through the island's national park. In the eastern Mediterranean, **CYPRUS** is known for its combination of Greek and Turkish culture, where ancient tombs butt up against wild nightlife, rocky beaches and a ruggedly beautiful wine country producing award-winning and under-the-radar varieties. For a deeper dive into Turkish culture, head to **ISTANBUL**. Hagia Sophia, the Blue Mosque, and the Basilica Cistern top the must-see list, but you'll also love evenings spent smoking hookah along the Bosphorus, which divides Europe and Asia. For more about Turkey, read about my hot air balloon adventure in Cappadocia on pages 86–89!

Drive a Boat
IN GREECE

When I had a few extra days in Greece after a trip to Mykonos, I had no idea where to go and turned to Instagram for suggestions. Every single person recommended that I go to Corfu, so I booked a flight and hotel with zero expectations.

Although there are other places around Greece where you can drive or sail on a boat, Corfu combines everything I love about the Greek islands: hilly, densely forested, and surrounded by deep blue water that feels more like the ocean than the Mediterranean Sea. Our first day on the island, the manager at the hotel recommended we rent a boat for the day to explore the area. You don't need a license (or a captain!) and can just head out onto the water, following the map to find the best nearby beaches. We drove around to the island's eastern coast, where the scenery suddenly changed: This was the Mediterranean feel I'd been expecting! We motored from beach to beach, dropping the anchor and tanning, snorkeling, or going out for a swim. It was the perfect way to spend a day and we loved it so much that we did it again for the next three days!

If you're nervous about driving a boat, don't be: Every beachfront restaurant on Corfu has an attendant waiting to park the boat while you head inside to eat fresh fruit and local seafood. When you're done, they're on the dock again, waiting to get you turned around and back on the water.

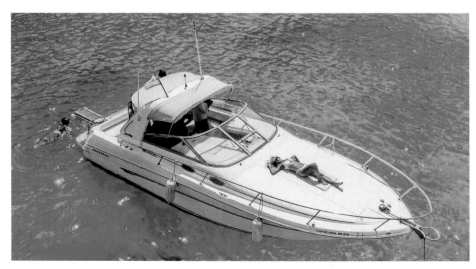

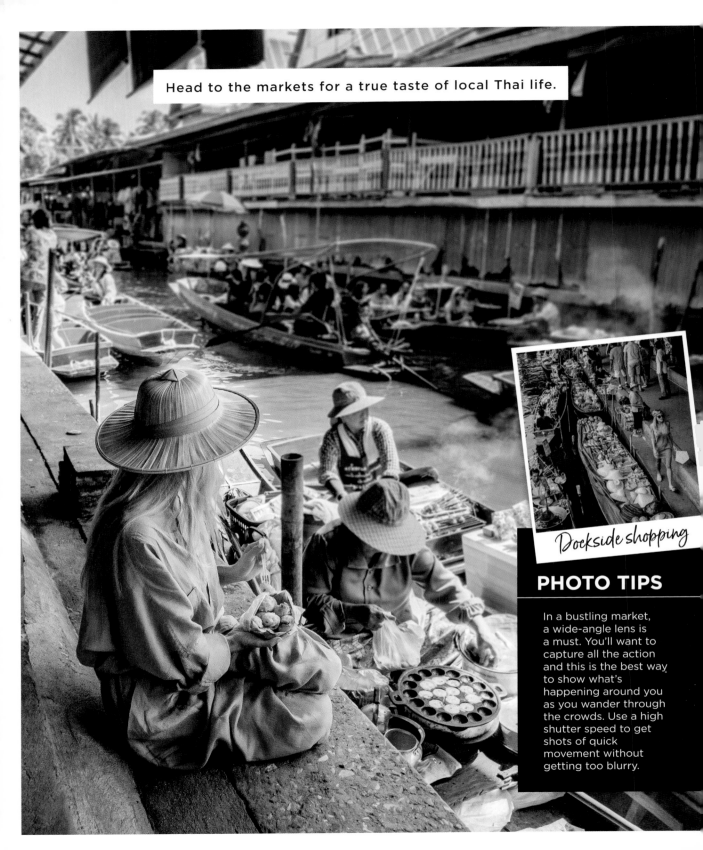

Head to the markets for a true taste of local Thai life.

Dockside shopping

PHOTO TIPS

In a bustling market, a wide-angle lens is a must. You'll want to capture all the action and this is the best way to show what's happening around you as you wander through the crowds. Use a high shutter speed to get shots of quick movement without getting too blurry.

LOCATION: **BANGKOK**
COUNTRY: **THAILAND**
May to September are
hot and humid and wet.
Visit from November to
February for drier days or
in March for smaller crowds.

Shop at a Floating Market
IN BANGKOK

What to bring

The street food looks (and smells!) amazing and it's worth tasting a few local specialties. Bring a dietary supplement like Travelan to help settle your stomach and make sure you don't get sick from the unusual ingredients—then ask your guide for suggestions and taste away!

Nearby places

The **MAEKLONG RAILWAY MARKET** might seem just like any other Thai market—until you hear the train horn and feel the rails that run down the center of the market begin to rumble. Vendors quickly and deftly move their wares off the tracks, with the train passing within inches of piles of fresh produce that might otherwise be flattened. It's incredible to see the massive locomotive squeeze through the perfectly sized space left by vendors as well as see how accustomed the vendors are to the regular (and quite loud!) interruption. The **KEEMALA HOTEL** in **PHUKET** has two kinds of treehouses you can sleep in: a pool house and a bird's nest. For a different treehouse experience, head to **KOH KOOD** and the **SONEVA KIRI RESORT**. There's a lot you can do here, including scuba diving and snorkeling, but the highlight is eating breakfast in a tree. No matter what you decide to do in Thailand, make sure your trip coincides with the **CHIANG MAI LANTERN FESTIVAL** (pages 184–185).

Where to go

DAMNOEN SADUAK FLOATING MARKET is one of the largest floating markets near Bangkok, easily reachable by taxi. It's probably the most touristy, so you might see more knickknacks and souvenirs than locals shopping for daily provisions.
AMPHAWA FLOATING MARKET is a favorite among tourists and locals alike. Keep an eye out for grilled seafood: Squid, huge prawns, and shellfish are all popular choices, best eaten on the steps that lead to the water.
KHLONG LAT MAYOM is a bit more authentic and has real local charm—in fact, you might be one of the few tourists floating among the stalls! The canal is narrow here, so you'll probably spend more time walking from vendor to vendor than in your boat.

Visiting local markets is one of my favorite ways to interact with locals and get a feel for daily life—and Bangkok is no exception. The markets are full of noise and movement: from entertainers with snakes around their necks to women who have been selling the same broth or street snacks for decades. I always visit these markets with a guide. They know the best vendors, can point you toward interesting and unique flavors and products, and speak the language, so they can help ask and answer questions that might come up as you're browsing.

When at the floating market, there are a few things that can't be missed. The first is *kanom krok*, a coconut and sugar pancake that's cooked in a griddle covered in half-moon holes. The second is Thai boat noodles, served in a rich and savory broth. The woman who sold the broth to us has been making it for 40 years! Lastly, don't skip the coconut ice cream! Even if you arrive at the market early in the morning, the weather will be hot by the time you leave—and a cool scoop is the perfect way to wrap up your tour.

Bangkok's markets are a crazy—and often overwhelming—feast for the senses. So bring your camera and your appetite—and hold on tight!

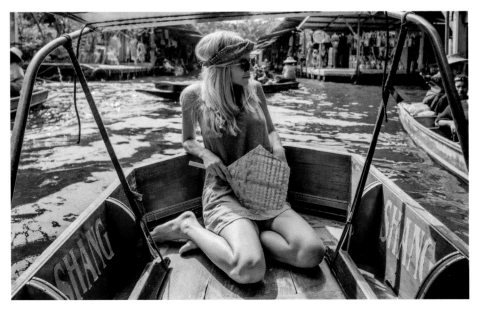

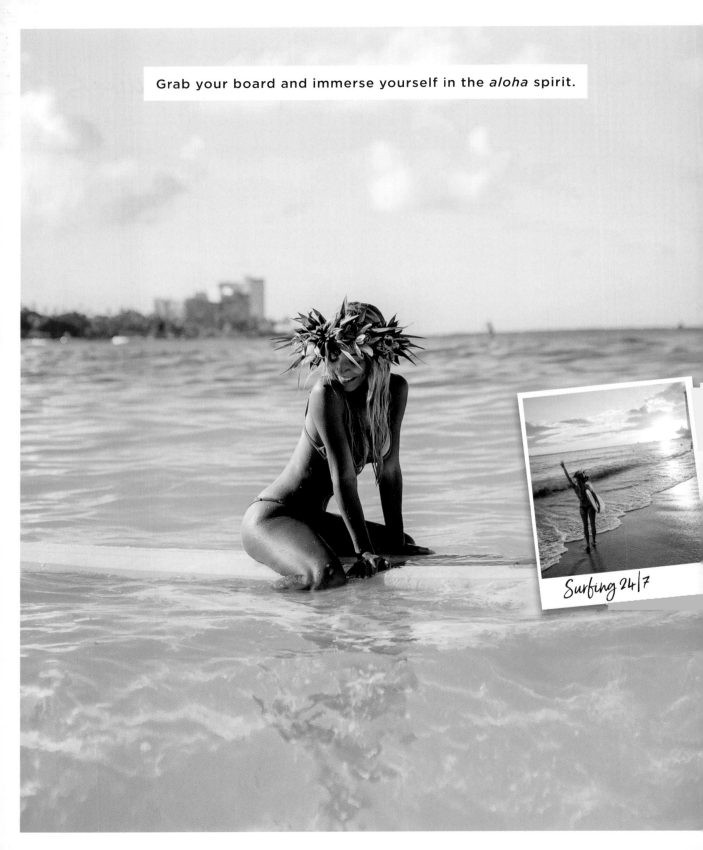

Grab your board and immerse yourself in the *aloha* spirit.

Surfing 24/7

HONOLULU

HAWAIIAN ISLANDS

Pacific Ocean

🧳 What to bring

Even the ocean is warm in Hawaii, so pack your bikini and leave the wetsuit at home. Consider a rashguard, though, as falling into the salty water can start to sting! (It's also a great way to prevent sunburn.) And, of course, lather up in reef-safe sunscreen before you hit the beach.

PHOTO TIPS

If you're hoping to get a video of yourself riding the perfect wave, make sure you bring a telescopic lens. The wide, shallow stretch at Waikiki Beach means the actual surfing takes place far out in the water, so you'll need this lens so your videographer can spot you from the shore.

LOCATION: **OAHU, HAWAII**
COUNTRY: **UNITED STATES**
There's no *bad* time to go to Hawaii, but avoid crowds at the end of May, the beginning of June, in mid-October, or at the beginning of November.

Where to go

WAIKIKI BEACH is on the south shore of Oahu, in the capital city of Honolulu—and it's where modern surfing first came to be among the smooth and rolling waves.
DIAMOND HEAD BEACH is a short walk from Waikiki but feels like a real getaway from the crowds. Expect a longer paddle but mellow waves.
BANZAI PIPELINE is for experienced surfers or those looking to watch the locals catch some big waves. If you're new to the sport, take a morning off and head to this area to see the pros in action—and maybe pick up a few pointers as they come out of the water!

Nearby places

After some time on Oahu, hop on a plane to **LANAI**, where you can check into the indulgent Four Seasons Resorts for a few days of rest and relaxation. Play a round of golf, visit Shipwreck Beach, or take a whale-watching tour in search of humpbacks and spinner dolphins. For a more outdoorsy, local feel, head to **KAUAI**—another trip by plane. Covered in dense jungles and known for its hiking, the island's Na Pali Coastline has appeared in movies like *Jurassic Park* and *Indiana Jones*. The dramatic cliffs are best seen from afar, so sign up for a helicopter tour or a sunset sail around the northern coast of the island.

Surf the Waves

IN **HONOLULU**

Surfing in Hawaii is all about embracing the *aloha* spirit. The relaxed, welcoming vibe is the perfect introduction for beginners, who will instantly feel welcome and eager to paddle back out and try again. The best place to learn to surf in Hawaii is on Waikiki Beach on the island of Oahu. It's shallow and warm (no wetsuit required!), so you're happy to be in the water even if it means you've fallen off your board yet again.

Even if surfing isn't your thing, Waikiki is still a great place to hang out. The wide beach is perfect for tanning and vendors are selling fruit and ice cream to hungry onlookers. Try your hand at stand-up paddleboarding, which requires just as much core strength but a little less fearlessness than surfing, or wander the nearby restaurants in search of the best açai bowl. If you want some guided adventure, rent an outrigger canoe for a few hours out on the water.

No matter which activity you pick, you'll feel the influence of Hawaiian culture the second you step off the plane. A trip to Hawaii is all about making time for yourself and getting out into nature, whether that's on a surfboard or hiking to Manoa Falls. So slow down, relax, and let the island lifestyle flow through your veins!

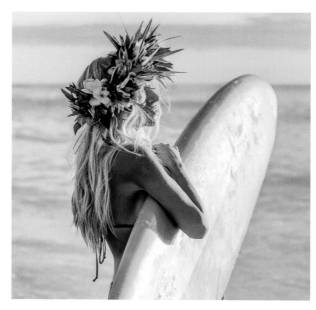

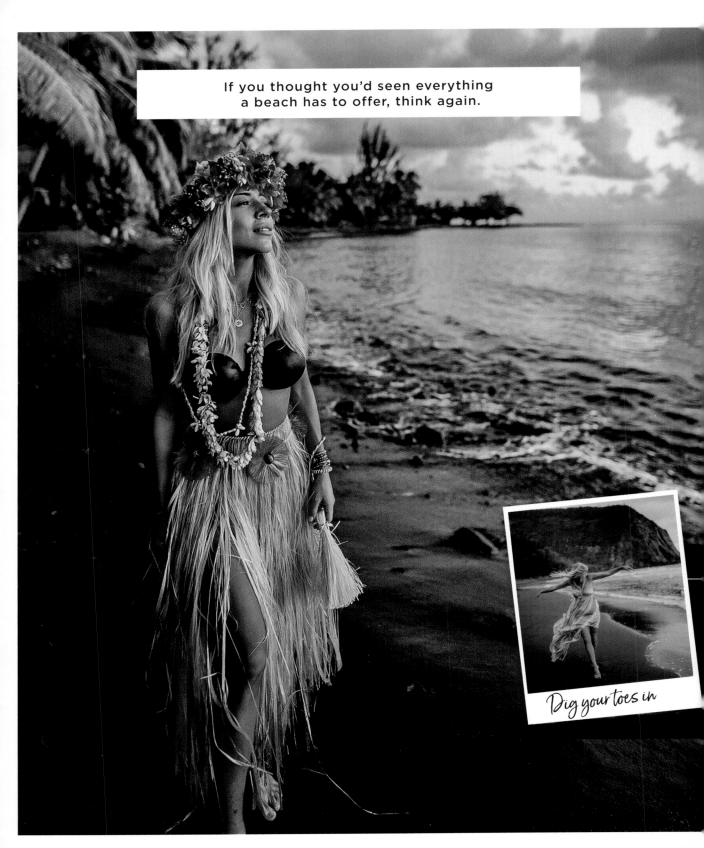

If you thought you'd seen everything
a beach has to offer, think again.

Dig your toes in

What to bring

Dark colors attract the sun, so pack a large beach towel or blanket to keep your skin cool. Don't forget a pair of sandals, as black sand can be hotter than its lighter counterpart, especially in the summer months.

Nearby places

So many of Earth's coastlines have been formed by volcanic activity, so black sand beaches can be found all over the world. In addition to remote tropical locations, you might be surprised to find black sand beaches in Italy (on the island of **STROMBOLI**, off the north coast of Sicily), South Korea (on the island of **JEJU**, south of the Korean peninsula), New Zealand (**KAREKARE BEACH** is less than an hour's drive from Auckland!), and Iceland (**DIAMOND BEACH**, in southeast Iceland, is scattered with pieces of glaciers that look like massive diamonds in a black velvet box).

LOCATION: HAWAII, BALI, TAHITI & MORE!
The best time to visit will depend on the beach you choose. Avoid peak season to have each dramatic beach all to yourself!

Where to go

LAFAYETTE BEACH (TAHITI) is on the island's northern shore and overlooks Moorea. It's a wide stretch of dark volcanic sand that edges Matavai Bay. The sand is so soft in some places, you might actually sink in as you walk!

PUNALU'U (HAWAII) has a dark and rocky beach that was created by a lava flow. It's a dramatic contrast to the rest of the island's coast. The beach is a popular snorkeling destination, as endangered hawksbill turtles and green turtles call the coastline home.

KERAMAS BEACH (BALI) is on the southeastern coast of the island. It's a striking destination for sunbathers and surfers alike. This remote stretch is often quite quiet— the perfect place to take photos as you watch the pros catch rolling waves.

Search for Black Sand Beaches
AROUND THE WORLD

The first time I stumbled upon a black sand beach, I couldn't believe what I was seeing. We'd just spent 54 days sailing from Mexico to Nuku Hiva and my visions of white sand and blowing palm trees were replaced with a dramatic scene straight out of *Jurassic Park*. It was a surprise to say the least, but as soon as I set foot on the dark sand, I knew I'd found something special.

Volcanic sand is incredibly soft—softer than most of the white sand you've ever felt—and has a unique texture that feels different from other beaches. It makes even laying out to tan a unique and exciting experience—and it happens to look amazing in photos! There's something so enchanting about the contrast of black sand and white frothy waves that's totally addicting and has made black sand beaches something I seek out wherever I go.

Black sand beaches are absolutely rare and exotic, but you'll be happy to learn they can be found all over the world. Some of my favorites are in Tahiti, Bali, and Hawaii, but even Spain and Italy have black sand along their coastlines. It's my personal quest to find as many as I can—and I hope you'll join me on this warm and inviting adventure.

PHOTO TIPS

Black sand beaches are striking on their own and even more so when they're deserted. Sunrise is the best time to get the full effect of the dark sand against the blue water and a colorful sky without any other visitors blocking your shot.

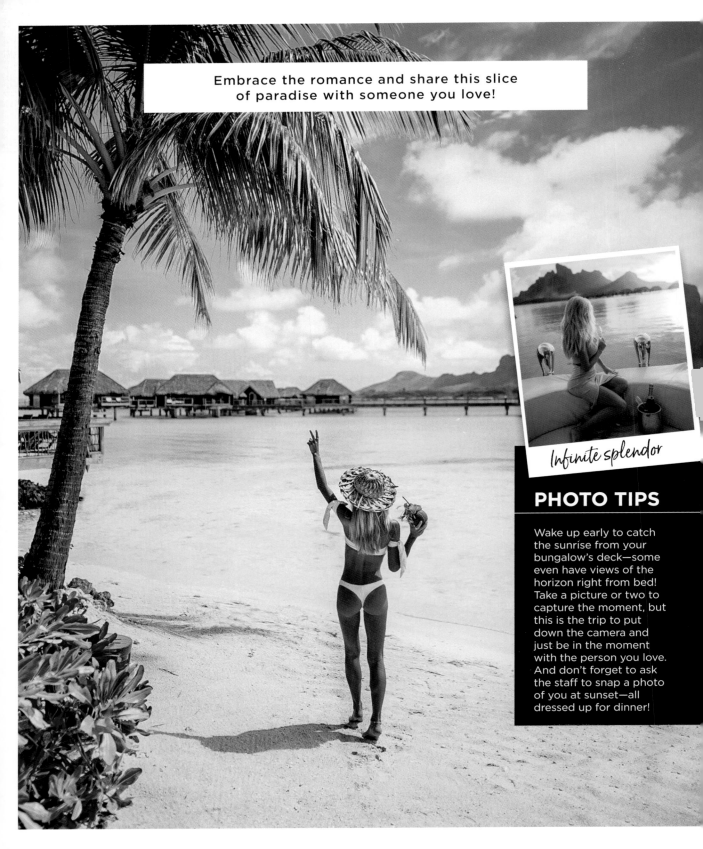

Embrace the romance and share this slice of paradise with someone you love!

Infinite splendor

PHOTO TIPS

Wake up early to catch the sunrise from your bungalow's deck—some even have views of the horizon right from bed! Take a picture or two to capture the moment, but this is the trip to put down the camera and just be in the moment with the person you love. And don't forget to ask the staff to snap a photo of you at sunset—all dressed up for dinner!

BORA BORA

South Pacific Ocean

What to bring

Bring your bathing suit and someone special to share the experience with. Each bungalow is like a slice of heaven—and you'll never want to leave. If you're going to take one incredible trip with the person you love, Bora Bora is the place to go!

Nearby places

If you're looking for a different kind of island experience, you can hike **MOUNT OTEMANU**, a dormant volcano rising from the center of the island; tour the island on a scooter; or explore the center city of **VAITAPE**. But Bora Bora isn't the only tropical paradise in the South Pacific. You'll find **TAHITI**, the **COOK ISLANDS**, and **FIJI**—all within a few hours' flight. Either extend your getaway to another tropical destination or pick and choose the island that's right for you. This region is also the perfect place to unwind for a few days before or after a trip to **AUSTRALIA**. The continent offers a plethora of destinations and exciting activities—whether you're diving the **GREAT BARRIER REEF** (pages 26–27), road-tripping along the coast (pages 90–91), or learning to surf at **BONDI BEACH** (pages 36–37).

LOCATION: **BORA BORA**
COUNTRY: **FRENCH POLYNESIA**
You'll want to plan your trip between November and April. This season has smaller crowds, making your water time better.

Where to go

FOUR SEASONS RESORT BORA BORA is one of the most iconic properties in the area. The resort offers stunning mountain views and private plunge pools—if the clear ocean water isn't tempting enough.

ST. REGIS BORA BORA RESORT offers the largest overwater suites in the South Pacific, so you can really indulge for a honeymoon like no other. With butler service and steps leading right into the ocean, you might never leave your room.

CONRAD BORA BORA NUI has the longest private beach in the area if you feel like leaving your bungalow in search of some sand. Moto Tapu, the resort's private islet, is perfect for an afternoon of snorkeling, a champagne lunch, or the world's most romantic sunset proposal. You'll never forget that!

Experience The Beauty OF BORA BORA

The first time I visited Bora Bora, we stopped on the island for a few weeks around Christmas. We lived on our boat, taking a dinghy into town and mingling with the locals as we enjoyed a bit of time on dry land. It was beautiful and relaxing.

Staying in an overwater bungalow is like having a slice of paradise all to yourself. Each room is super private, with steps leading right into the ocean so you never even have to visit the hotel's beach. In fact, some even have glass floors to blur the line between indoors and outdoors even further as you watch fish swim beneath your feet!

Bora Bora is also one of the best places to have an ocean adventure: Swim with reef sharks, sea turtles, and stingrays; take a boat out into the lagoon; or unleash your inner speed demon on the back of a Jet Ski. Once you've had your fill of the sun, devote the rest of the day to relaxing as much as possible in the spa. What I love most about Bora Bora is how welcoming the island is. The resorts are staffed by locals who are genuinely happy to have you, and you can feel and see the influence of the rich French Polynesian culture at every turn. It's exactly the vibe you want when you're planning an indulgent, over-the-top, once-in-a-lifetime experience with the person you love.

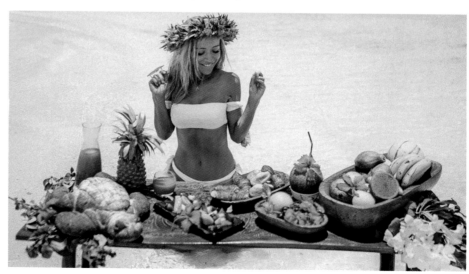

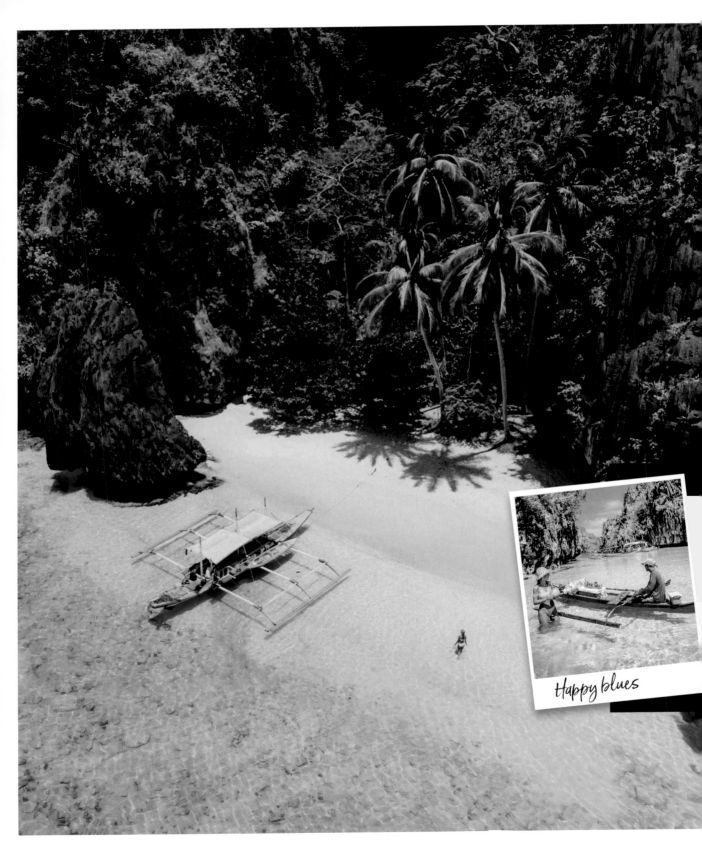

Happy blues

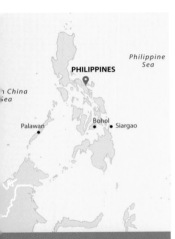

LOCATION: **PHILIPPINES**
Visit during the dry season (November to April) to ensure you'll be able to fly between islands. Rain (or even typhoons!) in the wet season can cause flight cancellations.

Where to go

SIARGAO is a surfing destination, but the deep blue water of Subga Lagoon is also enticing and worth a visit.
EL NIDO has lagoons and beaches that are a major draw. Swim through the hole to float and lounge in the Secret Lagoon, boat out to Simizu Island to take in the incredible rock formations, or hike to the Nagkalit-Kalit waterfalls.
CORON is smaller and quieter than El Nido and the remote feeling is only enhanced by the rocky cliffs that tower over the secluded bay. It's no surprise the coastline is dotted with shipwrecks for scuba divers and snorkelers to explore!
CEBU has a mountainous center that's covered in rainforest, meaning there are waterfalls *everywhere*. Whether you want to hike, swim in the pools, or go rock climbing and canyoning, these falls (and the surrounding flora and fauna!) are the reason so many visitors make the trek.
BOHOL is known for its Chocolate Hills, but there's even more to see. Take a cruise down the Loboc River, weaving through the jungle and stopping at fishing villages, or go night kayaking as the jungle glows with the light of millions of fireflies.

What to bring

Pack your belongings in a soft-sided bag to make loading and unloading small puddle-jumpers and seaplanes a breeze. Many of the islands in the Philippines have incredible diving and snorkeling around epic hikes through the central hills and jungles, so don't forget your hiking boots *or* your bathing suit!

PHOTO TIPS

If you want to become a travel blogger, the Philippines is the place to do it. There's a huge social media presence on the island and meetups can be massive and so fun! Whatever you post, use #ItsMoreFunInThe-Philippines—you'll have your inbox flooded with DMs from locals who'll want to meet up and show you around.

Island-Hop
IN THE **PHILIPPINES**

If you're looking for an exotic getaway with picturesque views, friendly locals, and the most incredible mangoes, book a trip to the Philippines. It's an amazing destination that still feels under the radar, so you won't be bombarded by crowds as you make your way to the beach. And with over 7,500 islands in the archipelago, you can choose your own island-hopping adventure!

The hardest part of visiting the islands is getting from place to place. They're all reachable by plane, but you'll have to fly back to Manila to connect each time, which can add travel time! To make the most of your experience, pick two or three islands you want to see and plan to spend a few days at each, which means much more time to explore and much less time at the airport!

My three favorite islands are Siargao, Palawan, and Bohol. Siargao is young and hip, with a lot of surfing, cliff-jumping, and tiny islets to explore. If you want even more adventure, head to Coron or El Nido. Scuba dive around sunken Japanese warships or into the depths of the underwater canyons in Barracuda Lake, which you have to see to believe! For a more luxe experience, visit Bohol. It's dotted with fancy resorts scattered around the central mountains called the Chocolate Hills. In the dry season, the mountains look like a cluster of giant Hershey's Kisses floating in the ocean!

All that time on airplanes is worth it though. Not only are these islands stunningly beautiful, but the Filipinos I met are some of the nicest people in the entire world. You'll feel instantly welcome and won't have to look far for suggestions of things to do or places to go during your stay. In fact, you'll probably head home with a few new friends in addition to amazing memories!

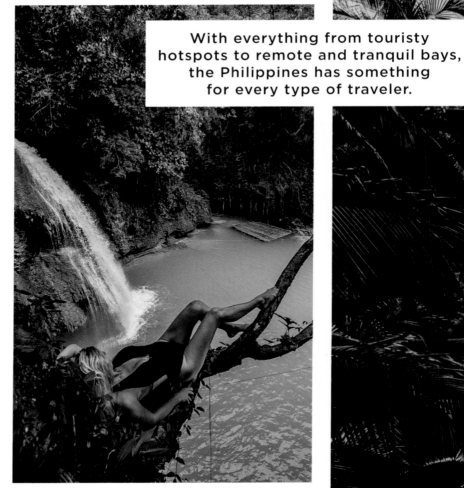

> With everything from touristy hotspots to remote and tranquil bays, the Philippines has something for every type of traveler.

Nearby places

Some of my favorite destinations are a (relatively!) short trip from the Philippines and are great places to visit before or after you go. If you'd like a more cosmopolitan experience in a big city, schedule a few days in **HONG KONG** (pages 162–163!). For even more beach time or a zen yoga retreat, make the trip to **BALI** in Indonesia (check out pages 22–23!). And if you want to wander bustling markets (pages 40–41) before sipping cocktails at one of the highest open-air bars in the world (pages 152–153), be sure to visit **BANGKOK**.

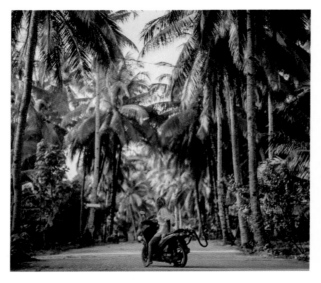

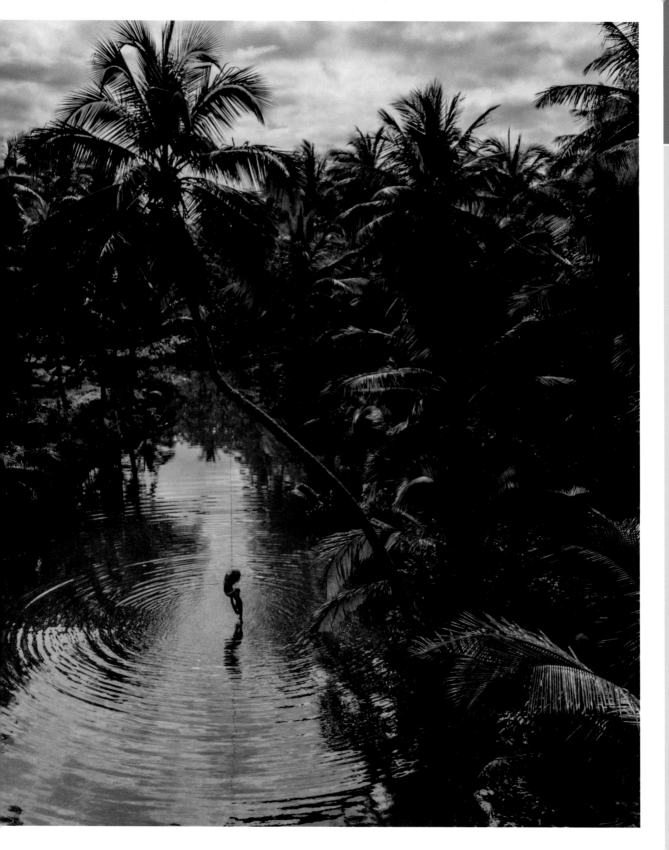

adventures

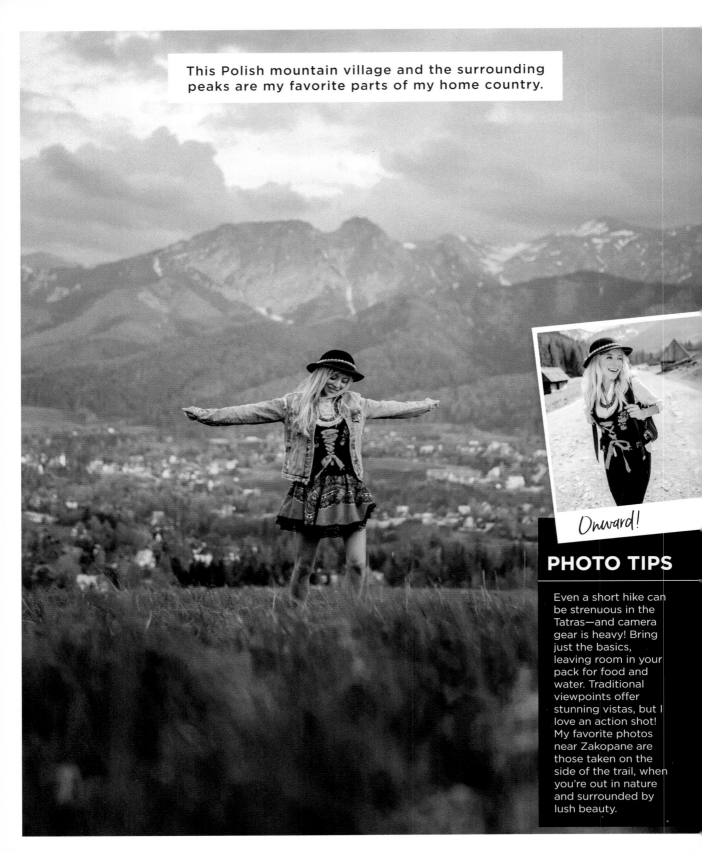

This Polish mountain village and the surrounding peaks are my favorite parts of my home country.

Onward!

PHOTO TIPS

Even a short hike can be strenuous in the Tatras—and camera gear is heavy! Bring just the basics, leaving room in your pack for food and water. Traditional viewpoints offer stunning vistas, but I love an action shot! My favorite photos near Zakopane are those taken on the side of the trail, when you're out in nature and surrounded by lush beauty.

LOCATION: **ZAKOPANE**
COUNTRY: **POLAND**
This mountainous region of Poland stays cool even in peak summer months and temperatures continue to drop the higher you climb!

Hike the Tatra Mountains
IN ZAKOPANE

I might be biased—I *am* Polish after all!—but there's no more charming place to get out into nature than in the Tatra Mountains in southern Poland. I deeply love my home country and the quaint town of Zakopane combines history, culture, and nature in a way that gives you a true taste of what Poland's about. I grew up visiting the mountains every summer with my family, so now whenever I have friends visit from abroad, we always go to Zakopane together.

The Tatra Mountains are a popular destination for skiers, but as the sun warms the peaks, the area is filled with hikers—whether you're out for the day or are spending weeks camping in yurts and training to climb the Himalayas. The Tatras aren't nearly as high, but the north-facing slopes come with constantly changing weather conditions that provide a great challenge and practice for serious adventure-seekers.

I'm usually more of the day-hike type, waking early to start a climb around 7 a.m. to avoid the crowds. I love having the mountains to myself, as it gives me a chance to reflect on the raw power and beauty the Tatras hold. Plus, you can be back in town by lunch for an afternoon of shopping!

And you should devote some time to visiting Zakopane. It's affordable, incredibly welcoming, and feels more boutique and undiscovered than similar areas in Austria or Germany. Add in the abundance of vodka and locals dancing to traditional Polish folk music—and I guarantee you'll leave loving Poland as much as I do.

What to bring

The paths throughout the Tatra Mountains are well maintained, so for a shorter day trip, you'll be happy in exercise clothes and sturdy sneakers. You can also go backpacking in the mountains, staying at huts and yurts along the way, in which case you'll want proper hiking and camping gear. Either way, bring layers! These north-facing mountains experience quick weather changes, so you'll want to be ready for anything.

Nearby places

Most trips to Poland begin with a flight into **KRAKÓW**, my favorite Polish city with the most charming old-town feel. You'll find medieval architecture, Jewish history, and amazing art museums. If you visit in the summertime, be sure to get ice cream. Polish people are obsessed and lines often wind around the block. In Zakopane, finish a day of hiking at **KRUPÓWKI**, the main shopping area filled with restaurants and nightlife. Stop by my favorite restaurant, **BĄKOWO ZOHYLINA**, where servers wear *stroje ludowe*, or traditional Polish attire, and there's live music with accordions and violins. Be sure to order the *oscypek*, a local sheep's cheese that's smoked and grilled, then topped with cranberry sauce—yum!

Where to go

MORSKIE OKO and **CZARNY STAW** are lakes nestled in the Rybi Potok Valley, with a trail leading between them that provides a number of views of Zakopane and the surrounding peaks of the Tatras.
DOLINA PIĘCIU STAWÓW is a dramatic valley (known as the "Valley of Five Lakes" in English) that was cut by a glacier. It's home to granite peaks, waterfalls, chilly mountain lakes, and lush green grasslands edged with towering pine trees.
GIEWONT and **KASPROWY WIERCH** are peaks that offer the most picturesque views of the Tatras, with mountaintops that kiss the sky as well as the expanse of the Polish countryside below. If you'd prefer not to hike, a cable car can take you to the top of Kasprowy Wierch, a popular route for skiers in the winter.
DOLINA CHOCHOŁOWSKA and **DOLINA KOŚCIELISKA** are two valleys that offer two different experiences. Dolina Chochołowska is mostly covered by trees, perfect for a shaded walk in nature. And Dolina Kościeliska is noted for its rock formations and caves, which are a blast to explore.

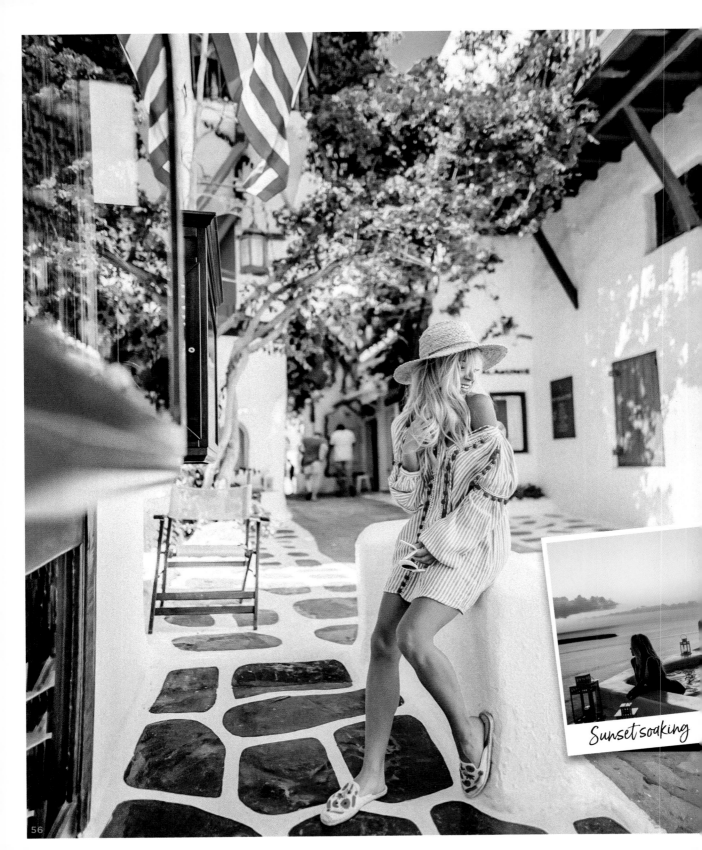

Sunset soaking

What to bring

Make your Grecian experience your own—whether you're wearing your fanciest beachwear in Mykonos or topping your bikini with cutoff shorts at a little taverna in Corfu. I love to bring my favorite white dress and really get dressed up just as much as I love leaving the salt in my hair and just hanging out on the beach.

PHOTO TIPS

If you want to shoot the town or beach without crowds, aim for early morning or late in the afternoon, when everyone goes back to their hotel for a siesta before a night out. No matter where you stay, find a great rooftop to photograph the sunset —Greece has some of the best in the world!

LOCATION: **MYKONOS, SANTORINI, AND CORFU**
COUNTRY: **GREECE**
A trip to Greece is all about sun, sand, and water. Visit in June, July, or September for lots of sun and fewer crowds.

Where to go

MYKONOS is where modern luxury meets an old Greek village. It has the best clubbing in Europe and definitely the best sunsets.
SANTORINI is often touted as a honeymoon destination and it's the island you see when you google "Greek islands." The tiny town of Oia in the west is filled with whitewashed buildings tucked into rugged cliffs and the eastern coast is home to the black sand Perissa Beach.
CORFU is off of Greece's northwestern coast. This island has an Italian flare and the most insane turquoise water. It's the perfect place to spend the day exploring waterfront towns by boat! (See pages 38–39 for more on sailing around the Mediterranean.)

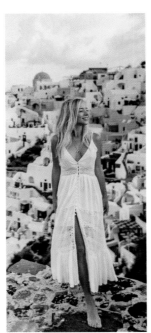

Celebrate Life
IN THE **GREEK ISLES**

I'm always looking for a reason to celebrate, to take a break from the daily routine, and to focus on appreciating family, friends, and life. And there's nowhere I love celebrating life quite like on the islands of Greece.

While Greece is surrounded by thousands of islands, three really stand out to me: Mykonos, Santorini, and Corfu. To me, these islands are what summer is all about and I spend all winter waiting for the sun to kiss Europe's beaches so I can pack my bikini and go. It's bright and warm, and Europeans know how to embrace those fleeting summer months better than anyone else.

For a more relaxed and quiet beach getaway, head to Oia on Santorini. This tiny cliff town is painted completely white, and while it's a major draw for tourists, it's as quaint and adorable as it sounds. For a bit of privacy, stay in nearby Finikia. These tiny towns quiet down at night—ideal for watching the sunset and enjoying a few chilled glasses of Greek wine over a leisurely dinner.

Mykonos, however, is totally posh, although you can choose between a high-end party or a low-key evening depending on where you stay. If you're looking to rub shoulders with the rich and famous, this is where to do it! Book a daybed at Nammos in Psarrou to join the all-day party or head to Nammos Village for open-air, high-end shopping in the Greek sun. What I love most about Mykonos is how easy it is to get away from the madness. The outskirts of each town are full of adorable bed-and-breakfasts and affordable tavernas where you can find a cozy room and eat the best Greek salad of your life.

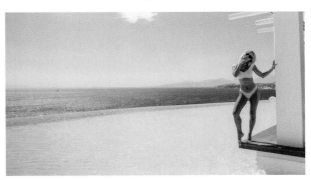

On the other side of Greece is Corfu, which mixes the best of Greek beaches with Old World charm. Wander the central square in Old Town, which feels straight out of 19th-century France, or take a dip in the deep blue water.

Whatever you're celebrating and however you want to celebrate it, there's a Greek island ready for you to explore—the perfect backdrop for any of life's memories and milestones.

Nothing compares with a celebratory summer getaway to Greece.

Nearby places

If you want a bit of a city vibe, spend a few days in **ATHENS** on your way to the beach. The city gets quite warm in the summer but empties out in August, making for a crowd-free experience. Inspired by the black sand beaches of Santorini? Check out pages 44–45 for a few of my other favorite black sand beaches around the world. In the market for even more of a party? Head to **IBIZA**, off the eastern coast of Spain. Whether you dance in a club or on the beach, tan all day or stay up all night, a trip to Ibiza is a party like no other.

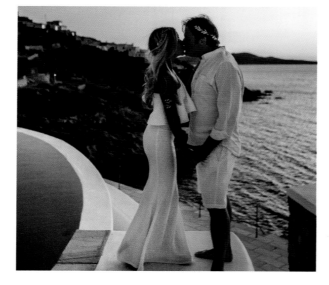

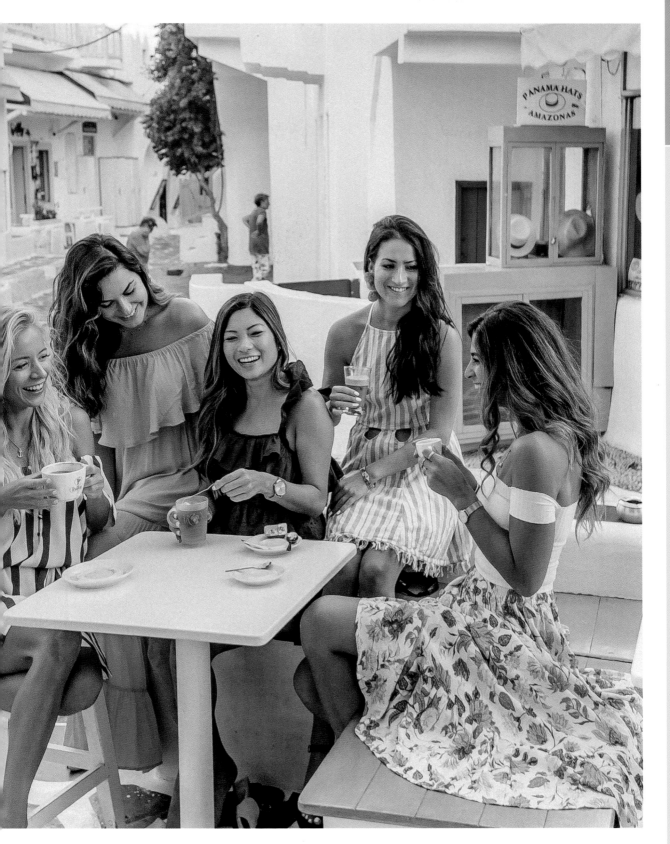

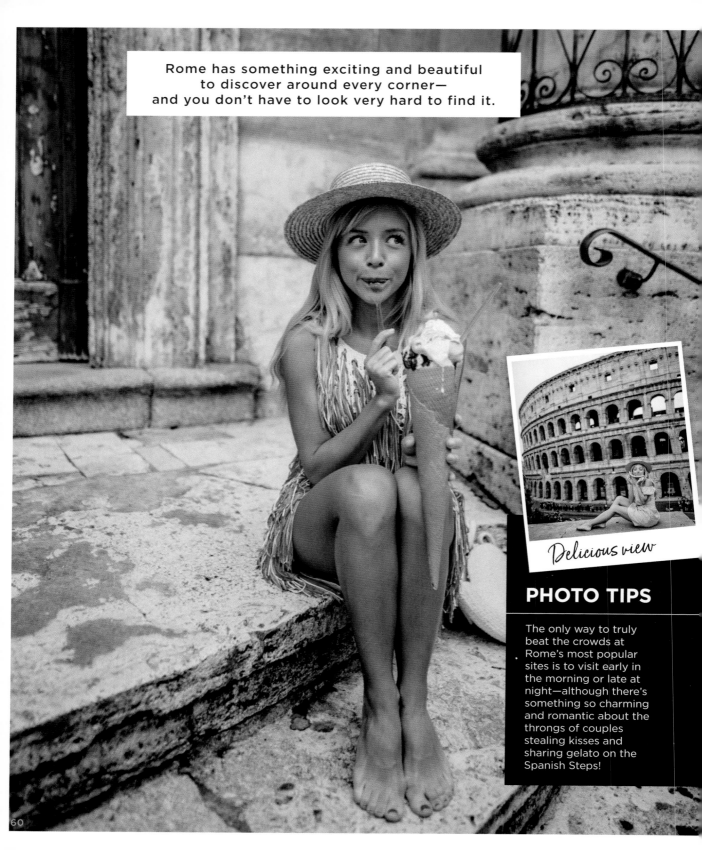

Rome has something exciting and beautiful to discover around every corner— and you don't have to look very hard to find it.

Delicious view

PHOTO TIPS

The only way to truly beat the crowds at Rome's most popular sites is to visit early in the morning or late at night—although there's something so charming and romantic about the throngs of couples stealing kisses and sharing gelato on the Spanish Steps!

![map of Italy showing Rome]

What to bring

Comfortable shoes are a must—they'll make it much easier to traverse the meandering cobblestone streets!

Nearby places

Rome was one of the first big European cities I visited as a child and I've been back many times since then. It always works its magic on me and every visit reveals something new about the city as well as something new about myself. Founded nearly 3,000 years ago, Rome is full of history—but the surrounding area is also worth exploring. Just west of Rome lies **TIVOLI**, the site of Hadrian's Villa. The emperor Hadrian constructed the villa in the second century, and to this day, it stands as a sprawling complex of gardens, fountains, and Greek architecture that hints at the emperor's wealth and grandeur. If you like truffles, drive north to **UMBRIA**, where you can join a truffle hunt (or enjoy them shaved over pizza or pasta). Before the Romans, there were the Etruscans and the ruins of this ancient civilization are centered in **CERVETERI**. While much of the city and its culture still remains a mystery, you can join historians and archaeologists and wander the tombs of the necropolis.

LOCATION: **ROME**
COUNTRY: **ITALY**

Summers in Rome can be hot and crowded. Travel instead in May, June, September, and October for mild temps and smaller crowds.

Where to go

THE TREVI FOUNTAIN is a can't-miss attraction in the heart of Rome and the ornate sculptures are fantastic photo ops. Bring a few coins, toss them over your shoulder into the water, and make a wish!

THE COLOSSEUM is the largest amphitheater in the world and even the building's ruins are awe-inducing, making it easy to imagine crowds of 80,000 gathering to see gladiators do battle with lions—and one another. Join a tour so you can skip the line. A VIP night tour means smaller crowds and a chance to explore the amphitheater floor.

VATICAN CITY is the heart of the Catholic Church as well as the smallest independent country in the world. Home to the Sistine Chapel, St. Peter's Basilica, and the immense collection of the Vatican Museum, it's worth braving the crowds. Guided tours are abundant, but history and art lovers might prefer to simply purchase tickets in advance and then explore on your own so you can linger in the gardens or galleries.

VILLA BORGHESE GARDENS surrounds the Galleria Borghese, a lush and tranquil escape in the middle of the city. If you're looking for a photo op with a distinctly Old World feel, the garden's tree-lined walkways and ornate architecture will be right up your alley.

Eat Pray Love
IN ROME

Eat: I'm a pizza person—and pizza in Rome is some of my favorite. Roman-style pizza is designed to have a sturdier crust (which means more toppings!). They also sell *pizza al taglio*—rectangular pizzas that are sold by desired length. And, of course, there's gelato! There's nothing better than meandering from one landmark to the next with a creamy gelato in hand.

Pray: It's hard to deny the beauty of the churches scattered around Rome. St. Peter's Basilica and the Pantheon get most of the attention, but my favorites are the smaller neighborhood churches. They might be petite, but they're equally beautiful, with stunning frescoes and towering ceilings scented delicately with frankincense. Anywhere else in the world, each of these churches would be a main attraction, but in Rome, they're an everyday find and there's a new church to discover around every turn.

Love: Rome is also an incredibly romantic city—whether you're there with a lover or are discovering the city on your own. Some of history's most incredible artists flocked to Rome to paint, sculpt, and create, infusing the city with a passion that can still be felt today. You might even be called *amore* by some of the more flirtatious Italians!

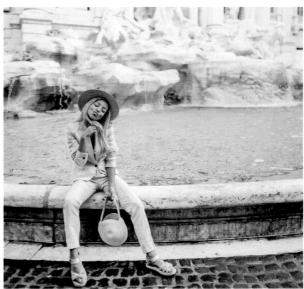

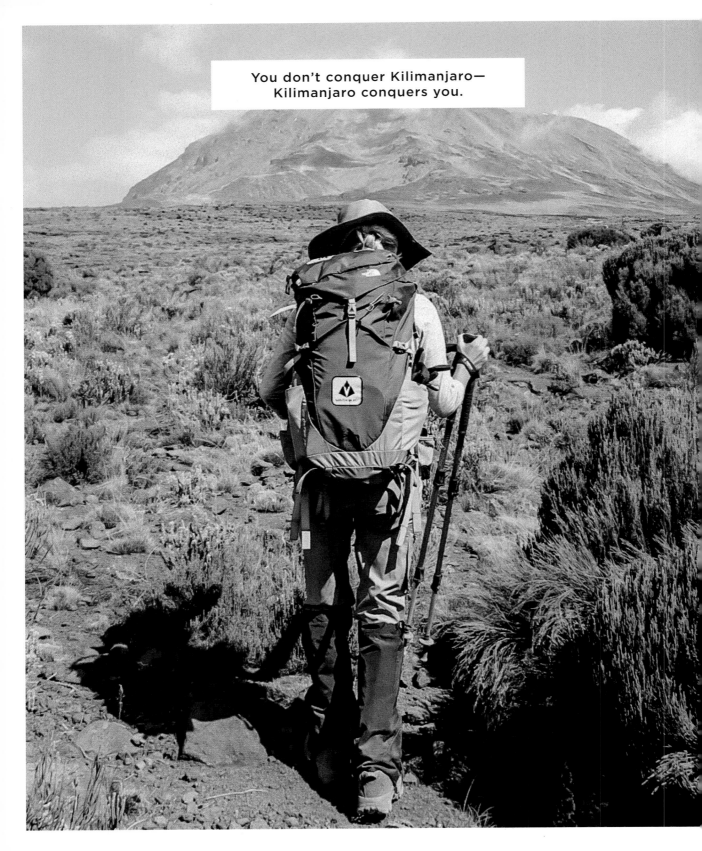

You don't conquer Kilimanjaro—
Kilimanjaro conquers you.

UGANDA
KENYA
MT. KILIMANJARO
TANZANIA

What to bring

They say "the better the gear, the easier the climb"—and they're right. High-quality gear is lighter, more effective, and will keep you more comfortable, especially during such a strenuous endeavor.

Every tour provides you with a list of items to pack, but these are the ones I loved best: Capilene base layers, which kept me warm without adding bulk, as well as two pairs of hiking boots: one pair of short boots for the first few days and a sturdier pair for the final climb. I also brought a 0°F sleeping bag, which was perfect for chilly nights.

Be sure to bring a CamelBak or something similar so you can stay hydrated without having to stop to open water bottles. And don't forget sunscreen! Bring an SPF of at least 30 that contains zinc. You'll also want to pack basics, such as toilet paper, shower wipes, and hand sanitizer.

Finally, snacks are crucial! Load up on fruit- and veggie-based energy gels and bars, but omit the nuts because they require lots of energy and water to digest.

It's tempting to load up on gear, but try to pack light. You won't use most of the extra "stuff," but your porter will still have to carry your bag on his head (plus his own!) while completing the exact same climb.

LOCATION: **KILIMANJARO**
COUNTRY: **TANZANIA**
January to March and June to October are when to avoid heavy rain or snow as well as cold temps that make an ascent more challenging.

Where to go

MARANGU GATE (6,102 FEET) is the starting point of the Marangu, or Coca-Cola, route to the summit. This path offers huts to camp in each night, while other routes require camping in tents.
MANDARA HUT (8,907 FEET) is the first camp you'll reach after a 5-mile hike, which took us about 5 hours. Each A-frame hut has 6 to 8 bunks.
HOROMBO HUT (12,156 FEET) has incredible views of the peak and the stars. It took 6 hours to climb 7.2 miles. We paused here for an extra day of acclimatization—which is highly recommended! This camp has accommodations for more than 100 hikers.
ZEBRA ROCKS (13,123 FEET) is where you'll hike to on your acclimatization day. It's about a 3-hour hike to ascend 2.2 miles, plus 90 minutes back to Horombo Hut.
KIBO HUT (15,518 FEET) is your final camp before ascending to the summit. After a 6-hour hike of 6 miles, you'll pause here for dinner and a few hours of sleep before departing at midnight.
UHURU PEAK (19,341 FEET) is the highest point in Africa! The final stretch is only 3.4 miles, but it's steep and strenuous (and the hike is done almost entirely in the dark!). The goal is to reach Gilman's Point (18,668 feet) just before sunrise, then finish the hike and arrive at the peak around 8 a.m. From here, you'll descend to Kibo Hut for a brief rest, then continue down to Horombo Hut to get out of the extreme altitude and cold before returning down to Marangu Gate on the last day.

Climb Mount Kilimanjaro IN AFRICA

For my birthday, I find a way to spoil myself. Not with gifts or cake or fine wine—but with adventure. It's a reminder that the clock is always ticking on the dreams we've yet to accomplish as well as an incredible way to mark a milestone. In 2016, I took on my biggest (literally!) challenge to date: I summited Mount Kilimanjaro, reaching the peak on my birthday and celebrating by watching the sunrise from the highest point in Africa.

So why climb Kilimanjaro? A good "why" makes the "how" a formality. I've made it my life's priority to follow my yearning for adventure and to truly live life to the fullest, including pushing myself to my own limits. For years, Africa had been calling my name. The continent (and Mount Kilimanjaro itself) is home to every ecosystem on Earth—from dense tropical jungles to barren alpine deserts and glacier fields. Climbing Kilimanjaro is strenuous and dangerous—around 10 people lose their lives climbing the mountain every year—but it's also attainable if you prepare well. More than 30,000 climbers attempt it every year and about 60% reach the top. Those are better than your odds in Vegas and it humbles you even as you realize just what you've accomplished. It's a bet I was eager to make.

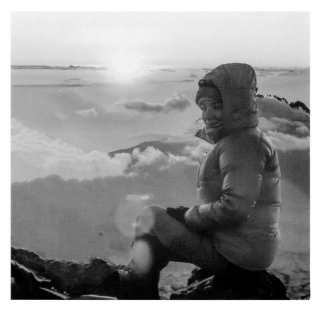

Six months before heading to Tanzania, we began to train. From hours on the StairMaster to hikes wearing an altitude mask (designed to make it harder to breathe, mimicking low-oxygen conditions at high elevations) to hikes throughout North America, I did everything I could to prepare physically—and mentally—for the feat ahead. We were lucky to have some expert advice from Leszek Cichy, a legendary Polish climber who has climbed all Seven Summits, climbed Kili more than 20 times, and was the first person to ever climb Mount Everest in the winter (as if doing so in the summer isn't hard and cold enough!). He walked us through our route, how to train, and what to expect. We also met an incredible couple while climbing in British Columbia. At the time, Martin and Esther Kafer were 90 and 89, respectively. They held the record as the oldest people to climb Kilimanjaro (when they were 85 and 84, respectively) and have summited more than 77 major peaks around the world. Their passion for life was infectious and they served as constant inspiration every step of the way.

We headed to Tanzania in mid-September, spending a few days on safari to acclimate to the altitude (we weren't at sea level in Los Angeles anymore!) and enjoy the spectacular setting. Then it was time to climb our mountain. There are two main routes to the summit of Kilimanjaro: Coca-Cola (supposedly easier because you sleep in huts) and Whiskey (with a less strenuous final climb but cold nights spent in tents). We chose Coca-Cola, which sets out from Marangu Gate. My climbing partner and I opted for a private climb instead of a group hike, which meant we got to set the pace. We had a team of seven with us: one main guide, one assistant guide, one cook, and four porters, who carried all our gear up the mountain. It was crazy to see these porters literally running up the hill carrying these huge bags, especially as we struggled even after months of training.

On the first day, we climbed from Marangu Gate (6,102 feet) to Mandara Hut (8,907 feet)—a hike of 5 miles that took about 5 hours. We got a late start and wound up climbing rather quickly, but the lush jungle that surrounds this first leg is so gorgeous that you barely notice how far you've gone. After dinner (which started with popcorn and hot tea every evening!), we headed to bed—interrupted only by bathroom trips as a result of our altitude sickness medications.

Nearby places

Spend a few days in Tanzania before beginning your climb—to see the country's amazing wildlife and to acclimate to the elevation. Head to the **NGORONGORO CRATER**—the floor at 5,900 feet in elevation, which is similar to Marangu Gate. For a taste of Maasai culture, spend a night or two at the **ORIGINAL MAASAI HOTEL** (pages 106–109). As you're training to climb Kili, you'll absolutely want to get out into nature and go on some strenuous hikes. We traveled to Whistler in Canada, Yosemite National Park in California, Mount Baldy near Los Angeles, and Zion National Park in Utah. And once you're done climbing, treat yourself to some rest and relaxation (down at sea level!) on the beaches of **ZANZIBAR**!

PHOTO TIPS

A good DSLR will take better photos than your phone or point-and-shoot camera, but the higher you get, the heavier it will feel. Instead, bring a smaller camera and keep it inside your jacket so it doesn't freeze. The same goes for batteries, which will get too cold in your pack. Keep the batteries separate from the camera and put them in only when you'll be taking photos.

Above the clouds

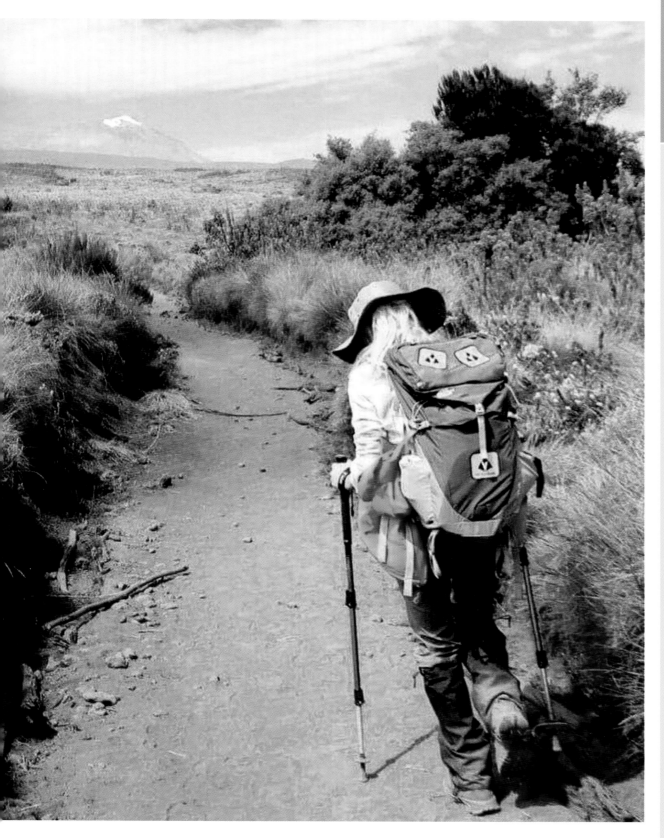

The next morning, we set out from Mandara Hut to Horombo Hut (12,156 feet), covering 7.2 miles in 6 hours. The path can get quite dusty and crowded, so I was grateful when our guide, Emmanuel, led us to a parallel path through the grass where we could walk at our own pace. Horombo Hut is absolutely beautiful. At this point, you're above the clouds, with the Serengeti stretching out below you and the peak of Kilimanjaro high above. The only other time I saw stars as spectacular as the ones we saw that night was during my sailing trip from Mexico to Australia (pages 8–10)—also along the equator but on the opposite side of the planet.

Day three was devoted to acclimating to the altitude. While the summit can be reached in 5 days, I'd recommend adding on at least one day like we did (if not two!) to do a shorter hike and get your body used to the high altitude. We headed from Horombo Hut up to Zebra Rocks (13,123 feet)—a hike of 2.2 miles that took 3 hours up and 90 minutes down—to give our lungs and our circulatory system a chance to acclimate.

On day four, we continued our ascent from Horombo Hut to Kibo Hut (15,518 feet), taking 6 hours to hike 6 miles. We took our time, knowing we'd be arriving at camp in the afternoon only to depart again at midnight for the final ascent.

At Kibo Hut, we paused for dinner and a few hours of sleep. I did my best to get some rest, but the nerves and excitement (and the cold!) made it difficult. Before I knew it, we were getting our 11:30 p.m. wake-up call and prepping to head to the summit. I was nervous about not making it after we'd come so far and worked so hard, but Emmanuel reassured me. He said I had an 85% chance of making it to the top—even better than the average!—and with that boost of confidence, I was ready to go.

Just after midnight, we started up the trail: a 3.4-mile ascent up to Uhuru Peak (19,341 feet) in complete darkness. All we could see ahead of us was the bobbing of headlights, with nothing to alert us to just how steep the slope around us was (something I was happy about in retrospect once we could see the trail on the way down!). As we reached 16,500 feet, we paused to catch our breath. Every step was a new personal record for how high I'd climbed, and at that point, I was feeling great! But another 500 feet in elevation and it was a different story. I began to feel cold and short of breath, my heart was racing, my stomach ached, and now each step was a struggle. I was ready to turn around, but it was still dark and we'd yet to reach Gilman's Point. Another climber gave me a heartfelt pep talk, reminding me that I was about to see the most beautiful sunrise of my life, which was enough to keep me going. And he was right: The sunrise at Gilman's Point brought us all to tears in awe of Mother Nature's beauty.

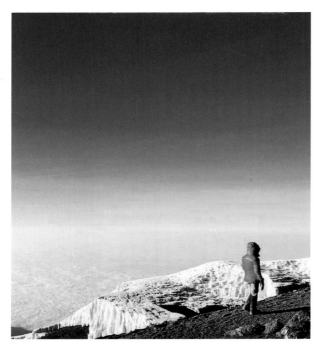

Climbing Kilimanjaro taught me so much about myself. First, it taught me patience. The words you'll hear most on your climb are *pole, pole*—which means "slowly, slowly" in Swahili. While it can be tempting to move at a good pace from one camp to the next, a slower pace will give your body more time to adjust to the increasing altitude and decreasing oxygen. Second, it taught me just how true the three golden rules of mountaineering are: 1) It's always farther than it looks; 2) it's always longer than it looks; and 3) it's always harder than it looks. Climbing a mountain is a mental game. Your brain tries to tell your body to stop before your body is ready to give up and figuring out how to push through and overcome is what will get you to the summit. So whether you're climbing Mount Kilimanjaro or off on any of the other innumerable adventures this world has to offer, remember what I learned on my climb: Breathe deeply, walk slowly, and never stop moving.

Just as I was marveling at the sunrise, I felt a sharp pain in my eye—which I later learned was a torn cornea. Adding that to my altitude sickness, I was convinced I couldn't go on. But Emmanuel had a different perspective. "Aggie," he said, "you are a woman—and women are strong. If a man says he can't go any longer, he is not able to take another step. But when a woman says the same thing, she can still make it to the summit." And so, with his help, I continued.

Finally, just after 8 a.m., we reached the summit at Uhuru Peak. All I felt was relief that we didn't have to climb anymore. No joy, no sense of accomplishment—just relief. I summoned the strength to put on my birthday crown and take a picture. I hadn't conquered Kilimanjaro—Kilimanjaro had conquered me.

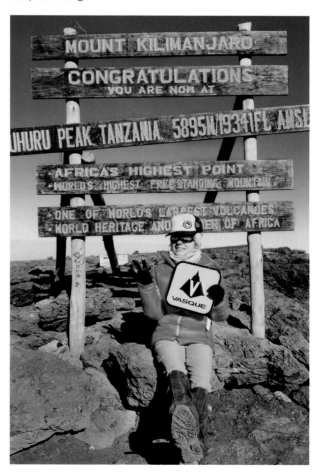

We made our way back down, often sliding down the path on our butts because it was so steep, and paused briefly at Kibo Hut before finishing our descent to Horombo Hut. While a rest was nice, Kibo Hut is still too high for your body to recover comfortably, which is why you descend another 6 miles (and more than 3,000 feet in elevation) before stopping for the day. Once there, our altitude sickness symptoms began to wane, replaced by exhaustion after 31 hours of climbing and the toll it takes on your body. Somehow, our cook managed to bake me a birthday cake and it was so sweet to share that little ritual with my climbing partner, our guides, and the rest of our team.

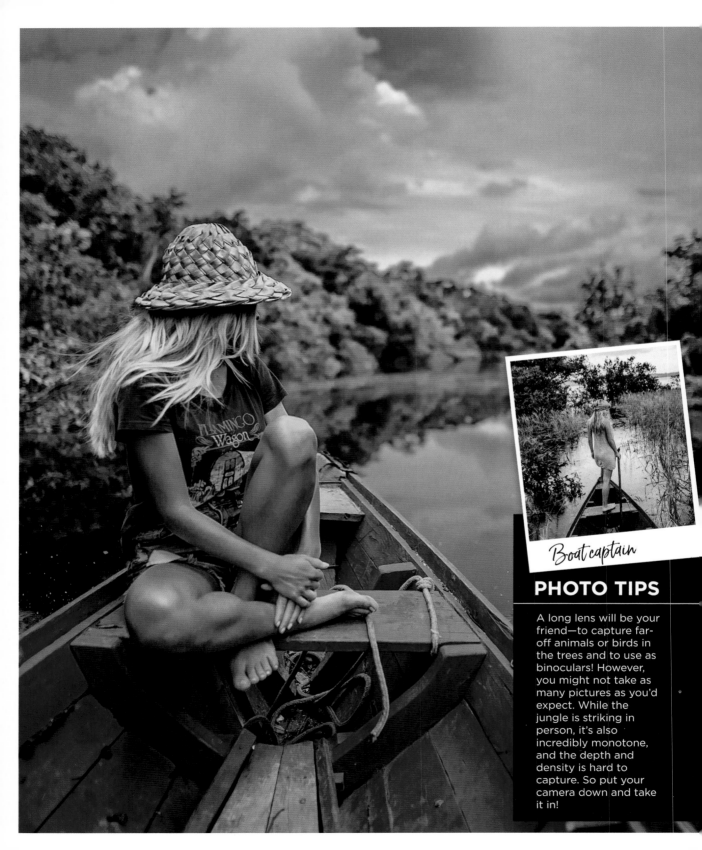

Boat captain

PHOTO TIPS

A long lens will be your friend—to capture far-off animals or birds in the trees and to use as binoculars! However, you might not take as many pictures as you'd expect. While the jungle is striking in person, it's also incredibly monotone, and the depth and density is hard to capture. So put your camera down and take it in!

The wettest time is from December to May, when temps are in the mid-80s. June to November is drier—with fewer mosquitoes!

Visit the Amazon Rainforest
IN BRAZIL

What to bring

Even during low mosquito season, you will want to stay covered and protect yourself from malaria. Opt for long sleeves and pants, and pack a mosquito repellent with at least 30% DEET. Talk to your doctor about taking malaria medication before and during your trip. You will also want to pack a hat, sunscreen, and a seat cushion or foam camp chair—you'll spend many long hours on a boat making your way up the river, so a bit of support will come in handy!

Nearby places

A trip to Brazil (and into the Amazon in particular) requires a lot of long and arduous travel, so it's tempting to combine this adventure with a few days dancing at Carnival in **RIO DE JANEIRO** (pages 176–177). However, Carnival takes place in March, toward the tail end of the wettest season in the Amazon Rainforest, so prepare accordingly! If you'd like to pair your trek with some beach time, head to **TULUM** (pages 78–81) to unleash your inner hippie or to **COSTA RICA** (pages 126–127) for a romantic horseback ride on the beach.

Where to go

MANAUS is located in the middle of Brazil, where the Amazon River and Rio Negro meet. It might seem remote on the map, but it's actually a huge city built on industry (in addition to being the base from which adventurers head out into the rainforest).

THE AMAZON RIVER is the largest river in the world, both by length (4,000 miles) and by volume (7,400,000 cubic feet per second, or 20% of the global river discharge into the world's oceans!). It starts in Peru, stretches east across Brazil, and deposits into the Atlantic Ocean. The Amazon is surrounded by the Amazon Rainforest, 2.1 million square miles of incomparable biodiversity that are home to one-tenth of the known species on the planet.

RIO NEGRO is the largest blackwater river in the world and one of the largest tributaries of the Amazon River. It flows 1,400 miles from Colombia to Manaus, where it converges with the Amazon. The river is home to nearly 1,000 species of fish—700 that have been identified and many more that have yet to be named or described.

Visiting the Amazon Rainforest is like going back in time, surrounded by millions of miles of dense green jungle that feels as far as you can get from civilization. But time hasn't stopped deep in the heart of northern Brazil. In fact, you're surrounded by life as the jungle and its inhabitants pulse with activity around you.

When I visited the Amazon, I joined a tour that headed from the city of Manaus along the Rio Negro, a darker river that flows from the north and joins the Amazon River just outside the city. Because of its mineral makeup and darker color, the Rio Negro is said to have fewer mosquitoes—but bring the DEET anyway!

After a long and bumpy drive, we arrived at our base: a no-frills camp that might not have had hot water but offered the luxuries of AC and bathrooms (something you'll come to cherish after a few days in the jungle!). We filled our days and nights with adventure, from jungle walks and bird-watching to a late-night alligator quest and an evening spent camping around a fire in the heart of the jungle.

The evening of our alligator tour, we boarded a boat around 9 p.m. and our guide steered us from the wide, lake-like river into narrow channels between the trees. We kept our hands inside the boat and avoided touching the trees, which our guide kindly reminded us are crawling (literally!) with massive deadly spiders, as we scanned the surface for the sparkle of alligators' eyes peering out of the water. But nothing prepared me for the moment our guide jumped into the water to go get us an alligator. He waded into the jungle, leaving us floating alone for 10 minutes as we wondered how in the world we'd find our way back if he didn't return! Thankfully, he came back—with a baby alligator in hand—and we got to take a closer look before making our way back to the safety of our camp.

By far my favorite part of the trip was getting to meet a local tribe. We took boats to the village, filled with the sounds of roosters crowing and the smell of smoke wafting from fires. We met the locals, where the women taught me the difference between the paint that men and women wear, then walked out of the village to set up camp for the night. After two hours of trekking and looking for monkeys and birds, our guide set up a tarp and hung our hammocks between the trees, then got to work carving cutlery out of bamboo as chickens purchased from the village roasted over the fire. We told stories around the fire in the dark before climbing into our hammocks—the safest way to sleep so you're not easy prey for bugs or snakes (or worse!) on the ground. The jungle is not a quiet place, with animals becoming even more active and vocal at night, so my imagination was running wild and I barely slept!

A visit to the Amazon is far from a luxury experience—you spend a lot of time and money to spend days out in the wild without a proper shower!—but the region is home to incredible biodiversity, opening your eyes to how different— and how similar—we all are.

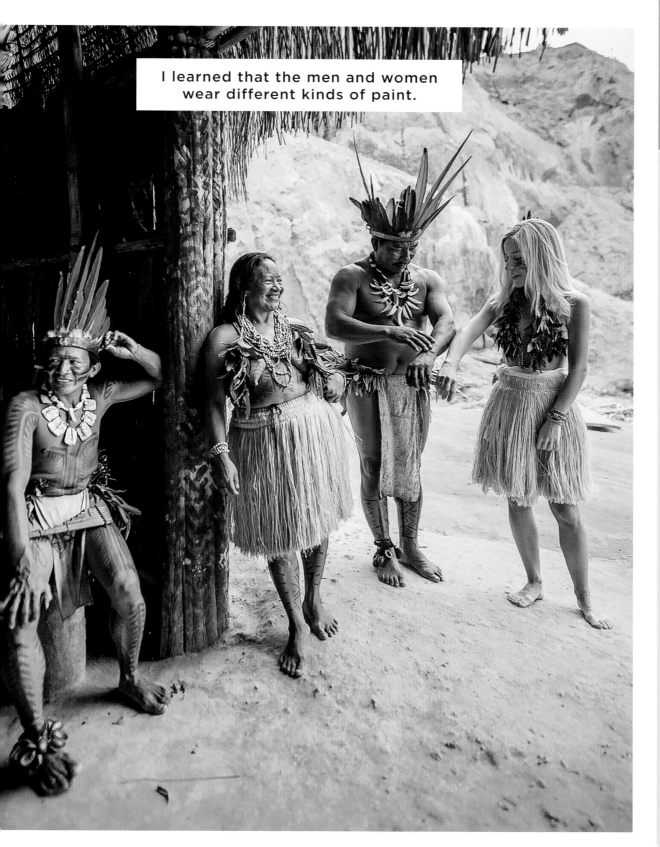

I learned that the men and women wear different kinds of paint.

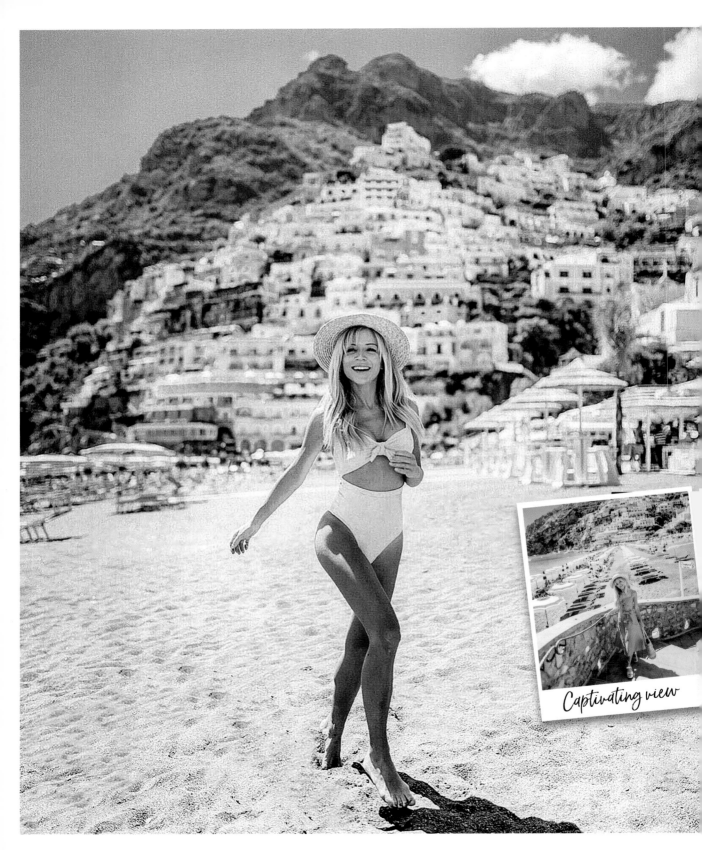

Captivating view

LOCATION: **AMALFI COAST**
COUNTRY: **ITALY**

The best time is the summer months, but this can mean crowded beaches. For a more peaceful experience, visit in May or early September.

ITALY

Naples

Gulf of Naples

AMALFI COAST

Positano
Amalfi
Sorrento Praiano

What to bring

Now's the time to pack all your bathing suits and sundresses. Straw hats can be hard to pack, so it's easier to pick one up in a local boutique than to try to bring your own. Opt for flat sandals, which are easier to wear on the cobblestone streets. A loose and flowy sundress is your friend. The Amalfi Coast might be the one place in the world where pizza and pasta are considered beach food!

PHOTO TIPS

Italians love their sleep, so you'll have plenty of time in the morning to take crowd-free photos if you're an early riser. However, the rows upon rows of beach umbrellas are part of the Amalfi Coast's charm, so embrace the hustle and bustle and the summery colors!

Where to go

POSITANO is known for the colorful houses that dot the cliffs as well as the steep stairs that take you through town. It's the most glamorous town on the coast, with high-end shopping, luxe hotels, lots of nightlife, and plenty of chances for celebrity-spotting.

AMALFI is the largest town along the coast and its central location makes it incredibly popular for tourists. It's the perfect home base for exploring the region and is full of medieval history.

PRAIANO is quiet, tiny, and incredibly romantic. You'll be surrounded by Italians here, who love that the beach is sunny all day.

SORRENTO is the first town you'll come to when driving south to the Amalfi Coast from Naples. Accessibility does mean it's quite busy, but it's a great place to stay if you're planning to take day trips during your visit.

Experience *La Dolce Vita*
ON THE AMALFI COAST

You've seen it in your Instagram feed and ogled over the pristine waters and dramatic views, but nothing compares with experiencing *la dolce vita* on the Amalfi Coast in person. This Italian mantra is all about living life to the fullest, immersing yourself in your surroundings and enjoying every second. It's a mantra I try to live by—especially when I'm at such a spectacular destination!

The Amalfi Coast isn't your normal collection of beachfront stops. Thirteen towns are tucked precariously along the rocky coast, combining everything from lush nature and your favorite ocean activities to historic sites and some of the country's best food (which is saying a lot when it comes to Italy!).

I'd heard so many good things about the region and I knew I needed to see it for myself. The second I arrived, I fell in love—and now I make a pilgrimage back every year. The Amalfi Coast is everything you've imagined an Italian holiday would be: Colorful beach umbrellas dot the coast, cobblestone streets weave past tiny shops and ancient churches, and afternoons of fresh seafood and pizza give way to evening indulgences of pasta and local red wine. The region is hilly and full of steep stairs, a built-in workout that leads you from one delicious bite to the next. It's a feast for all the senses and incredible memories await you around every turn.

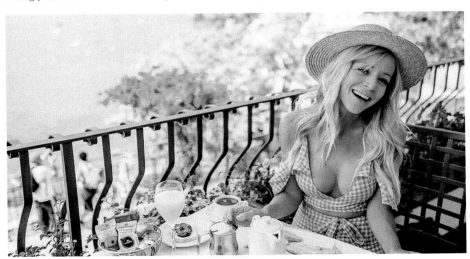

The best way to experience *la dolce vita* along the Amalfi Coast is to get totally immersed. Follow the locals as they enjoy afternoon gelato, sip pre-dinner Aperol spritzes, and linger over limoncello long after the sun has set. You'll return sun-kissed and relaxed (and maybe a few pounds heavier) and will be looking for ways to bring that same feeling into your everyday life—a worthwhile pursuit if I've ever heard of one!

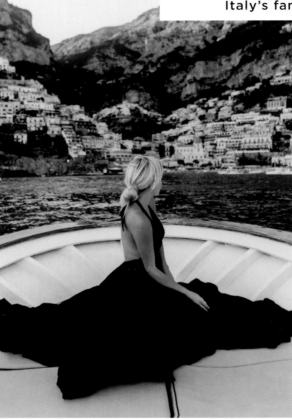

La dolce vita ("the sweet life") is about more than just Italy's famous gelato.

Nearby places

Southern Italy is full of history and charm—whether you're planning a longer stay or a day trip away from the beach. Hop on the ferry from Positano to **CAPRI**, where you can take a boat out to the infamous Blue Grotto. If you're traveling through **NAPLES**, be sure to stop at Mount Vesuvius and Pompeii to take a peek at some of Italy's most famous ruins. Those looking for a more laid-back experience will love **CAMPANIA**, just south of the Amalfi Coast and nestled between the Mediterranean and dramatically rising hills. The area's under-the-radar wine region is prime for exploring (without all the tourists!) and it's home to one of Italy's most iconic exports: buffalo mozzarella!

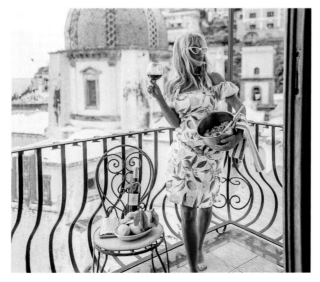

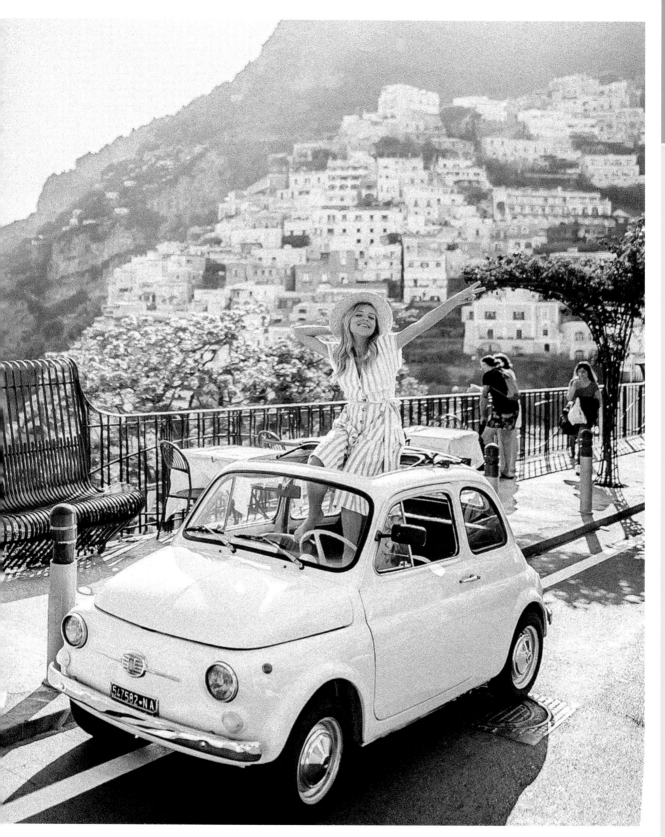

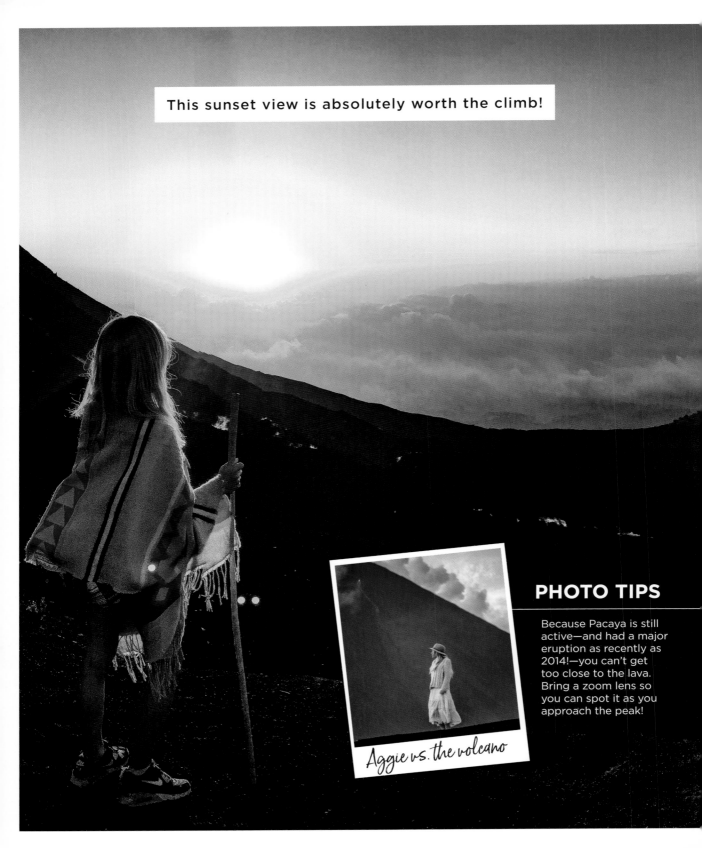

This sunset view is absolutely worth the climb!

PHOTO TIPS

Because Pacaya is still active—and had a major eruption as recently as 2014!—you can't get too close to the lava. Bring a zoom lens so you can spot it as you approach the peak!

Aggie vs. the volcano

LOCATION: **PACAYA NATIONAL PARK**
COUNTRY: **GUATEMALA**

The dry season stretches from November to April, but even the rainy season is pleasant, with just a bit of daily rain.

What to bring

The hike is strenuous but not overly challenging—you won't need much gear beyond exercise clothing and sneakers. However, the best time to climb is before dawn (to see the sunrise) or before dusk (to see the sunset). The temperature is much cooler without the sun, so bring a jacket—and a flashlight for when it's dark!

Nearby places

Visit **LAKE ATITLÁN**, where Mayan villages and towering volcanoes surround the deep crater lake. **PANAJACHEL** offers dramatic views of the sparkling lake as well as great shopping (hello, coffee!). Stay in **SAN PEDRO LA LAGUNA** for a party vibe or visit **SAN MARCOS LA LAGUNA** to immerse yourself in the spiritual energy the Mayans have long believed surrounds the lake, which the locals call the "belly button of the world."

Where to go

ANTIGUA GUATEMALA is a city in the central highlands that feels like time has stopped. Indigenous Mayans wear traditional outfits, and the streets are full of colorful buildings and shops serving fragrant and delicious coffee. If you can time it right, visit during Dia de los Muertos, when locals honor the dead with massive kites that are erected between the graves of the local cemetery.

GUATEMALA CITY is the capital of Guatemala, a large and diverse city that combines the country's rich Mayan and colonial history with modern trappings. It's less touristy than Antigua and you'll be wowed by volcano views and colorful "chicken buses"—school buses that have been shortened and painted with elaborate decorations—that serve as the city's bus system.

SAN FRANCISCO DE SALES is at the base of Pacaya Volcano. This is where you'll meet up with your mandatory hiking guide, purchase a walking stick, or opt to mount a horse for the climb.

Hike an Active Volcano
IN GUATEMALA

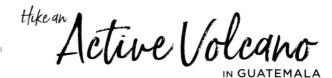

There's something brewing in Guatemala—and it's not just the country's famous coffee. Volcán Pacaya, located in south-central Guatemala, is the most consistently active volcano in Central America and has been erupting in one form or another since the 1970s. The elevation is nearly 8,500 feet and a hike to the top offers a firsthand peek at the action as well as stunning views of the surrounding mountains, volcanoes, and forest.

Every hike up Pacaya must be with a guide, so while the climb itself is energetic, the group pace isn't too overwhelming. As you climb, it's incredible to watch the scenery around you change from lush and green to dark and gravelly, with steam and heat escaping from the rocks.

The first time I visited, we hiked up in the afternoon to watch the sunset, which was absolutely epic. By the time you reach the top, you're up above the clouds and watching the sun peek in and out as it sets. On my second visit, we climbed Pacaya to see the sunrise. It's an early wake-up call (around 2 a.m.!), but if the sky is clear, the sunrise is quite pretty. While marshmallows aren't a traditional treat, many tours bring s'mores supplies up the mountain so you can enjoy a toasty sweet at the summit. Chocolate, however, is a Guatemalan specialty and you should sample it every chance you get!

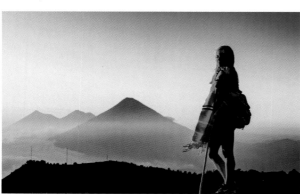

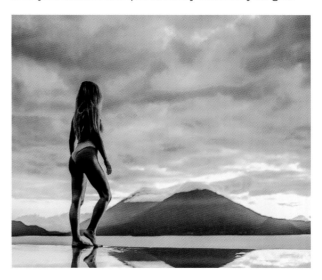

Floating away

LOCATION: **TULUM**
COUNTRY: **MEXICO**

October to December are warm but not overwhelming. You'll also miss hurricane season, which means more sunny days on the beach!

Where to go

FOLLOW THAT DREAM is a road sign that shows up all the time on Instagram, but you're the one who has to give it meaning. What's your dream? What path do you have to follow to get there? Start your adventure at this sign, located near Sueños Tulum on the main hotel strip—and then start moving.

CENOTES DOS OJOS are two eye-shaped openings that lead to a sinkhole full of clear blue water, part of a flooded underground cavern system. Arrive early so you can snorkel before the crowds arrive or simply lie back in the water and let your cares float away.

AZULIK VILLAS are ground-level treehouses that are the perfect place to connect with nature. These stunning structures are free of distractions, such as Wi-Fi (or even electricity!), encouraging you to unplug and reconnect with your inner self. Enjoy breakfast as the sun rises around you or admire the moon's reflection in the Caribbean as you unwind in a bath filled from the resort's natural cenote.

RAW LOVE CAFÉ is a vegan paradise in this bohemian city. It's just what you need after a day of adventures. Kick off your shoes, dig your toes into the sand, and enjoy your surroundings—and the fresh and colorful food.

What to bring

Tulum is a mecca for freedom of expression, so embrace the disheveled, hippie vibe this paradise is known for. Maxi dresses and flat sandals are a must, like you've wandered out of a Free People catalog. You won't see anyone in Chanel here (it's not Mykonos!), but that boho ensemble you spotted could very well cost more than a month's rent back home.

PHOTO TIPS

Whether you're up at the crack of dawn for sunrise yoga or you never went to bed last night, those early mornings aren't to be missed. Use a slower shutter speed to really capture that color and consider a tripod to keep your camera steady. If you're going to be in the photo, pick a pose that's easy for you to hold to avoid any blurry images!

Channel your Inner Hippie IN TULUM

Tulum is a city where history meets paradise. Once a vibrant Mayan community, this area is now a popular tourist destination—but the draw is the same. Tulum boasts warm temperatures, an easygoing nature, and powerful natural vibrations that call to hippies, yogis, and partiers alike. At first, you might feel lost without much electricity (or cell service!), but this lack of modern necessities allows you to immerse yourself in the present—whether you're visiting alone to find yourself or traveling with friends or a lover in search of a perfectly relaxing adventure.

Ditch your shoes as soon as you arrive, feeling your toes in the sand with every step. Hop from one beachfront hotel to the next, listening to live music and enjoying the best margaritas you've ever had. If you're interested in a swim, take a dip in one of the vibrant blue cenotes—dramatic underground caverns begging for an Instagram post (but that will have to wait until you're back in the city!). Looking for a little retail therapy? Join the crowds of hippies with an Amex as you peruse the perfectly curated boho boutiques.

I love that Tulum offers something for everyone. You can find an all-night party under a full moon or sign up for a yoga retreat and cleanse led by a Mayan healer. Whatever you choose, the premise is the same: Connect with yourself and form a connection with the people around you.

Nearby places

The **RIVIERA MAYA** stretches along the northeastern Yucatan Peninsula, from Playa del Carmen in the north to Tulum in the south. Take your pick of resort towns, from affordable and low-key to pricey and high-end. For a more luxe experience (think AC, fancy restaurants, and spacious suites), head to **CANCUN** or **PLAYA DEL CARMEN**. While it's easy to spend a lot on a hotel in Tulum, those services are hard to come by. The Mayans were drawn to Tulum for a reason, so be sure to set aside a few days to explore the picturesque cliff-top ruins, including El Castillo (the main pyramid), the Temple of the Frescoes (with intact murals inside!), and the jungle pyramid at **COBA**.

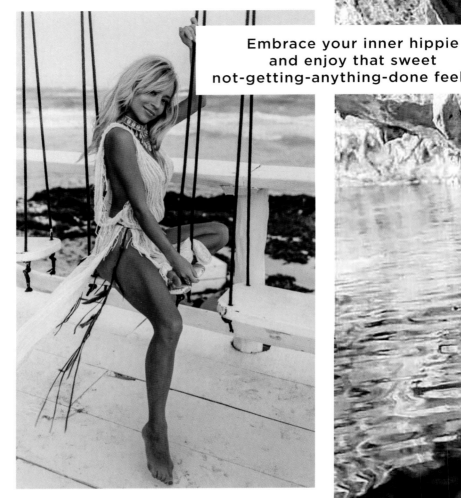

Embrace your inner hippie and enjoy that sweet not-getting-anything-done feeling.

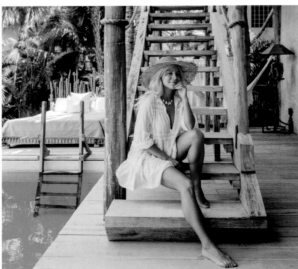

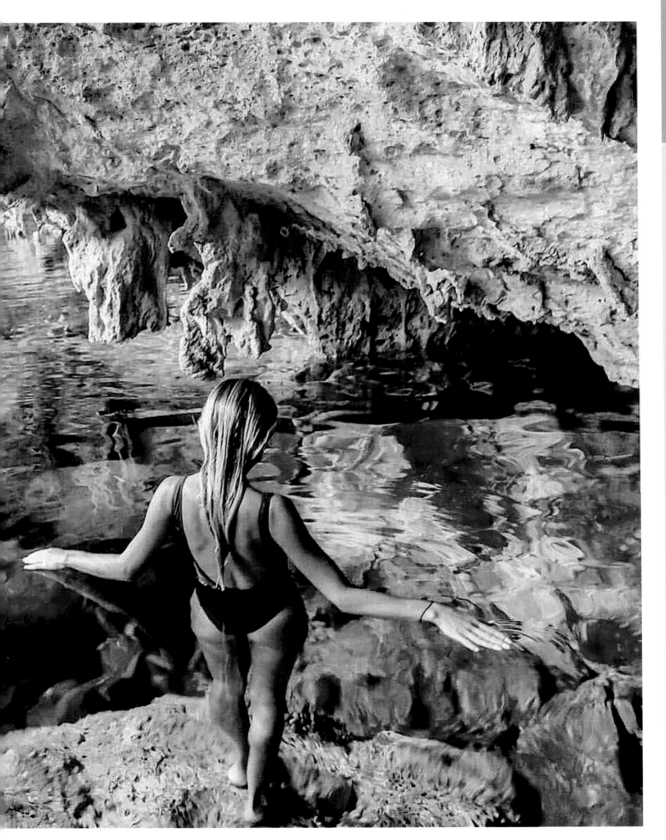

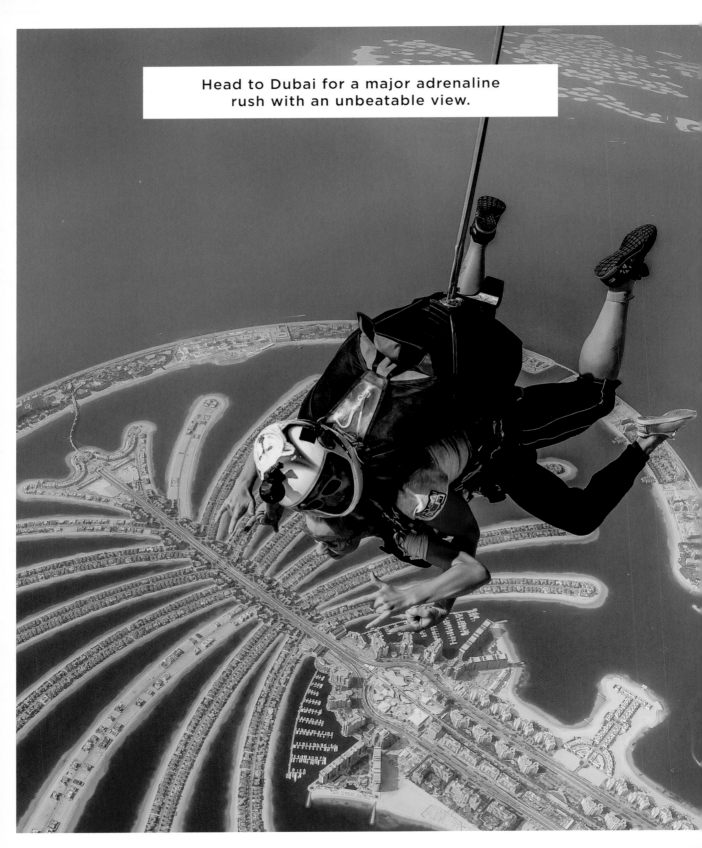

Head to Dubai for a major adrenaline
rush with an unbeatable view.

DUBAI

UNITED ARAB
EMIRATES

LOCATION: **DUBAI**
COUNTRY: **UNITED ARAB EMIRATES**
Dubai is hot, so schedule your skydive for early in the morning to beat the heat—and maybe catch the sunrise.

Skydive
OVER DUBAI

What to bring

You're about to jump out of an airplane, so bringing your courage is an absolute must! Skydive Dubai will provide you with wind suits and goggles, so just be sure to pack a hair tie so you can pull your hair back.

PHOTO TIPS

Professional photos and video of your jump are included in the package, so leave your camera gear at the hotel!

Where to go

PALM JUMEIRAH is an artificial archipelago in the Persian Gulf that's designed to look like a fanned palm tree from above. The fronds are covered with waterfront villas and a monorail connects the islands to the mainland. A number of luxury resorts are set on the fronds as well as beach clubs that become lively nightclubs as the sun sets.
SKYDIVE DUBAI provides all the skydiving adventures in Dubai, but the dive over Palm Jumeirah might be their most famous. You'll reach a height of about 13,000 feet before jumping from the plane over this man-made island!
SKYDIVE DUBAI DESERT CAMPUS offers a different—but equally dramatic—setting for your big jump. Head farther inland to skydive over the dunes of the Arabian Desert, with Dubai's skyline rising in the distance.

Nearby places

Not sure about leaping out of an airplane over a dense city of dazzling skyscrapers? Stay a little closer to the ground at **INFLIGHT DUBAI**, an indoor skydiving facility that will give you the rush without the risk. Or for a view of Palm Jumeirah from your own two feet—while staying on the ground!—head up to the observation deck at **BURJ KHALIFA**, the highest such structure in the world. You'll have amazing views of the city and the Persian Gulf any time of day, but sunsets are particularly spectacular!

If you're a real thrill-seeker, you know there are adventures to be had with your feet off the ground. So if you ever have the opportunity to leap out of an airplane high over Dubai, you should "jump" at the chance!

After my first skydiving experience in Australia, I was sure I'd never do it again. Yes, it was exhilarating, but I was sure once was enough! That is, however, until I learned you could skydive over the iconic Palm Jumeirah in Dubai.

After a morning of shopping, we made our way to the skydiving center, where huge groups of people had gathered to make the same jump I was preparing for. With skyscrapers squeezed in together along the water's edge, Dubai is one of the hardest places in the world to skydive. Every instructor has hundreds, if not thousands, of dives under their belt, so you know you're in the best hands possible—a fact that was just enough to ease my fears and get me on the plane.

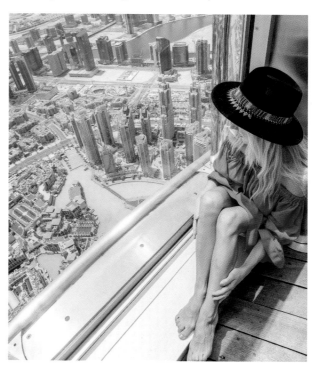

Tandem skydiving is all about trust. After all, you can't even see the person you're diving with because they're strapped behind you. I was shaking with nerves as my guide and I worked our way toward the open plane doors, watching as other skydivers jumped out one by one. Just when I was about to change my mind, it was my turn, and the next thing I knew, we were falling, flipping, and spinning high above Dubai.

The view was absolutely incredible. While the design of Palm Jumeirah is impressive, you can't see the archipelago clearly from the ground, which means jumping out of a plane is the best way to get a good view. Compared with a jump over coastal Australia, being over a dense city was invigorating, scary, and totally new.

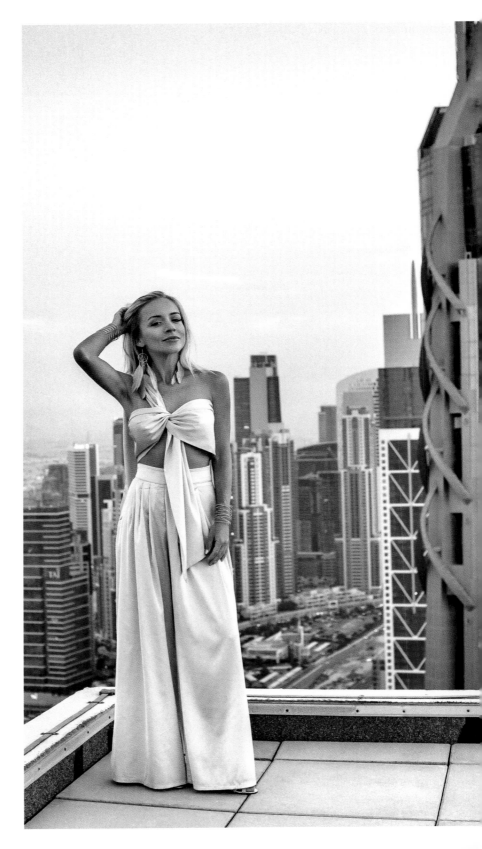

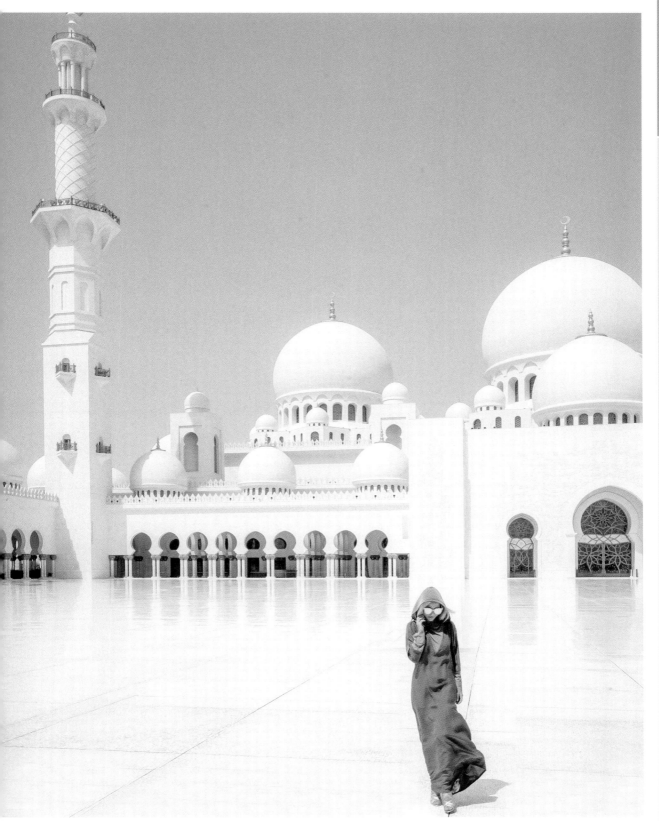

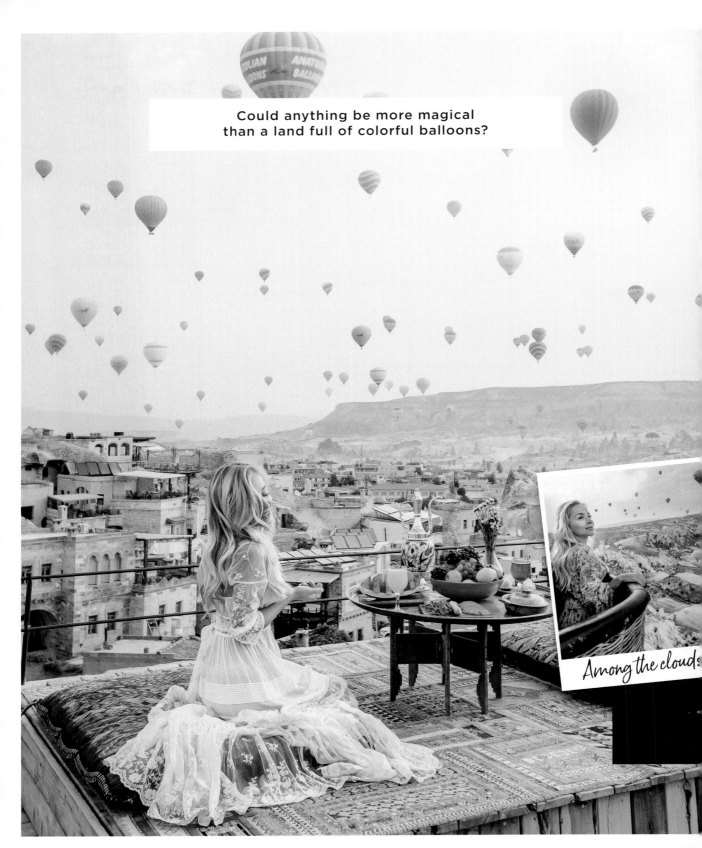

Could anything be more magical
than a land full of colorful balloons?

Among the clouds

LOCATION: **CAPPADOCIA**
COUNTRY: **TURKEY**
This historical region is home to spectacular stone landscapes you have to see to believe—amazing backdrops for colorful balloons.

What to bring

The best time to ride a hot air balloon is at sunrise or sunset, so be sure to pack light layers. Avoid anything too bulky because space in the basket is limited! You'll also appreciate the layers when in the cool (and sometimes damp) caves.

PHOTO TIPS

There's no room to back up in a balloon basket, so opt for a wide lens to give you the most sweeping view possible. Although balloons appear to rise and descend slowly from the ground, they move quite a bit while you're in them, so don't forget to put the strap around your neck! And consider shooting automatic as the sun begins to rise because the quickly changing light can cause the sky to get blown out.

Where to go

GÖREME is the ideal base for a ballooning adventure. The city is famous for its fairy chimney rock formations, dramatic structures carved by centuries of wind and water through the valleys that are even more mystical when viewed from the air during a sunrise balloon ride!

ÜRGÜP is the best place to find a cave hotel, where you can stay in a room carved into the rock. It's also a great place to sample some of the region's best wines.

DERINKUYU is a city underground that was big enough to accommodate up to 20,000 people as they hid to escape the Arab-Byzantine wars in the 8th–12th centuries. It had miles of tunnels and multiple levels of rooms and passages, with space for stables, wine presses, and chapels, and connected to other underground cities.

IHLARA VALLEY is a deep and dramatic valley that's a favorite destination for hikers. You can walk for hours among vineyards and farms, stopping to visit the valley's ancient cave churches.

Ride a Hot Air Balloon
OVER CAPPADOCIA

I wanted to ring in my 30th birthday with a little bit of magic and there's nothing more magical than Cappadocia. This area in Central Anatolia is as enchanting as it gets, with hotels and churches carved into soft volcanic rock, dramatic natural spires called fairy chimneys—formed by thousands of years of wind and water erosion—rising over the valley floor, and hundreds of colorful hot air balloons floating in the sky.

On our first morning, we woke before sunrise to watch the balloons from the rooftop of our hotel, enjoying breakfast overlooking the desert. The sky filled with warmth and color, dotted with vibrant balloons, as we ate local goat cheese and fresh bread with jam. I couldn't get over the excitement of being in a land full of balloons or the fact we'd be joining them so soon!

The next day, we got a taste of balloon culture ourselves, heading out in the early morning darkness to see the balloons being inflated and to climb into a basket for ourselves. Those first few moments are exhilarating as you lift off the ground, leaving the world behind with only the sounds of the fire heating the air breaking the meditative silence. From up above, the endless fields of fairy chimneys look like something you might see rising from the depths of the ocean and it's easy to understand how ancient people were mystified by and drawn to these incredible formations. And while I've seen many amazing sunrises in my life, the chance to be at the same level as the sun as it breaks above the horizon is a view I'll never forget.

After soaring across the valley, we landed in the middle of nowhere and joined our pilot in running across the fabric of the balloon to push out all the air. We celebrated another successful and beautiful flight with breakfast and champagne, a daily occurence that I could absolutely get used to!

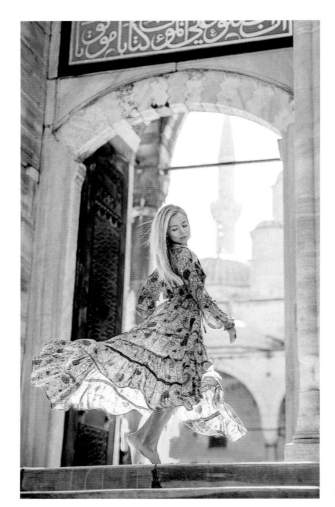

Nearby places

In addition to a few days in Cappadocia, be sure to extend your stay in Turkey with a visit to **ISTANBUL**. Don't miss the Hagia Sophia and the Blue Mosque, and be sure to cruise down the Bosphorus or enjoy dinner on the banks. Between sites, wander the city streets and the maze of the Grand Bazaar. And remember to taste everything! Indulge in coffee and tea, eat chestnuts from street vendors, and sample the rich spices that combine in iconic Turkish cuisine. More than anything, though, get to know the warm and hospitable locals and bask in the city's magical sunlight!

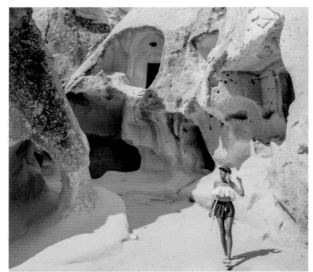

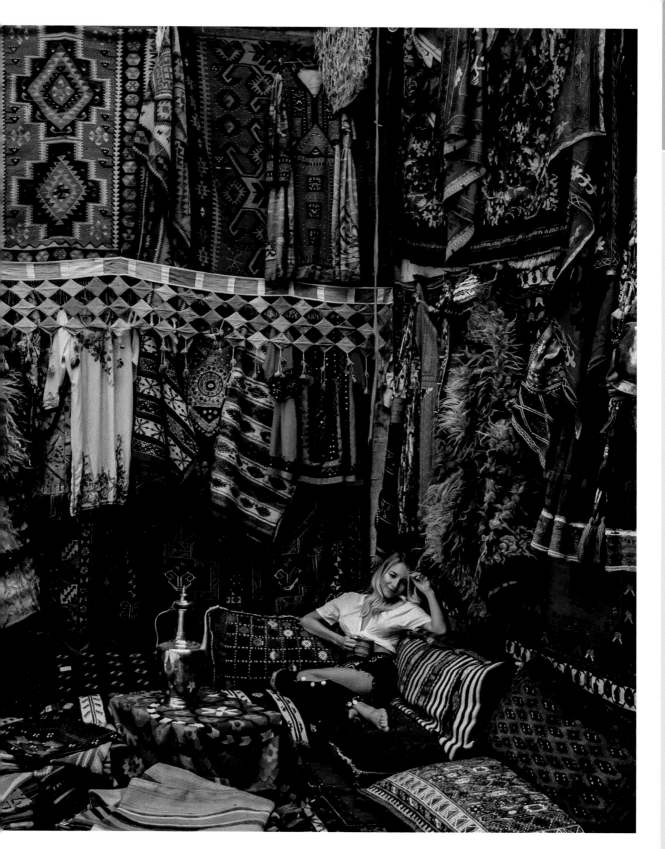

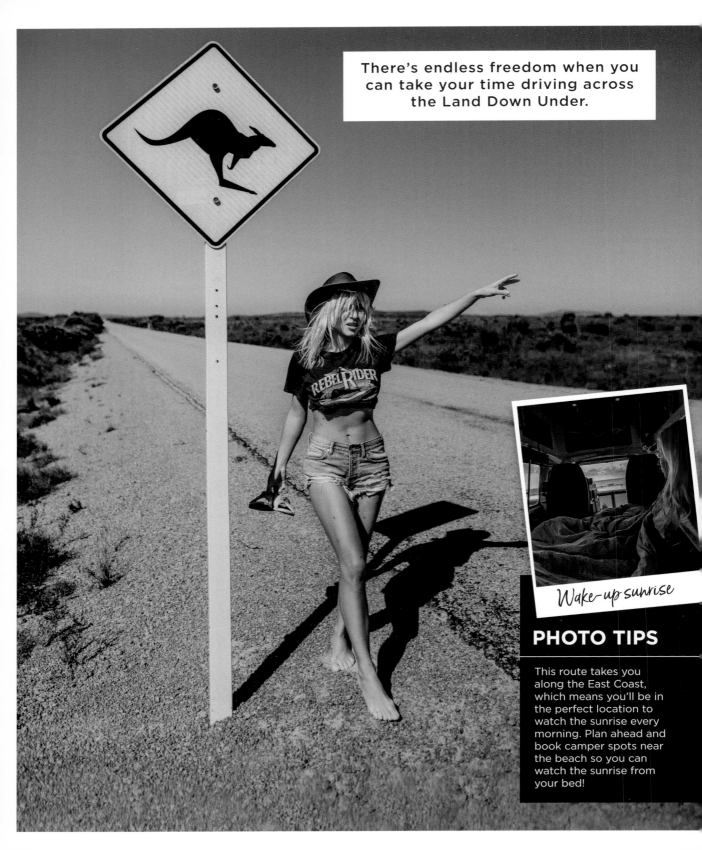

There's endless freedom when you can take your time driving across the Land Down Under.

Wake-up sunrise

PHOTO TIPS

This route takes you along the East Coast, which means you'll be in the perfect location to watch the sunrise every morning. Plan ahead and book camper spots near the beach so you can watch the sunrise from your bed!

LOCATION: **QUEENSLAND**
COUNTRY: **AUSTRALIA**
Travel the eastern and northern coasts from April to June or September to November, when temps are mild and there's less tourism.

Where to go

BYRON BAY is known for its surfing, and from May to November, you can see the humpback migration.
GOLD COAST is a great place to catch a wave at Surfers Paradise, indulge your need for speed at one of the many amusement parks, or zipline through the lush forest.
NOOSA is surrounded by a subtropical rainforest on one side and calm, clear waters on the other. Tour the Everglades in a kayak in search of spinner dolphins, mountain bike in Tewantin National Park, or ride horses along the sandy beach.
FRASER ISLAND is the perfect place to pitch a tent. Find a campsite near the SS *Maheno*, a famous shipwreck nestled on the beach. And head north to take a dip at the scenic Champagne Pools.
AIRLIE BEACH is where you can learn to sail or you can hop on a plane to a remote beach for a picnic lunch.
TULLY offers whitewater rafting. The Tully River is famous for its rapids, which will thrill adventure-seekers of all experience levels.
CAIRNS is home to Tjapukai Cultural Center, where you can earn more about Australia's indigenous Aboriginal people. Watch traditional dances and participate in interactive demonstrations, then sample traditionally made cuisine.
CAPE TRIBULATION is where you can snorkel along the Great Barrier Reef, take a night walk through the jungle, or take a leisurely walk along the Dubuji Boardwalk. Look for a campsite near the water to catch one perfect final sunrise before you head home.

What to bring

Many camper companies offer packages that allow you to rent everything you might need—from bedding to kitchen utensils to camping chairs—so you don't need to worry about packing any gear. Make sure you have swimsuits, sneakers, and fitness attire in your suitcase so you're ready for adventure!

Nearby places

Once you've wrapped up your road trip near Cairns, you'll be in the perfect spot to start another adventure on the **GREAT BARRIER REEF** (pages 26–27). Spend a few days on a boat for some of the best scuba diving of your life or book a seaplane to see the expansive reef from above. In the mood for some surf lessons and a quest for the best avocado toast? Head south to Sydney and join the surfers at **BONDI BEACH** (pages 36–37). Or continue your trip north to spend a week or two island-hopping in the Philippines (pages 48–51).

Drive a Camper

ALONG THE **AUSTRALIAN COAST**

Some countries just beg for a good road trip—and Australia is one of them. With nearly 3 million square miles to explore, it's the best way to see a large portion of the country in a single trip and to really get a taste for the local culture.

Over the course of two weeks, I made a camper van my home and drove more 1,200 miles. I'd never stayed in a camper van before and loved the feeling of getting to take my home with me every time I hit the road! We explored dozens of tiny towns, woke up on beach after beach, and even climbed up onto the roof of the van for a little sunrise yoga before our daily drives.

We filled our days with adventures—from a visit to a koala sanctuary to some of the most intense whitewater rafting in the world along the Tully River to a seaplane flight over the Whitsunday Islands and Heart Reef. I got another dose of adrenaline in Cape Tribulation, where we went jungle surfing—a.k.a. ziplining—through the canopy and even ate ants (spoiler alert: they're delicious). Just watch out for those spiders!

Whether you spend a few days or a few weeks traveling across Australia, you'll love the chance to see the country at your own pace. A trip like this is all about going with the flow and making your own plans—and loving every moment!

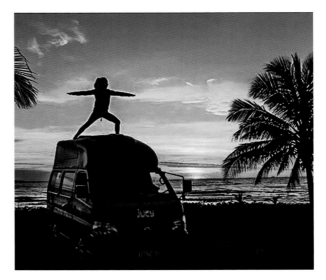

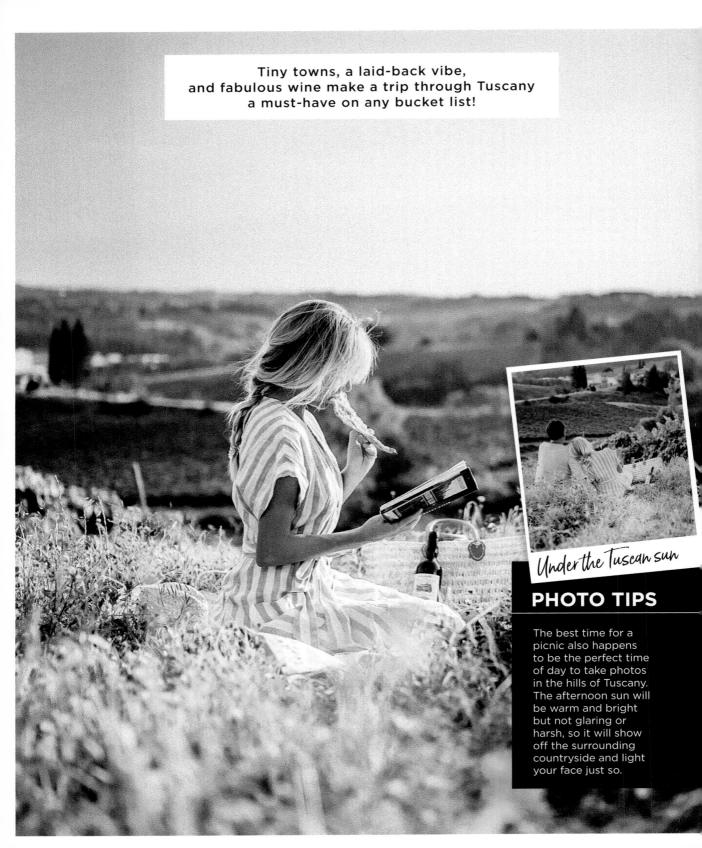

Tiny towns, a laid-back vibe,
and fabulous wine make a trip through Tuscany
a must-have on any bucket list!

Under the Tuscan sun

PHOTO TIPS

The best time for a picnic also happens to be the perfect time of day to take photos in the hills of Tuscany. The afternoon sun will be warm and bright but not glaring or harsh, so it will show off the surrounding countryside and light your face just so.

LOCATION: **TUSCANY**
COUNTRY: **ITALY**

Nothing beats harvest season in September and October: Leaves are changing, grapes are being picked, and harvest festivals abound.

Enjoy a Picnic
IN TUSCANY

What to bring

While you'll want to source all your picnic gear locally, you can get ready for this indulgent experience by bringing a few light layers of clothing that will be comfortable for sitting on the ground. Bring a collapsible tote or use one as your carry-on—you can unload your essentials and turn it into a makeshift picnic basket! No matter what you pack, be sure to leave room in your suitcase to bring home a few bottles of wine. Wrap them in sweaters or a few layers of T-shirts to ensure they survive the flight home in your checked luggage.

Nearby places

Explore **ROME** and its incredible history. See pages 60–61 for how to fill your itinerary! After traveling through Tuscany, head north to **BOLOGNA**—the home of Parmesan cheese, tagliatelle al ragù, and sparkling red Lambrusco. And burn some calories climbing 498 steps up Asinelli Tower. Even farther north is **VERONA**, which you might recognize from Shakespeare. In addition to seeing Juliet's famous balcony, wander streets surrounded by painted brick buildings, catch a performance at the Roman-era Verona Arena, and indulge in creamy risotto.

Where to go

FLORENCE is the capital of Tuscany and is loaded with the best the area has to offer: ancient history, incredible art, and amazing food and wine. Peruse the jewelry shops on Ponte Vecchio, see Michelangelo's *David* at the Galleria dell'Accademia, or climb the Duomo at the Cathedral of Santa Maria del Fiore. This city's truly everything you've heard it is—and yet so much more!

PISA is all about that leaning tower. If you'd like to climb the tower, buy tickets in advance to ensure you can join the limited hourly admission. But don't miss the city's colorful Keith Haring mural for an Instagram-worthy snap and be sure to indulge in a scoop or two of ice cream at Gelateria De Coltelli.

BRUNELLO is one of Tuscany's most famous wine areas—and for good reason. Made of 100% Sangiovese, it's a smooth and high-acidity wine with fruit flavors that are perfect for pairing with food. Stop into any of the number of vineyards producing this DOCG (Denomination of Controlled Origin) wine or order a local bottle to enjoy alongside handmade pasta topped with wild boar ragu.

CHIANTI is situated near Brunello, but the wine is a world away. A blend of Sangiovese, Canaiolo, and either Cabernet Sauvignon, Merlot, or Syrah grapes, Chianti wines range from light and crisp (think Italian table wine) to full and rich.

I've had so many people recommend a trip to Tuscany, but it wasn't until I got there that I realized why everyone loves it. After attending a wedding near Rome, my husband, Michael, and I rented a convertible and drove north into the Italian countryside. We stayed at an Airbnb in the hills that was an intimate and authentic experience with the perfect relaxed vibe.

Having the perfect picnic in Tuscany is really about grabbing a bottle of wine, finding something delicious to eat, and deciding which field looks the most promising. Tuscany is the perfect place to learn about the complexities of wine. Every tasting comes with a lesson about what makes the wine you're sipping unique. All that knowledge is a souvenir you can really use when you get home!

We spent the morning tasting, then chose our favorite wine and took it to go. A pit stop in town led us to my favorite Italian food—pizza!—and we were ready to bask in the sunshine. We found a meadow, laid out a blanket, and took time to savor every bite and sip, enjoying how calm and comforting such an unsuspecting moment is.

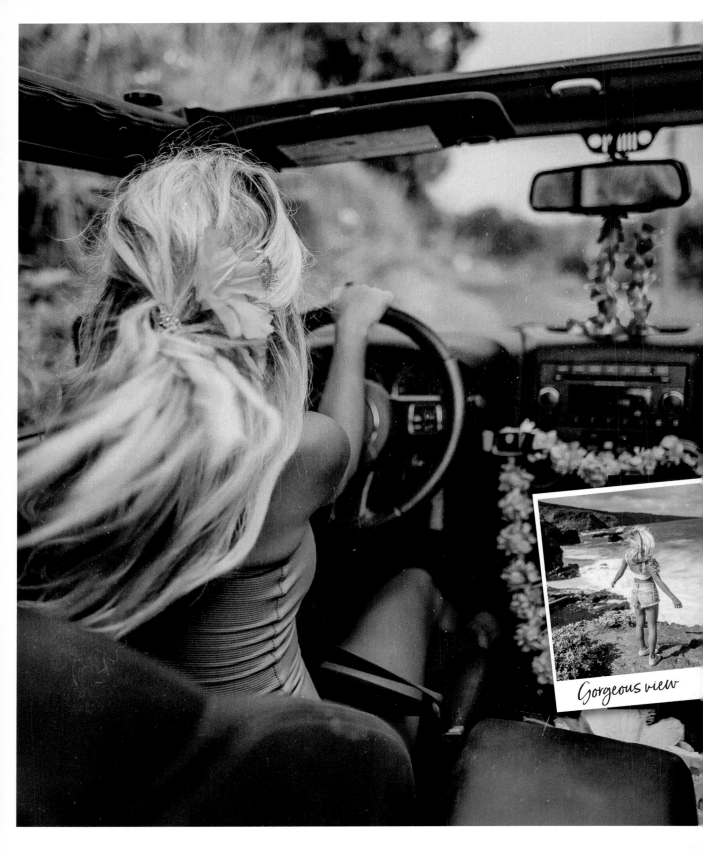

Gorgeous view

HAWAIIAN ISLANDS

Maui

Island of Hawaii

c Ocean

Drive with the **Top Down** IN HAWAII

What to bring

Driving around with the top down requires three things: sunscreen (for a burn-free tan), a hair tie (so you aren't left with a giant knot after your drive), and snacks (go local with fresh fruit, spam musubi, Portuguese-style donuts called malasadas, and taro chips). On the Big Island, rent a car with four-wheel drive, like a Jeep. The Road to Hana on Maui is a little smoother, so you won't need that feature.

PHOTO TIPS

It's all about the view! Most drives exploring Hawaiian islands will take you around the coast, so stop at a scenic overlook to snap a shot of the jungle meeting the sea. Stick with your phone in the car (if you're not driving, that is!), then use your larger camera when you've stopped to take it all in.

LOCATION: **HAWAII**
COUNTRY: **UNITED STATES**
June to August are dry, while December to April have the best surfing. Aim for September to November for quiet, open roads.

Where to go

MAUI is home to the famous Road to Hana, a 64-mile drive between Kahului and Hana along Maui's northern coast. Stretch your legs with a hike to Twin Falls, watch the surfers at Ho'okipa Lookout, and finish your drive on the stunning red sand of Kaihalulu Beach.

THE BIG ISLAND (HAWAII) is a great place to hop in a Jeep and explore the lava deserts scattered between lush forests. Head to Hawaii Volcanoes National Park for an upclose look at the lava flows and be sure to stop at a coffee plantation or two around Kona. Hike through the Waipio Valley, which meets the ocean at one of my favorite black sand beaches.

OAHU is the perfect place for a low-key day trip. You can drive to Electric Beach to see sea turtles, seek out the best açaï bowl in Honolulu, or take a break to join a tour that will take you out into the water to swim with dolphins.

There's nothing quite like the feeling of the wind in your hair as you drive along a coast with the top down. And there's no better place for that feeling than in Hawaii! Whether it's an afternoon drive on Oahu, spending the day driving the Road to Hana on Maui, or trekking from town to town on the Big Island of Hawaii, there's a trip (and destination!) to suit every kind of road-tripper—just remember to put the top down!

One of my favorite drives is the Road to Hana. It's totally iconic—and for good reason: You wind along the coast, past jungles and waterfalls, and always have an amazing view of the ocean. I loved it so much, we did the drive three times, back and forth between Hana and Kahului, to make sure we didn't miss a thing. I loved stopping at the waterfalls and saw so many rainbows in the mist over the cliffs. Leave a few hours for a stop at Wai'anapanapa State Park, with a gorgeous black sand beach and freshwater caves to explore. Because Maui is so small, you can do the whole drive in a few hours or spread it out into a longer excursion. If you're looking for a drive with a more local vibe, Maui is the place to go.

On the Big Island, it's all about volcanoes. There are five on the island of Hawaii (three are active!), with lava flows and rock fields scattered across the island. Rent a car with four-wheel drive so you can drive through Hawaii Volcanoes National Park!

If you're not sure you're up for a true road trip, rent a car and cruise around Oahu. Waikiki is full of shops and restaurants, while nearby towns feature adorable coffee shops and plenty of access to pristine white beaches.

Wherever you decide to drive, take your time! Explore the unique vibe each island offers and embrace the *aloha* spirit.

Put the top down, put your shades on—and start driving!

Nearby places

A scenic drive is a great way to see what each island is about, but don't spend all of your time in the car. If you're on Oahu, be sure to visit **WAIKIKI BEACH** for a surf lesson (pages 42–43). On Maui, hike through **'OHE'O GULCH** to swim in pools filled by cool waterfalls. For an ocean adventure on the Big Island, make your way to **KONA** to swim with manta rays (which you can also do in Moorea; see pages 138–139). Each Hawaiian island has its own vibe, so do yourself a favor and do a little island-hopping to figure out which is your favorite!

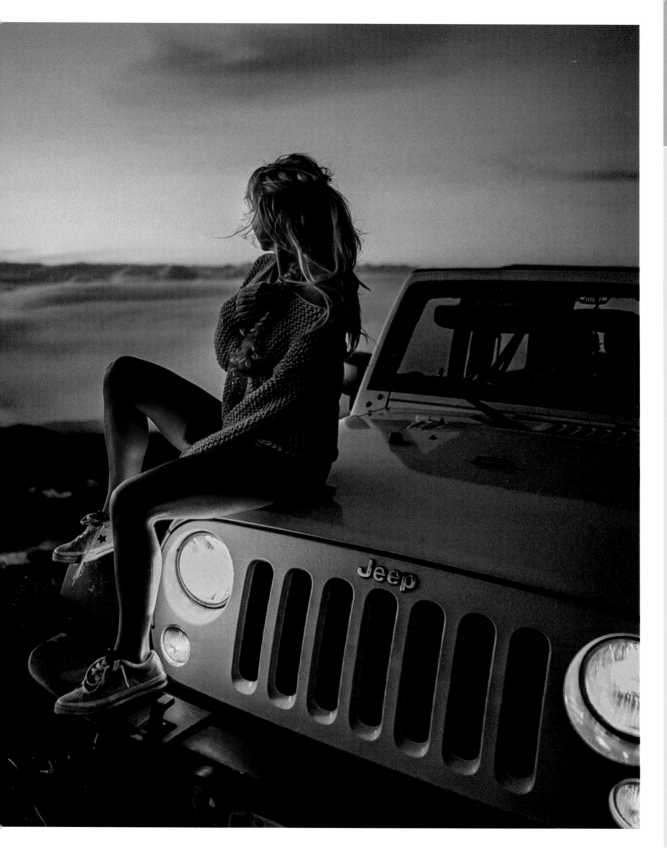

cultural experiences

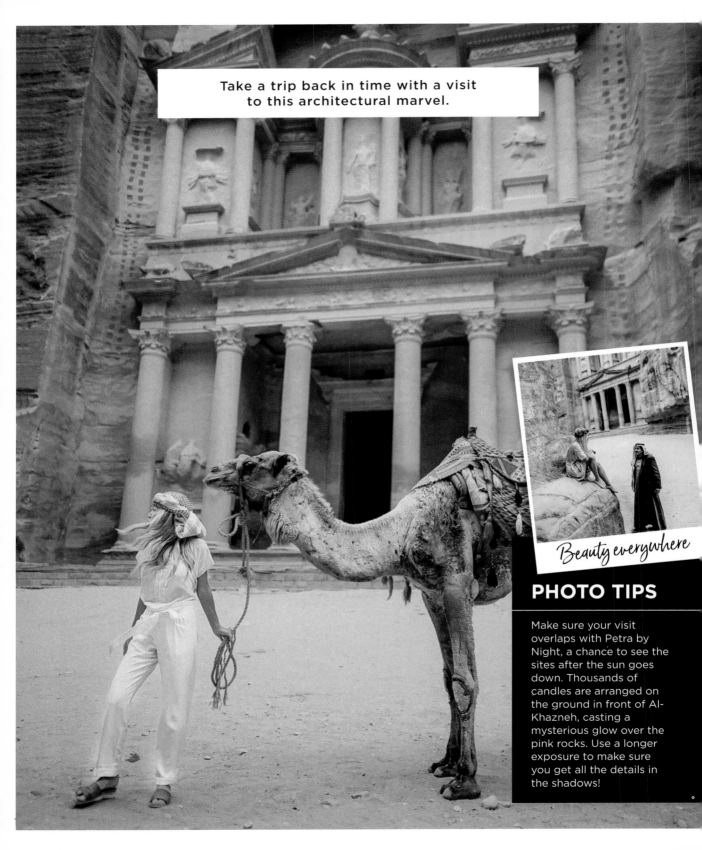

Take a trip back in time with a visit to this architectural marvel.

Beauty everywhere

PHOTO TIPS

Make sure your visit overlaps with Petra by Night, a chance to see the sites after the sun goes down. Thousands of candles are arranged on the ground in front of Al-Khazneh, casting a mysterious glow over the pink rocks. Use a longer exposure to make sure you get all the details in the shadows!

LOCATION: **MA'AN GOVERNORATE**
COUNTRY: **JORDAN**
Visit from March to May or September to November, when temps hover from the mid-60s to mid-70s.

Go Back in Time
IN PETRA

What drew me to Jordan was Petra. I'd seen so many incredible pictures of the spectacular Treasury in the middle of the desert and wondered about the feats of human ingenuity and creativity that it took to create this sprawling stone metropolis.

To get to Petra, you must first pass through the Siq, a narrow canyon with walls so high you can barely see the sky above you. Resist the urge to take a horse or donkey and instead walk for about 40 minutes to experience the approach the way the Nabataeans did. When we emerged from the canyon, the beauty of what I saw brought tears to my eyes. It's hard to fathom how something so stunning, so ornate, and so complex could have been constructed thousands of years ago—and then you look at the map and realize just how big Petra really is.

While most people will suggest arriving early to beat the heat, I actually found that the afternoon was the best time to visit, once most of the crowds have left in the hour or two before the park closes. The quiet can be eerie, but it gives you a chance to soak it all in without having to dodge other visitors or feel like you're being hurried along. Plan to spend a few days in the area and visit two or three times to really have an opportunity to explore!

Visiting Petra was also an amazing opportunity to get to know members of the local Bedouin tribe. They were all so welcoming and wanted to teach us about the area, and I'm so glad we hired a local guide for a hike to the cliffs above the Treasury for an even more dramatic view.

Of course, every destination and every culture has its own practices and particulars, and while I always felt incredibly safe in Jordan, I recommend traveling in a group—and that women shouldn't travel in this area without a man in the group. If these spectacular structures call to you as much as they did to me but you're concerned about heading to Jordan alone, there are many larger tour groups that organize trips and prioritize safety, making sure you can see one of the New Seven Wonders of the World in a way that makes you feel comfortable and excited to explore.

What to bring

The challenge of a trip to the desert is staying covered *and* cool. Bring light, breathable layers that you can add and remove as needed, especially when temps start to drop after the sun sets. Don't forget a scarf to cover your nose and mouth from desert dust as well as sturdy walking or hiking shoes to navigate the miles between the ancient city's stunning ruins.

Nearby places

You'll should devote some extra time to also seeing the rest of Jordan. Head north to spend some time floating effortlessly in the **DEAD SEA** (pages 32–33) or ride a camel with Bedouins (and even stay in a desert camp!) in **WADI RUM** (pages 116–117). For a more cosmopolitan experience, enjoy the sights, sounds, and flavors of the capital city of **AMMAN**.

Where to go

AL-KHAZNEH is the most iconic structure in Petra—the one you'll recognize from Instagram posts! This 131-foot-high structure is the first thing you'll see when you exit the Siq (the canyon walkway you'll follow to access the city). It received its name ("The Treasury" in English) from the Bedouins, who believed it contained incredible treasures. **AD DEIR** ("The Monastery") is located high in the hills northwest of the city center. It's a significant walk from Al-Khazneh, so allow for at least an hour plus time to stop at the other sites you'll see along the way. **THE GREAT TEMPLE** is the largest free-standing structure in Petra. Unlike Al-Khazneh or Ad Deir, which were carved into the sandstone cliffs, it covers a large open area and combines columns, a theater, and a central sacred enclosure. It's also home to incredible frescoes, mosaics, and ornate architecture that's still being excavated and preserved by archaeologists.

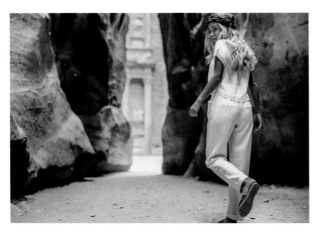

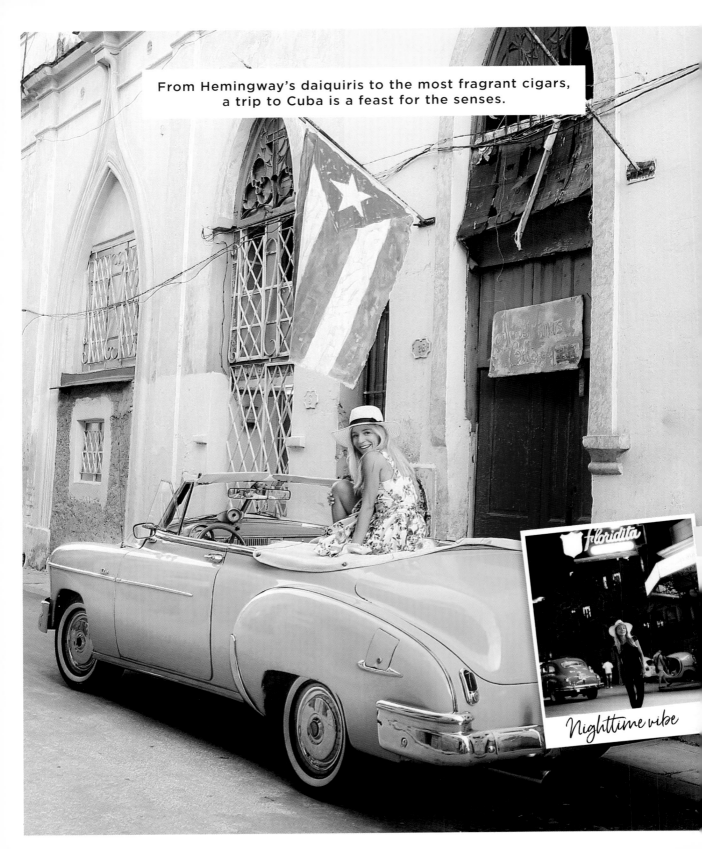

From Hemingway's daiquiris to the most fragrant cigars, a trip to Cuba is a feast for the senses.

Nighttime vibe

What to bring

Pack basic cosmetics and toiletries, such as lipstick, mascara, shampoo, and conditioner. Because of trade restrictions, a lot of these goods aren't available in Cuba. I had so many local women ask me if I would share what I'd packed and I wish I'd brought more to give away.

PHOTO TIPS

Be sure to bring extra memory cards for your camera, especially if you usually back your photos up to the cloud. Internet service can be spotty throughout Cuba, so you might not be able to upload the photos you've taken until you return home!

LOCATION: VIÑALES VALLEY
COUNTRY: CUBA
The best time to visit is from November to April, when the weather is dry, the temps are comfortable, and the risk of hurricanes is low.

Where to go

HAVANA is like being on a movie set, with gorgeous European-style architecture that's been timeworn but still maintains its patina—just like the '50s-era cars that serve as the city's colorful cabs. Sip an authentic daiquiri, drink sweet Cuban espresso, and immerse yourself in the rich culture.
VIÑALES VALLEY is a dramatic natural formation in western Cuba, where thousand-foot-tall limestone cliffs tower around lush tobacco fields. If you're visiting Cuba in search of one of the country's iconic cigars, head to the valley to see how tobacco is produced and enjoy a cigar straight from the source.

Nearby places

Cuba is surrounded by some of my favorite Caribbean destinations. Head northeast to the **BAHAMAS**, where you can explore the archipelago of more than 700 islands to relax in the sand, sip fruity punch, dive and snorkel around coral reefs, or even swim with pigs (pages 140–141)! Or head southeast toward Venezuela to the island of **ARUBA**. That's where you'll find vibrant architecture, sunset surfing, incredible nightlife, and a private island that's home to a flock of flamingos.

Discover Havana
IN CUBA

One of the things I most wanted to do in Cuba was smoke a Cuban cigar and ride a horse through tobacco and coffee plantations. We headed west from Havana, making our way down into the Viñales Valley. We stayed in a quaint Airbnb, where the hostess made us traditional Cuban meals (including amazing black beans!). Her neighbor has a tobacco plantation, so the next day, he picked us up with his horses and we rode through the fields to the shack where they store and dry the leaves. He taught us how to roll cigars, and while it wasn't the sexy tanned woman rolling leaves on her thighs that I'd envisioned, it was amazing to see the precision and technique that goes into a perfectly crafted cigar.

While I wouldn't condone smoking in almost any other situation, this was a once-in-a-lifetime opportunity that I had to partake in. We sat in the shade, enjoying the rich flavor, as the horses grazed around us, then rode to a nearby coffee plantation to taste the local beans. In fact, we tasted so much coffee, I couldn't sleep that night!

Traveling to Cuba was like exploring another culture and also traveling back in time. The country feels as though it's frozen in the past, with colorful buildings slowly crumbling, vintage Chevys driving through the streets of Havana, and lush plantations giving way to dense mountain jungles. The country's beauty is mind-blowing, and at every turn, you feel like you've wandered onto another pristine movie set. While access to this island country isn't always easy, if you ever have a chance to go, take it!

Admire the *Cherry Blossoms* IN JAPAN

by Michael Moretti (@moretti)

One of my lifelong dreams was to visit Japan during the cherry blossom season (*sakura*). When yet another March started to come to an end, I decided it was time to go. This is Japan's busiest time of the year—and there's good reason for that. This is a special time for this Asian country because it's a reminder of how beautiful and special life is and how short it is. The beauty of the cherry blossoms brings hundreds of thousands of people every year, but the problem is, Mother Nature has a mind of her own.

Because spring flowers depend on the weather, the timing of the blossoms can change from year to year. When trying to decide when to go, it can be extremely difficult because there are various cities with different elevations, which of course can affect the timing of the flowers. The south of Japan is usually known to be the first to see the blossoms, with Tokyo and some of the lower elevations soon after. Higher elevations, such as the towns surrounding Mount Fuji and in the north, are much later.

We decided to try to catch the end of March and beginning of April. We got very lucky with Tokyo and Kyoto, as the blossoms were just coming into full bloom, but when we went to Mount Fuji, the flowers hadn't come out yet. But what we saw in Tokyo and Kyoto were enough color and beauty to last us a lifetime—or until we decide to go back to Japan.

LOCATION: **HONSHU**
COUNTRY: **JAPAN**
If you're in Tokyo, Kyoto, and Osaka, Hanami—cherry blossom festivals—typically take place in early April.

Where to go

TOKYO is one of the world's most populous cities. Take a kayak or an open-air boat down the Meguro River to see the city from a different—and slower—perspective. For nearly a mile down a narrow canal in the Nakameguro neighborhood, you can see the bright pink of cherry blossoms overwhelm you from both sides. Paper lanterns light up the trees until 9 p.m. each night, so don't miss out and get left in the dark.

KYOTO has a roughly one-mile path in the Higashiyama district that captures almost 1,200 years of history of Japan's former capital. Walking these streets give you such an amazing feeling of Japan's great heritage there—and the food is some of the best in the world. I highly recommend staying in Kyoto for a few days to soak in all this city has to offer.

MOUNT FUJI might seem like an unusual place to see cherry blossoms, but the majestic volcano provides a beautiful backdrop to the Japanese cherry trees that flourish in the Five Lakes area around it. Kawaguchiko Lake is the easiest of the lakes to access, and from there, you can capture stunning reflections of this impressive mountain.

What to bring

The weather in Japan varies from city to city, but it was never so cold for me to need a heavy jacket. Your smartphone is going to be your best friend because you'll want to look up things to do and places to go while you're there. My #1 use was Google Maps and it made my life so much easier. Because taxis in Tokyo are expensive, I used the subway system as much as possible and Google Maps navigated me with simple directions on which platform to take and how many feet to walk to get to it! While you're using the subway, make sure you get a Suica card that lets you hop on a train without having to constantly buy a ticket each time. You can even use your Suica card to buy drinks and food in vending machines around Tokyo—even hot coffee!

Nearby places

The beauty of Japan is its bullet train system and how fast it is to get from one place or another. If you're looking for other nature experiences, head to Sankeien Garden in **YOKOHAMA** for cherry blossoms in spring, roses in summer, and daffodils in winter; to Hitsujiyama Park in **CHICHIBU** for the shibazakura (pink moss); or to Kairakuen Garden in **MITO** for the 3,000 plum trees.

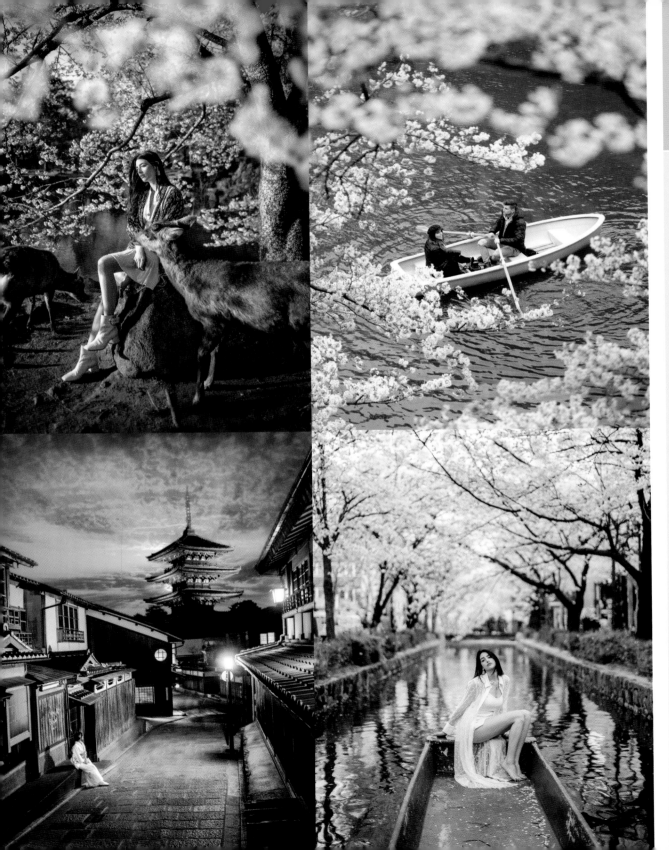

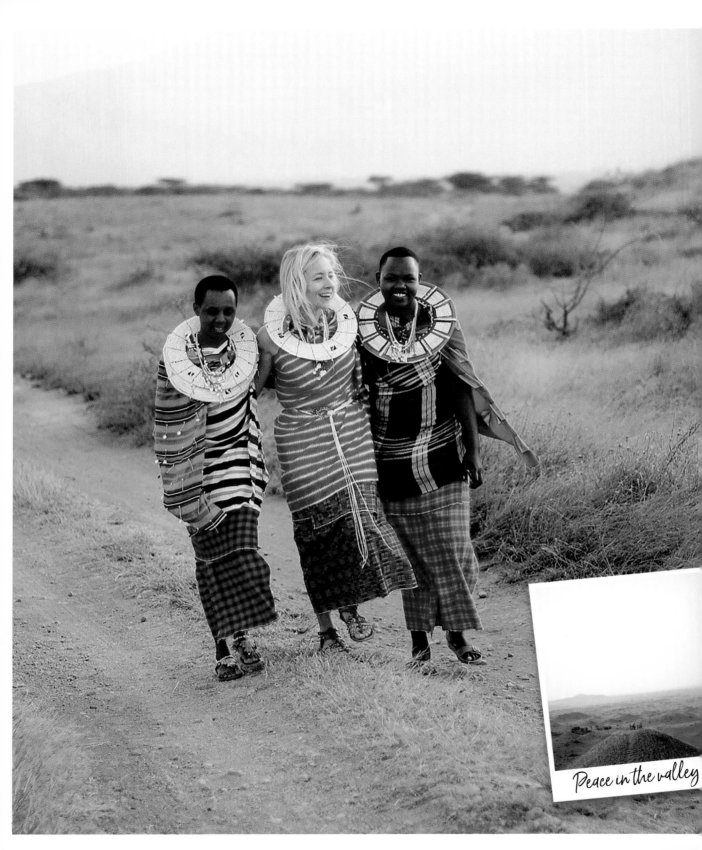

Peace in the valley

LOCATION: **NGARE NANYUKI**
COUNTRY: **TANZANIA**
The best time to visit is the dry season from late June to October, a fantastic opportunity for clear weather and ample game-viewing.

What to bring

Natural-colored clothing (think khaki, olive green, and beige) is recommended for safaris, allowing you to blend more easily into the landscape when viewing game. Be sure to bring layers, as Tanzania has a tropical climate that's quite warm during the heat of the day but cools off significantly in the mornings and evenings.

PHOTO TIPS

The thing that will strike you the most is how *big* Tanzania feels. Everywhere you look, there's space! Experiment with depth and proximity in your photos, playing around with focus and angles to find a combo that captures that grandeur.

Where to go

Africa Amini Life offers three lodging options—all in the shadow of Mount Kilimanjaro.
ORIGINAL MAASAI LODGE is styled after a traditional Maasai village, with 14 earth houses scattered around a pool and central restaurant. Dine on traditional Swahili dishes, learn to throw a spear, or walk in nature with a Maasai guide.
HILLSIDE RETREAT is an intimate private lodge with space for up to seven guests, right on the edge of Arusha National Park—the perfect jumping-off point for a safari or a tour of a local Maasai village.
NATURE HOMES are set in an acacia grove overlooking Mount Meru, also near Arusha National Park and surrounded by African wildlife.

Stay at the Original
Maasai Lodge
IN TANZANIA

If you're looking for a way to be immersed in the Maasai culture firsthand, a stay at the Original Maasai Lodge should be at the top of your list. Built and run by the local Maasai people, this nonprofit lodge provides incredible support to an otherwise underserved community—all while helping to maintain self-sufficiency among the Maasai people. The Maasai in the nearby village work at the hotel, then are able to afford the local school and hospital—taking care of their children and their community in the process.

The Original Maasai Lodge is styled after a traditional village, with a series of huts scattered around the property. It's all run on solar power, but while you might not find hair dryers or air conditioning, each hut-turned–guest room reveals beautiful five-star design in a setting that pairs cultural immersion with luxury travel.

I visited the lodge on my way to climb Mount Kilimanjaro and it was an amazing way to unwind and connect with my surroundings before our climb. I instantly felt like part of the family: Every person on the staff knew my name and my curiosity about the Maasai culture was rewarded with open invitations to learn and participate. The Maasai who work at the lodge are proud and protective of what the lodge has become and are eager to invite visitors in.

Whether you're heading into Tanzania for a safari, preparing to climb Mount Kilimanjaro, or looking for a boutique experience in a truly wild setting, the Original Maasai Lodge is a window into a rich and historic culture like you won't get anywhere else.

You'll feel like family at this boutique lodge styled after a Maasai village.

Nearby places

A trip to Tanzania is an opportunity to experience Mother Nature at her best (and sometimes her most challenging). Climb **MOUNT KILIMANJARO** (pages 62–67)—the highest peak in Africa—to watch the sunrise from the top of the world. It's a grueling task but a journey worth taking if you are up to it. Slightly farther west, the **NGORONGORO CRATER** (pages 142–145) is a sunken ecosystem known for its dramatic views and incredible variety of native wildlife that can be viewed year-round—even while camping in tents set up on the crater floor! In northern Tanzania you'll find **SERENGETI NATIONAL PARK**, home to the Great Migration, where you can take a safari (pages 142–145).

PHOTO TIP

When photographing the Maasai, avoid stopping just to photograph someone standing by the road—many are nontribe members who dress in traditional clothing just to make money, so if you do want to take your picture with a member of the Maasai tribe, make sure they're the real thing!

New roads, new friends

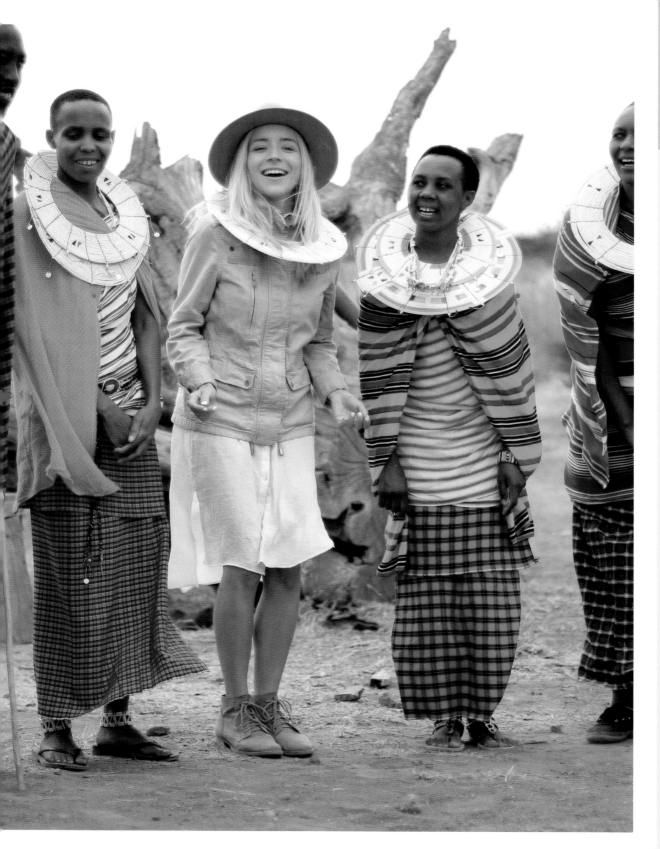

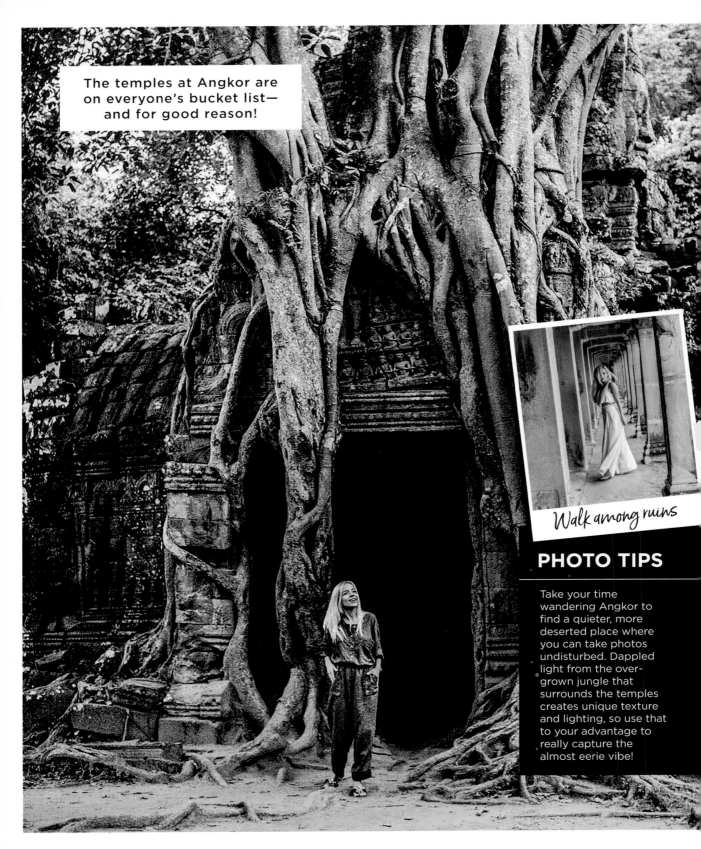

The temples at Angkor are on everyone's bucket list—and for good reason!

Walk among ruins

PHOTO TIPS

Take your time wandering Angkor to find a quieter, more deserted place where you can take photos undisturbed. Dappled light from the overgrown jungle that surrounds the temples creates unique texture and lighting, so use that to your advantage to really capture the almost eerie vibe!

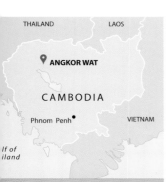

LOCATION: **ANGKOR**
COUNTRY: **CAMBODIA**
Visit in October or early
November, when crowds are
smaller and rain makes the
jungles lush and green. It's
hot no matter when you go.

Explore Temples
IN ANGKOR

What to bring

The temples of Angkor are still active religious sites, so all visitors must have their shoulders and knees covered. Opt for the lightest fabrics possible because even at the crack of dawn, it can be quite hot!

Nearby places

Most visitors to Angkor stay in **SIEM REAP**. In addition to taking a rickshaw out to see the majestic temples, be sure to eat plenty of curry (a little less spicy than Thai varieties) and indulge in some reflexology along Pub Street. Extend your stay in the area by a few days with a visit to **BANGKOK** (pages 40–41 and 152–153). If you're traveling with your lover, schedule your trip to overlap with the completely magical lantern festival in **CHIANG MAI** (pages 184–185). Looking for some beach time? Head further east to the **PHILIPPINES**, where you can visit lush tropical islands (pages 48–51) and even swim with whale sharks (pages 136–137)!

Where to go

I spent each morning of my visit at a different temple to get a feel for the incredible architecture and the details that make each temple unique. I was blown away by the scale of it all.
ANGKOR WAT is the most famous temple in the ancient city of Angkor, a sprawling and spectacular complex that was built as a Hindu temple dedicated to Vishnu and was later transformed into a Buddhist temple. It's a true symbol of Cambodia—and even appears on the country's flag!
TA PROHM is also known as the *Tomb Raider* temple, as it served as the backdrop for Angelina Jolie's 2001 film about fictional archaeologist Lara Croft. Dramatic strangler fig trees have taken over the building, giving it a mysterious feel that's totally captivating.
BANTEAY SREI is a temple dedicated to Shiva that's completely covered in intricate carvings. It's much smaller than many other temples at Angkor, but the ornate decorations make it a can't-miss destination.

A wake-up call well before dawn might not sound like a bucket-list activity to some, but the sunrise you'll see glowing over the temples of Angkor is one that just doesn't compare with anything else.

A sprawling temple complex in the heart of Cambodia, Angkor is most known for Angkor Wat, although it actually contains dozens of Hindu and Buddhist temples that are each unique and worth exploring in their own right. A three-day pass gives you plenty of time to wander among the ruins, although you'll want to get an early start every morning. Schedule a pre-dawn rickshaw to take you from Siem Reap out to Angkor—you'll want to arrive early to get a good spot to see the sunrise over Angkor Wat! Pause and really take it in. Even with the crowds around you, the intense spirituality that fills the air is palpable, especially as day begins to break.

What I loved most was being able to get far off the beaten path. Abandon the crowds, follow your instincts, and give yourself time to explore an incredible city that nature has reclaimed.

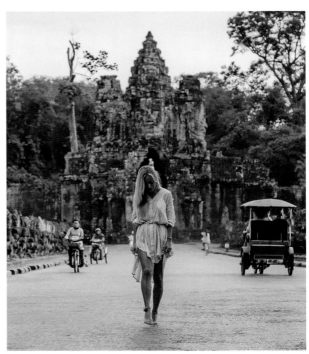

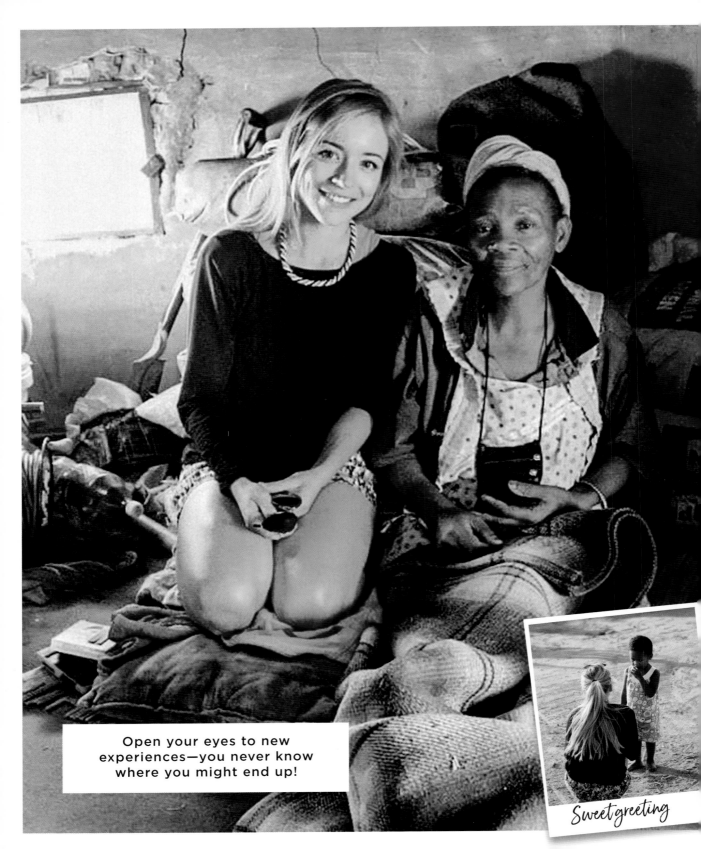

Open your eyes to new experiences—you never know where you might end up!

Sweet greeting

🧳 What to bring

Hand sanitizer is a must-have if you'll be spending an extended period of time in a Zulu village. Water is a scarce commodity, reserved for drinking and cooking, so a bit of hand sanitizer is a trash-free way to keep your hands clean.

Where to go

SHAKALAND is a popular Zulu cultural village where you can learn about cultural crafts, taste traditional Zulu foods, and even spend the night in a beehive-style hut. The Zulu culture is rich and full of amazing traditions, but it's also been commercialized for tourists. If you're looking for an authentic experience, hire a reputable local guide who can connect you with other true Zulu villages where you can get a taste of daily life.

PHOTO TIPS

As a rule of thumb, always ask before taking someone's picture. The Zulu people we met were open to tourism and having their photos taken, but don't assume everyone you encounter will feel the same way!

LOCATION: **KWAZULU-NATAL PROVINCE**
COUNTRY: **SOUTH AFRICA**
Temperatures in this region are relatively consistent, so it's all about rain and humidity. Humidity and temperatures peak from November to March, while June through September are drier and slightly cooler. Expect temperatures in the upper 70s and low 80s year-round.

Nearby places

South Africa is over 1,700 miles wide, filled with beautiful and diverse destinations to visit. **CAPE TOWN**, on the southwest coast, has award-winning restaurants (including gourmet vegan food!), stunning views from the top of Table Mountain, and access to the region's most important history—whether on Robben Island or in the galleries of the Museum of Contemporary Art Africa, home to the largest collection of contemporary African art in the world. Nearby **STELLENBOSCH**, in the heart of the Cape Winelands, pairs quaint cafés and boutiques with Shiraz and Pinotage wines that rival those of Bordeaux. And of course, you'll want to see South Africa's amazing wildlife! Head to the northeastern border and into **KRUGER NATIONAL PARK**, one of the largest game reserves on the continent and home to the Big Five (lion, leopard, rhinoceros, elephant, and Cape buffalo).

Stay in a Zulu Village

Durban is a beautiful city, but so much colonial influence can make it feel isolated from South Africa's history. I wanted to find a way to get to know the Zulu culture on a more personal level—not just see it in a museum or a gift shop—and was lucky to meet an employee at the hotel where I was staying who eagerly invited me to his cousin's nearby village. This truly local connection was the perfect way to get out of the bubble I felt trapped in.

When our new guide arrived, the first thing that struck me was the scale of the region. We drove for about 30 minutes, following the path he takes to walk to school every day—a walk that can take an hour and a half or more each way! The village was remote, but that distance from town meant we'd also finally gotten away from the commercialism and cultural appropriation that had made me feel uneasy closer to a big city.

We toured the beehive-style huts, visiting with the elders and seeing the village children run around as they played with the cows and goats that roamed between the buildings. It was modern Zulu life with no filters: We talked about everything from marriage and children (I was 26 at the time and they couldn't believe I didn't have children yet!) to gender roles (the mother served her husband and male children and let them eat—and even have seconds—before serving herself), and I was thankful for the opportunity to have an open and honest conversation with no expectations attached.

This chance encounter was a once-in-a-lifetime experience and it's something I'm grateful to have had. It was amazing to get to be with locals for a few days, to stay in their home, and to truly see how they live. They were so happy to share what makes their culture special and unique, and I encourage all travelers to take the time to seek authenticity and embrace the differences—and the similarities!—you might discover.

animal encounters

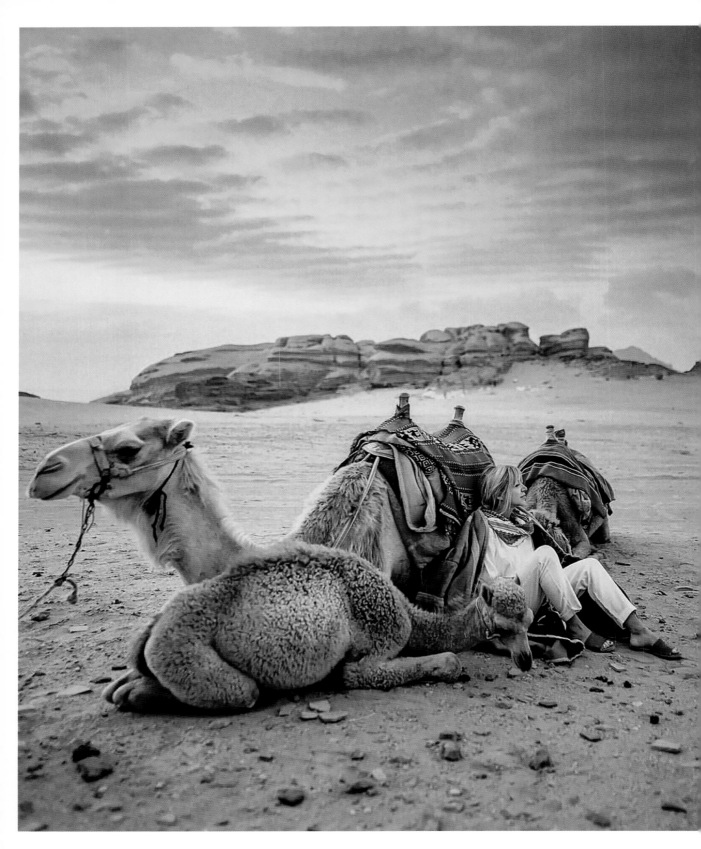

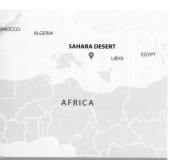

ALGERIA
ROCCO
SAHARA DESERT
LIBYA
EGYPT
AFRICA

LOCATION: **SAHARA DESERT & WADI RUM**
COUNTRIES: **MOROCCO & JORDAN**
Daytime temps are best in March, April, May, September, and October.

Hang out with Camels
IN THE MIDDLE EAST

Where to go

THE SAHARA DESERT is the largest in the world, bordered by Morocco's Atlas Mountains to the north, the Nile River to the east, and the Niger River valley to the south. Travel over the Atlas Mountains and through Berber villages to reach the vast expanse of windswept dunes along Morocco's southeastern border—the dunes in Erg Chebbi are up to 500 feet tall! If you visit Jordan from March to May, the desert is covered with wildflowers.

WADI RUM is also called the Valley of the Moon, a dramatic red landscape that seems to be from another planet. The valley is home to the Zalabia Bedouin, who make their living offering luxury camping, eco-adventure tourism, and camel rides. You've probably spotted this valley's dramatic peaks in such films as *Lawrence of Arabia* and Matt Damon's *The Martian*.

The desert can be an intimidating and sometimes dangerous place, but visits to deserts around the world have taught me to love how raw and remote this landscape can be. A trip to the desert is a meditative experience, with nothing to distract you from what's right in front of you, especially when accompanied by the gentle sway of a camel's plodding pace.

Camels have been the transportation of choice across the desert—from the Berbers in the Sahara to the Bedouins in Jordan—for thousands of years. While their humps don't actually hold water, these animals are uniquely able to store fat that helps keep them hydrated while their slow movement and classic kneeling position in the sand enables them to slow their metabolism to preserve energy—evolutionary tricks that make them the ideal way to cross the endless sand.

As you approach the desert, there are men offering camel rides everywhere, with dozens of animals tied together so you can hop on for a ride. Instead, though, I sought out smaller operations where I could tell each animal was being well treated. In fact, in Jordan, we spent just as much time socializing with baby camels and walking alongside the animals through Wadi Rum and Petra as we did riding them!

What to bring

Protect yourself from wind and sand with light layers and a long scarf or head covering that you can hold over your nose and mouth. Be sure to bring a hat to shield your eyes from the bright sun.

Serene desert

PHOTO TIPS

It's hard to judge the scale of the desert from a photograph without some sort of reference—whether a camp in the distance or a person atop a camel on the next dune—so make sure you're taking a picture of *something* and not just the sand!

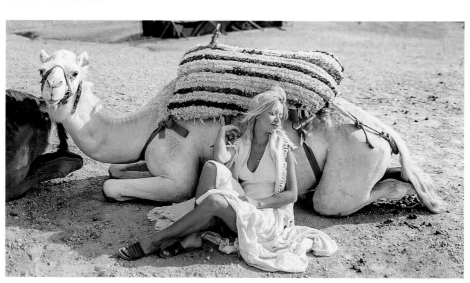

In Morocco, a camel caravan was our means of transportation out to a desert oasis, where we camped for the night in gorgeous tents draped in ornate fabrics. What might look like overkill during the heat of the day was a welcome and cozy retreat once the temperature dropped in the dark.

For the best experience, find a tour where the camels are being well cared for and the guides are indigenous and can give you insights into their culture, elevating a camel ride from a fun activity to an opportunity to experience life through someone else's eyes.

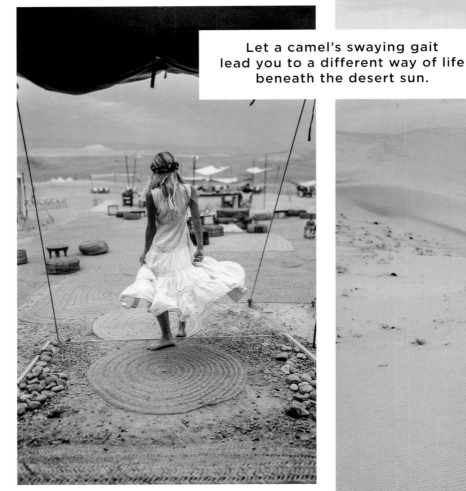

Let a camel's swaying gait lead you to a different way of life beneath the desert sun.

Nearby places

While you might need to head to more remote parts of the desert to find camels, nearby cities are full of fascinating culture. When in Morocco, spend a few days in **MARRAKECH** (pages 154–157). I highly recommend visiting during Ramadan, which falls during the mild spring shoulder season. In Jordan, take a day trip to the lowest point on Earth to float in the **DEAD SEA** (pages 32–33) or head north from Wadi Rum to the spectacular ruins of **PETRA** (pages 100–101).

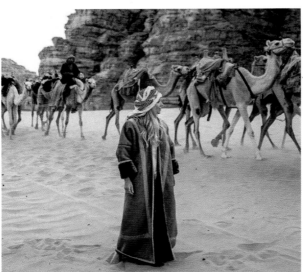

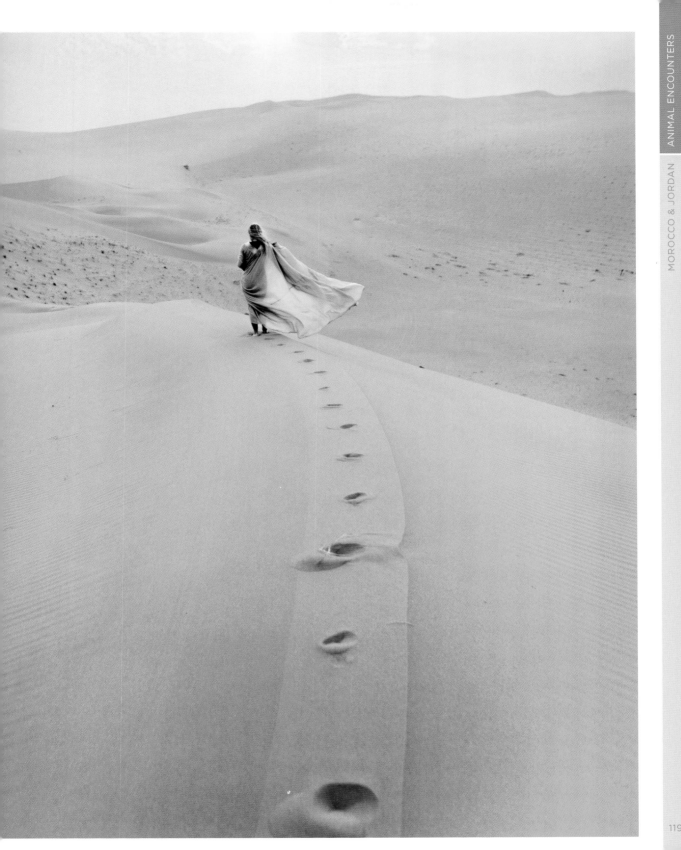

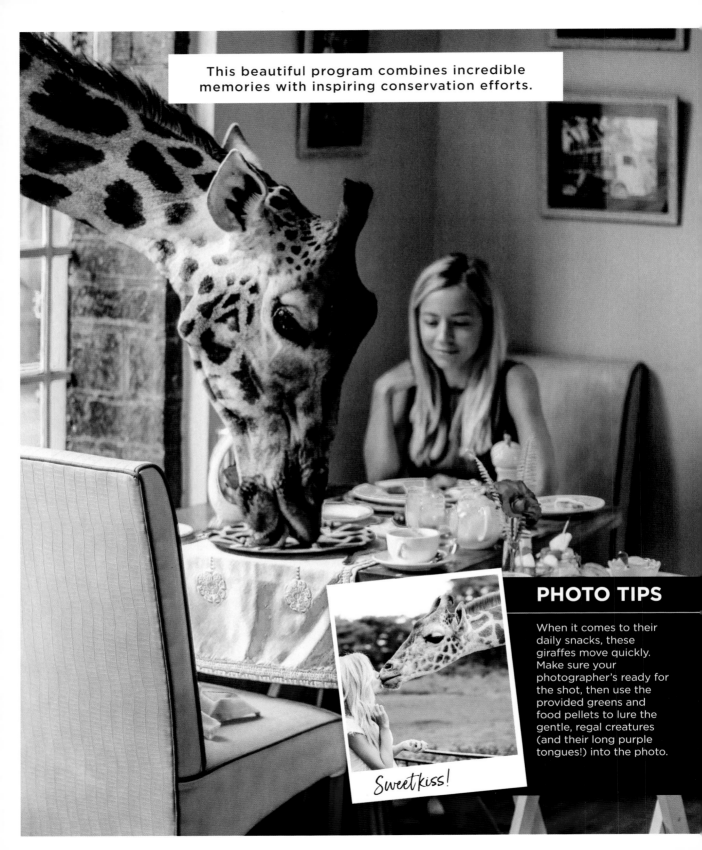

This beautiful program combines incredible memories with inspiring conservation efforts.

PHOTO TIPS

When it comes to their daily snacks, these giraffes move quickly. Make sure your photographer's ready for the shot, then use the provided greens and food pellets to lure the gentle, regal creatures (and their long purple tongues!) into the photo.

Sweet kiss!

LOCATION: **NAIROBI**
COUNTRY: **KENYA**

The hotel's 12 rooms fill up quickly, so schedule your trip far in advance. Thankfully, the weather in Kenya is quite good year-round.

What to bring

Channel your inner Jane Goodall in the chicest taupe and khaki attire you can find. A shirtdress, an army green jacket, and a wide-brimmed hat will look perfectly feminine for your breakfast date with a giraffe!

Nearby places

After breakfast with a Rothschild's giraffe, learn more about these endangered animals on a guided nature walk through the sanctuary. The Safari Collection, which manages the Giraffe Manor, offers a number of other amazing animal experiences throughout Africa—from a trip to the rhinoceros breeding sanctuary at **SOLIO RANCH** to learn about rhino preservation to five days in **VIRUNGA NATIONAL PARK** in the eastern part of the Democratic Republic of Congo, where you'll hike through the jungle to see mountain gorillas— something you can also do in Uganda (see pages 122–123). If baby elephants are calling to you, visit the **SHELDRICK WILDLIFE TRUST**, also in Nairobi, to help rescue orphaned elephants and support the organization's anti-poaching efforts.

Where to go

GIRAFFE MANOR is a beautiful 1930s building that has been transformed into a boutique hotel in a Nairobi suburb, but its beautiful façade isn't the real draw: It's the Rothschild's giraffes! The Giraffe Manor is set within 140 acres of indigenous forest that are home to a herd of these endangered creatures, many of whom will poke their heads through the windows of the hotel at breakfast in search of a snack.

THE GIRAFFE CENTRE is run by the African Fund for Endangered Wildlife, which operates a conservation center on land that includes the Giraffe Manor. While having giraffes join you for breakfast is reserved for guests staying at the manor, visitors to the area are welcome to stop by the Giraffe Centre to learn about the Rothschild's giraffes and offer these elegant animals a few treats.

Dine with Giraffes IN NAIROBI

If there's one experience in this book that should definitely be on your bucket list, this is it. I love supporting animal rescue organizations and the Giraffe Manor makes preserving the Rothschild's giraffe an exciting once-in-a-lifetime experience that you absolutely shouldn't miss.

On the outskirts of Nairobi, a beautiful hotel housed in a colonial building is surrounded by a giraffe sanctuary—and these graceful creatures are as friendly as they come. They're also hungry, so keep an eye on your food! Every morning, the staff opens the windows to the dining room and curious giraffes lean through in search of breakfast. The staff provides greens and food pellets, but the giraffes have been known to steal a few pieces of fruit or a scone from unsuspecting guests. I also love the communal feel they've created at the Giraffe Manor. Meals are served at large tables, encouraging the hotel's guests to get to know one another and make connections that crisscross the globe.

While dining with a giraffe is definitely memorable, it's the work done by the Giraffe Centre that's truly noteworthy. The property's rescue and breeding program helps keep these animals wild, working to reinvigorate the population so the giraffes can make their way back to their natural habitat.

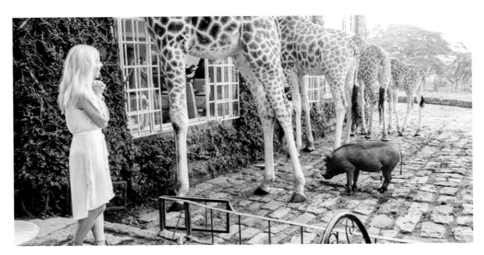

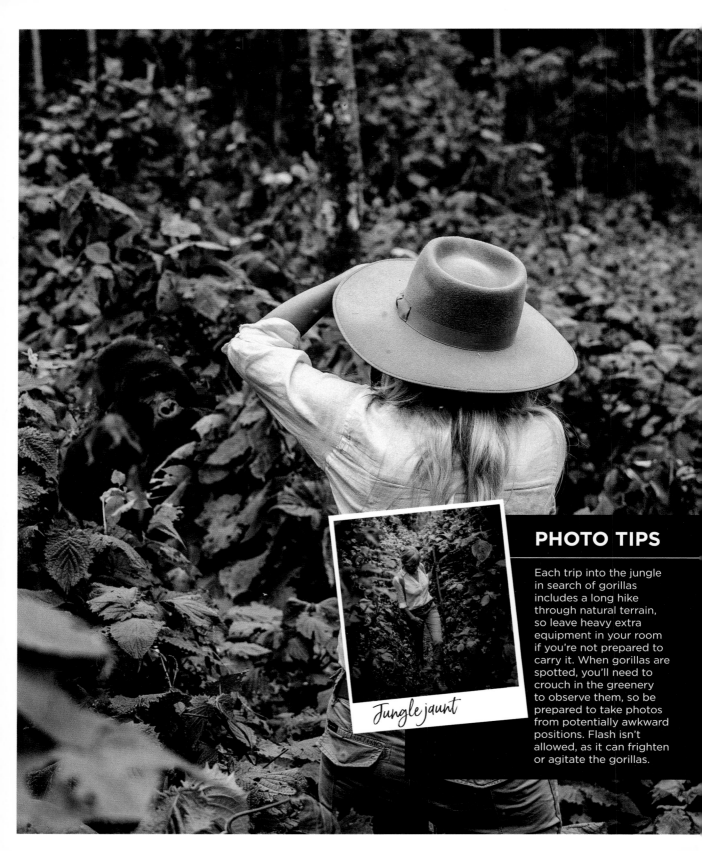

Jungle jaunt

PHOTO TIPS

Each trip into the jungle in search of gorillas includes a long hike through natural terrain, so leave heavy extra equipment in your room if you're not prepared to carry it. When gorillas are spotted, you'll need to crouch in the greenery to observe them, so be prepared to take photos from potentially awkward positions. Flash isn't allowed, as it can frighten or agitate the gorillas.

LOCATION: **KANUNGU & KISORO DISTRICTS**
COUNTRY: **UGANDA**

Permits are most affordable in April, May, and November, but the drier weather is from June to September.

Track Mountain Gorillas IN UGANDA

A gorilla trek is no easy feat. These majestic creatures—who share 98% of our DNA—are unpredictable and it can take hours of wandering the jungle behind a machete-wielding guide to find them. After a long hike, I was worried we might not get to see them at all when suddenly, our guide told us to crouch down and peer through the leaves just a few feet away from us. There they were: massive mountain gorillas, some with babies clinging to their chests, happily munching on roots and bark. And to think I nearly didn't see them right there!

For the next hour, we sat in near silence and watched the family of gorillas in their natural habitat—protected by the dominant silverback. It was an amazing opportunity to reflect on the role we humans must play in their survival. Deforestation and poaching have landed these animals on the endangered species list, but it's treks like these that can help save them. The trips are expensive, but bringing dollars into the community and supporting the local economy help protect mountain gorillas through conservation and by preventing the need for locals to cut down the forest to farm as a means of supporting their families. So as baby gorillas swing from the trees around you, know that your moments spent watching them in the wild is saving them just as much as they're inspiring you.

What to bring

All gorilla treks must be done with a guide and tour company, which will provide a packing list based on the season you're visiting. Bring long pants and long-sleeve shirts in durable fabric, as you'll be hiking through the thick jungle. You'll also want sturdy walking or hiking shoes to best tackle the hilly terrain. And don't forget your rain gear!

Where to go

BWINDI IMPENETRABLE FOREST NATIONAL PARK in southwestern Uganda is home to roughly half the world's population of mountain gorillas. The park is dedicated to protecting the animals as well as maintaining their habitat, especially because mountain gorillas can't survive outside this ecosystem. Along with more than 300 mountain gorillas, you'll see other primates, such as chimps and baboons, as well as more than 400 species of plants and 350 species of birds.

MGAHINGA GORILLA NATIONAL PARK is south of Bwindi along the Uganda-Rwanda border and there are about a dozen mountain gorillas here. The park is also home to other large mammals, such as elephants, buffalo, and leopards, as well as dozens of bird species. The real stars here are another endangered species: the golden monkey. These small primates are known for their vibrant black-and-orange coloring and live in large groups of up to 80 individuals!

Nearby places

Uganda straddles the equator, so head to **KAYABWE** to stand in both hemispheres at the same time. Fun fact: Water drains in opposite directions in the Northern and Southern hemispheres—but drains straight down if you're exactly on the equator! Extend your stay on the African continent by dining with giraffes in **KENYA** (pages 120–121), going on a safari to see the Big Five (lion, leopard, rhino, elephant, and buffalo) in **TANZANIA** (pages 142–145), or taking on a major feat of stamina and resilience by climbing **MOUNT KILIMANJARO** (pages 62–67).

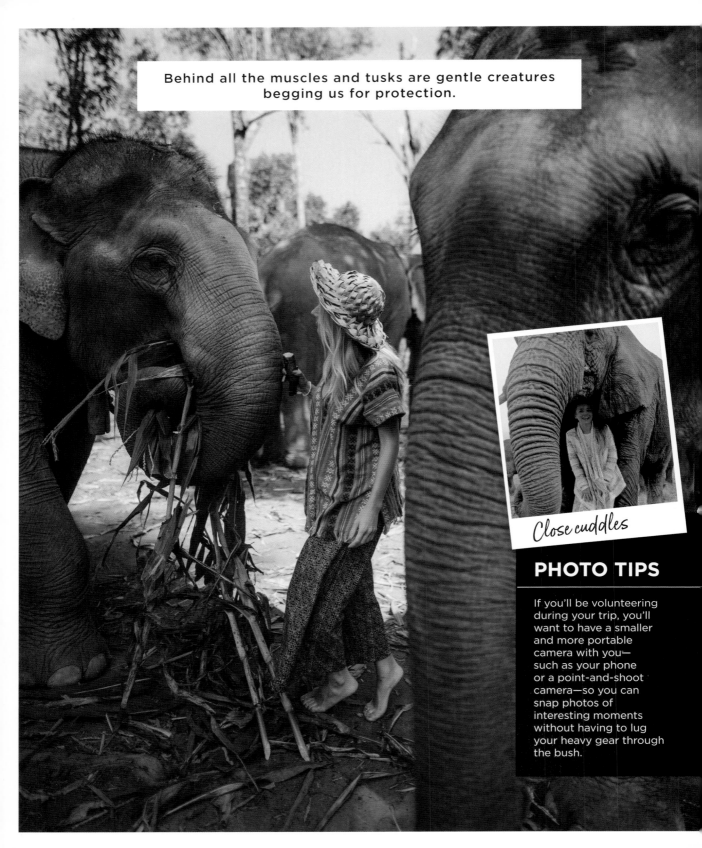

Behind all the muscles and tusks are gentle creatures begging us for protection.

Close cuddles

PHOTO TIPS

If you'll be volunteering during your trip, you'll want to have a smaller and more portable camera with you—such as your phone or a point-and-shoot camera—so you can snap photos of interesting moments without having to lug your heavy gear through the bush.

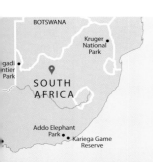

LOCATION: **SOUTH AFRICA**

If you'll be in the north, visit from May to October, when the weather is drier. For trips to the southern and coastal regions, avoid December to February—and the crowds.

What to bring

Pack for the weather and focus on neutral colors that are fit for a game drive, a bush walk, or a day volunteering on the reserve. You'll be spending lots of time outdoors, so opt for lighter technical fabrics and sturdy shoes.

Nearby places

To see more of South Africa's native animals, head to **CAPE TOWN** to see African penguins (pages 132–133). A visit to South Africa is also an amazing opportunity to see even more wildlife up close on a safari through **KRUGER NATIONAL PARK** along the South Africa–Mozambique border or **KGALAGADI TRANSFRONTIER PARK** on the border between South Africa and Botswana.

Where to go

THE KARIEGA GAME RESERVE on the eastern cape of South Africa combines incredible game viewing with conservation volunteer opportunities that allow visitors to see Africa's Big Five (lion, leopard, rhino, elephant, and buffalo) in their natural habitats while also contributing to the animals' survival. Work closely with the reserve's staff to collect data, including mapping elephant movements and tracking their impact on the local vegetation. You'll also get to volunteer at a rural farm school with local children as well as take a dip in the Indian Ocean—just 10 miles away!

ADDO ELEPHANT PARK, north of Port Elizabeth, is the third-largest national park in South Africa and is home to a large elephant population. The park provides them with a safe and protected habitat—and sightings are almost guaranteed during your visit.

Help Save Elephants
IN SOUTH AFRICA

Elephants might be massive and powerful, but beneath that thick and wrinkled skin is a vulnerable and gentle creature that needs to be protected. They're actually a lot like humans, thriving in large herds as they care for one another's young and form deep bonds with their extended families. Poaching has put African elephants on the list of vulnerable species—just one step above endangered status—but thankfully, organizations have formed across the African continent to prevent poaching and help rescue and rehabilitate those elephants that have fallen victim to poachers' guns and darts.

They're some of my favorite animals and I've always been in awe of their grace and beauty. But when I first visited an elephant sanctuary years ago, I was more focused on seeing an elephant up close than on how the animals were being treated. As I traveled more and learned what to look for and which questions to ask, I couldn't believe that some people would harm elephants in the name of profit. Today, we have access to a wealth of information about best practices and which sanctuaries are actually doing good work. It's our duty as travelers to do our research and ensure we're only supporting organizations that are actually helping save these amazing creatures.

When choosing an elephant sanctuary to visit, look for one that's as wild as possible. Any place where you're riding an elephant, for example, means the animals have been trained and domesticated instead of simply being cared for and rehabilitated. Of course, we all want a chance to feed or kiss an elephant, but in the long run, knowing that your entry fee is being used to help the animals instead of training them for entertainment is worth the trade-off of possibly not getting so close.

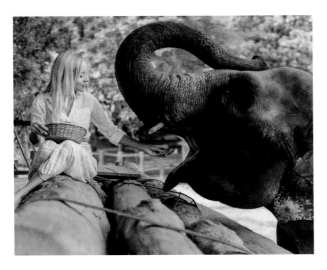

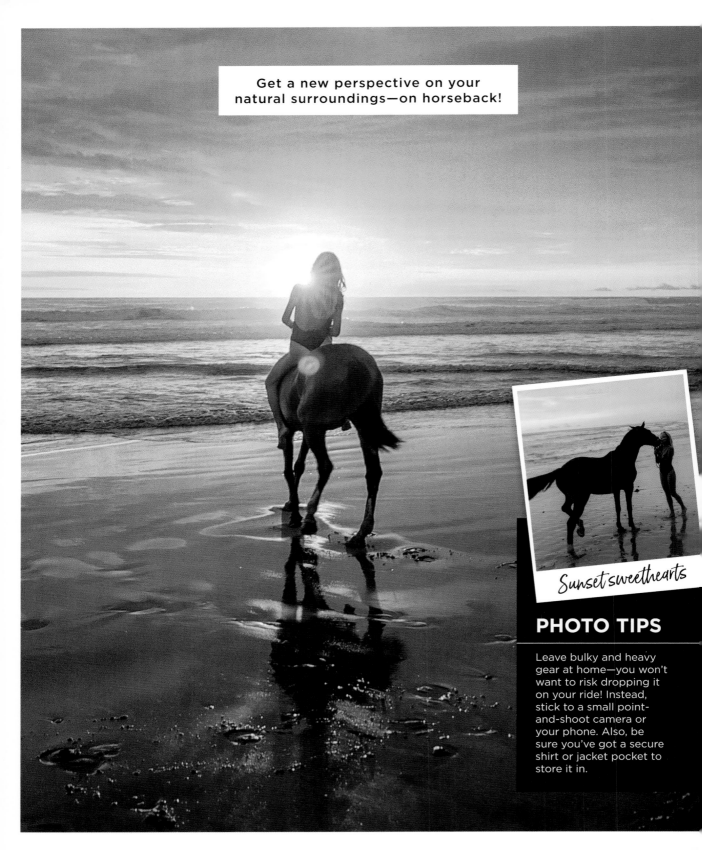

Get a new perspective on your natural surroundings—on horseback!

Sunset sweethearts

PHOTO TIPS

Leave bulky and heavy gear at home—you won't want to risk dropping it on your ride! Instead, stick to a small point-and-shoot camera or your phone. Also, be sure you've got a secure shirt or jacket pocket to store it in.

LOCATION: **SANTA TERESA**
COUNTRY: **COSTA RICA**
December to April is the dry season, but if you're looking to beat the crowds, visit from May to July, when the forests are lush and green.

Ride a Horse at Sunset
IN COSTA RICA

🧳 What to bring

Long pants and closed-toe shoes are a must if you're horseback riding through the jungle as part of your excursion. Choose items you don't mind getting wet, especially if you'll be crossing a river or riding in the surf! If you're just on the beach, swimwear is enough. No matter what tour you go on, be sure to bring a hat, sunscreen, and bug spray.

Nearby places

Costa Rica is an adventure lover's paradise but also has rejuvenating powers that draw travelers from around the world. You'll find activities like surfing, snorkeling, ziplining, and yoga throughout the country, with the **PAPAGAYO** and **NICOYA** peninsulas being the most popular destinations. Looking for wildlife out of the water? Roughly 25% of the country's land area is in protected parks, where you can see everything from the country's native monkeys to sloths and giant turtles. To explore more of this equatorial region, climb the Pacaya volcano in **GUATEMALA** (pages 76–77) or embrace your inner hippie in **TULUM** in Mexico (pages 78–81).

Where to go

SANTA TERESA is on the western coast of the Nicoya Peninsula and this fishing village-turned–vacation destination is famous for its sunsets. It's a charming surf town with soft sand beaches where you just might be able to hop on a horse for a ride through the waves.
LA FORTUNA in north-central Costa Rica is in the shadow of the Arenal Volcano, an incredibly diverse area where rides might take you from waterfalls to cloud forests. Centaura is one of the best-known outfitters in the area, with a huge stable full of well-loved horses and the ability to customize a ride to your ability—whether you're heading out for a half-day ride or a multiday adventure.
PLAYA SAMARA, north of Santa Teresa, is a gorgeous place for a jungle horseback ride that leads to a wide-open beach with shallow waters. Tours here cross rivers, wade through the surf, and take you through forests filled with monkeys and birds to remote beaches where you'll feel like the only ones for miles.

I grew up riding horses and have always loved the way a horseback ride connects you to nature. You're one with the animal, moving and swaying with the horse's rhythm, and have a chance to go farther and get closer to your surroundings than you might on foot. It's about the experience of the ride and not the destination—although in Costa Rica, those destinations are pretty amazing!

On a trip to Santa Teresa, we spent three days watching the rain before the sun finally came out on our last night in town. We headed down to the beach to watch the sunset when a local came by with his horses, leading them through the waves on their way home. He was kind enough to let me climb onto one of his horses. I couldn't have imagined a better way to end my trip than bareback in the water, feeling the heat and muscles of the horse beneath me and watching one of the best sunsets of my life over the ocean.

When you're planning a horseback riding tour, make sure to select a reputable company that takes great care of their animals—and their guests! Many offer a variety of horses paired to your ability and the type of ride you're going on—as well as helmets for less experienced riders—and those extra precautions will make you feel safe and ready for your adventure.

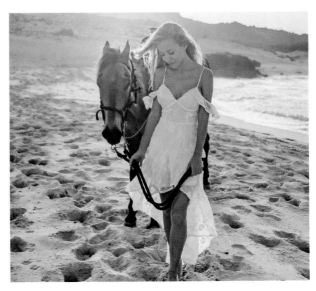

Meet Reindeer (and Santa) IN FINLAND

by Claudia Padgett (@zeebalife)

During the Christmas and festive seasons, tourists from all over the world make the journey to the Finnish Lapland so they can experience the festive spirit. With this and the search for all things Santa Claus also comes the desire to meet Santa's helpers: the reindeer. These beautiful animals that are known as the iconic symbol of the Finnish Lapland populate the region. It's said that there's roughly the same number of people as reindeer in the region! Before your encounter with these beautiful creatures, it's best to be prepared because there are many options you (and the little ones) can choose from, such as reindeer sleighing, visiting a reindeer farm, and even meeting the Sami—Finland's indigenous people—and their reindeer.

From my personal experience, the latter is the most conscious option of them all and the one I'd recommend because most highly touristic activities, such as reindeer sleighing, tend to be physically exhausting for the animals and it's done for pure entertainment. Some hotels also have their own "pet" reindeer for the convenience of the guests and at times, as I learned while I was there, at the expense of the well-being of the animal. In contrast, the Sami, following their traditional and cultural ways, tend to feed and care for the animals—whether it's their own reindeer or wild ones—and they also focus on their overall well-being. Plus, you also get to learn more about the Sami culture and their way of life.

Although it's a year-round destination, Finland is particularly most popular during its winter months. Bracing the winter is part of the experience, and believe it or not, once you see this winter wonderland and all it has to offer, you might not forget about the below-freezing temperatures, but the adrenaline will help keep you warm and in a festive mood!

LOCATION: **ROVANIEMI**
COUNTRY: **FINLAND**
The best (but most popular) months to visit are December and January, although February and March are also highly recommended.

Where to go

ROVANIEMI is a small city located in northern Finland that's not only an iconic winter destination that has made it to many travelers' bucket list, but it's also the official hometown of Santa Claus. When it comes to lodging here, you certainly have a great variety of options—from a traditional winter cabin to a glass igloo and even an arctic treehouse. Yes, a treehouse in the middle of a winter wonderland! Definitely an experience to add to the books and tick off the bucket list, especially if you're able to take a dip in your own Jacuzzi and sip on hot chocolate while it's snowing and it's –20°C (–4°F) outside.

Nearby places

From anywhere from 90 minutes to 4 hours, you can be in Helsinki, Stockholm, Oslo, Copenhagen, St. Petersburg, or Moscow. There are no shortages of experiences to have in these major cities. But Rovaniemi itself has plenty to offer: the aurora borealis, the iconic Rovaniemi city library, and the **ROVANIEMI ART MUSEUM** and the **ARKTIKUM SCIENCE MUSEUM**. If you're looking for something more adventurous, walk across the **LUMBERJACK CANDLE BRIDGE** (Jätkänkynttilä) to the **OUNASVAARA MOUNTAIN**, which offers trails for running, cross-country skiing, biking, and soaking up the nature around you.

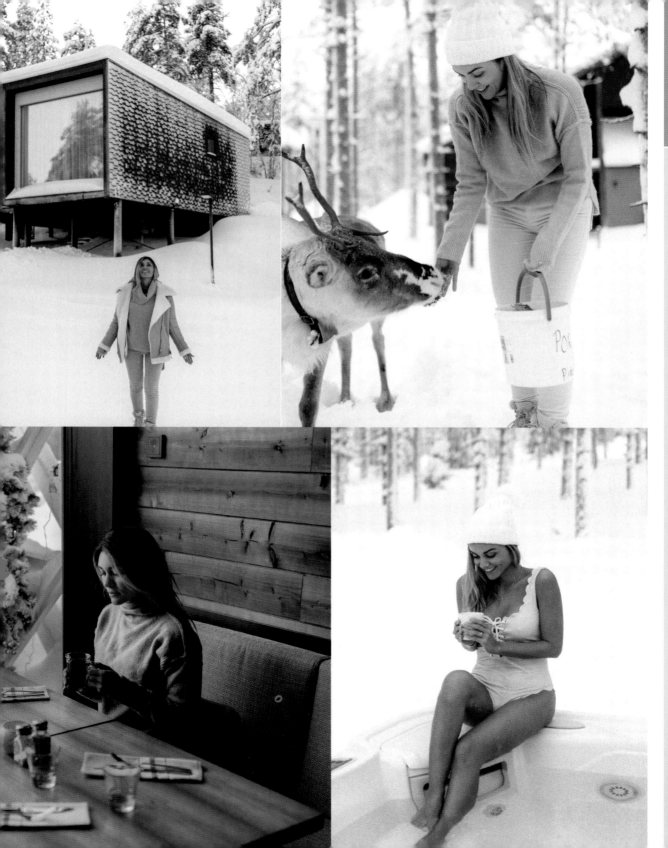

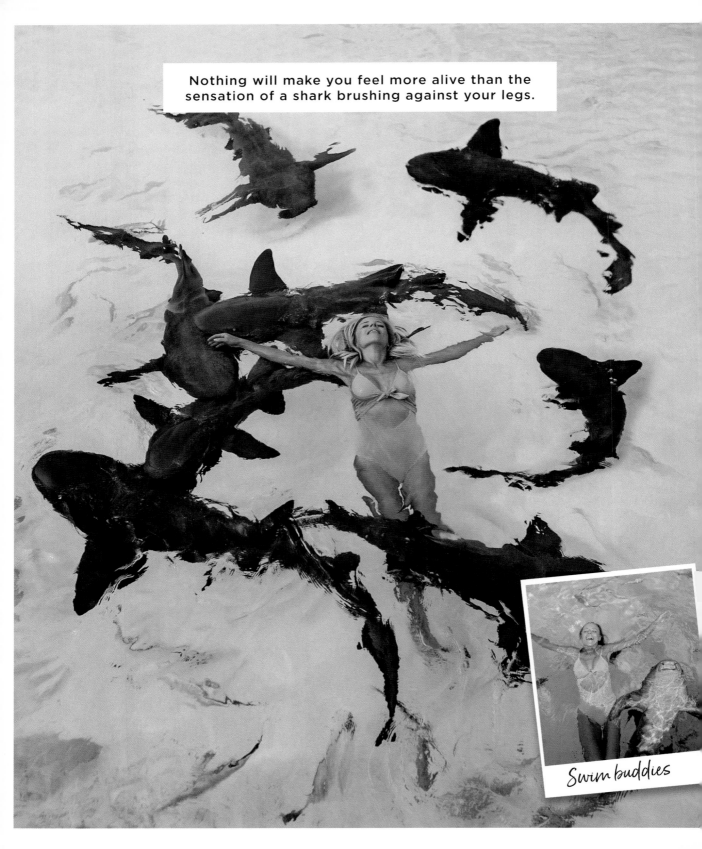

Nothing will make you feel more alive than the sensation of a shark brushing against your legs.

Swim buddies

THE BAHAMAS

Grand Bahama

• Nassau

• Exuma Cays

CUBA

🧳 What to bring

Besides a bathing suit and rashguard (most tours discourage the use of sunscreen, as it can be harmful to the sharks), what you'll really need to bring is your courage!

Nearby places

The Bahamas are also known for pristine beaches, warm sun, and a laid-back vibe that's perfect for relaxation. Head to Exuma for an adorable romp at **PIG BEACH** (pages 140–141). Visit **ELEUTHERA** for serious, remote romance or stick to **NASSAU** for high-end luxury and world-class restaurants. The Bahamas are just north of Cuba, so be sure to book a few days in **HAVANA** (pages 102–103)—and remember to order a daiquiri!

PHOTO TIPS

For an epic Instagram shot that's half in and half out of the water as sharks swim around your legs, pack a GoPro with an underwater casing or a camera with a bubble lens.

LOCATION: **GRAND BAHAMA, EXUMA & NASSAU**
COUNTRY: **THE BAHAMAS**
December to April is prime tourist season, but it's also the best time to avoid the hurricane season.

Where to go

COMPASS CAY in the Outer Exumas is home to nurse sharks, mild-mannered animals that will swim slowly and gracefully around you—whether you're wading up to your knees or have donned a snorkel and mask.

TIGER BEACH on Grand Bahama Island has gorgeous white sand as well as populations of tiger sharks, Caribbean reef sharks, lemon sharks, and hammerheads. Deeper water makes this area more popular with scuba divers, although the crystal-clear water means you can also easily see the prehistoric animals from the surface.

STUART COVE on Nassau is a great place for an educational experience, where guides pair shark diving with shark awareness and a chance to learn about shark behavior and habitats.

There are many other areas where you can put on a snorkel and mask to really swim with the sharks as they feed below you or even don scuba gear for a deeper dive with hammerheads. Whether they're large or small, when you're swimming with dozens of sharks, you'll have a thrill you won't forget!

Swim with Sharks
IN THE BAHAMAS

Sharks are some of the most feared and misunderstood animals on the planet. Yes, they can be ferocious and dangerous—particularly when their habitats are being disrupted and they feel threatened—but the temptation to swim with them can be hard for adrenaline junkies to resist.

If getting into a cage surrounded by great whites isn't your thing, though, book a trip to Exuma in the Bahamas instead. There, massive and aggressive sharks are replaced by their more docile and gentle counterparts: schools of nurse and reef sharks that swim in shallow water, peacefully searching for something to eat as groups of vacationers wade through the knee-deep surf. They still have sharp teeth, but because these whales are about six or seven feet long, they're not nearly as scary.

During my trip to Exuma, I was impressed by how much the locals care about these animals. We were let into the water in small groups so we wouldn't overwhelm them and only allowed to be in the water for about 20 minutes to give the sharks their space. Even that short time was long enough to feel their coarse skin against my legs as they swam past—I was definitely freaked out the first time a shark brushed up against me!

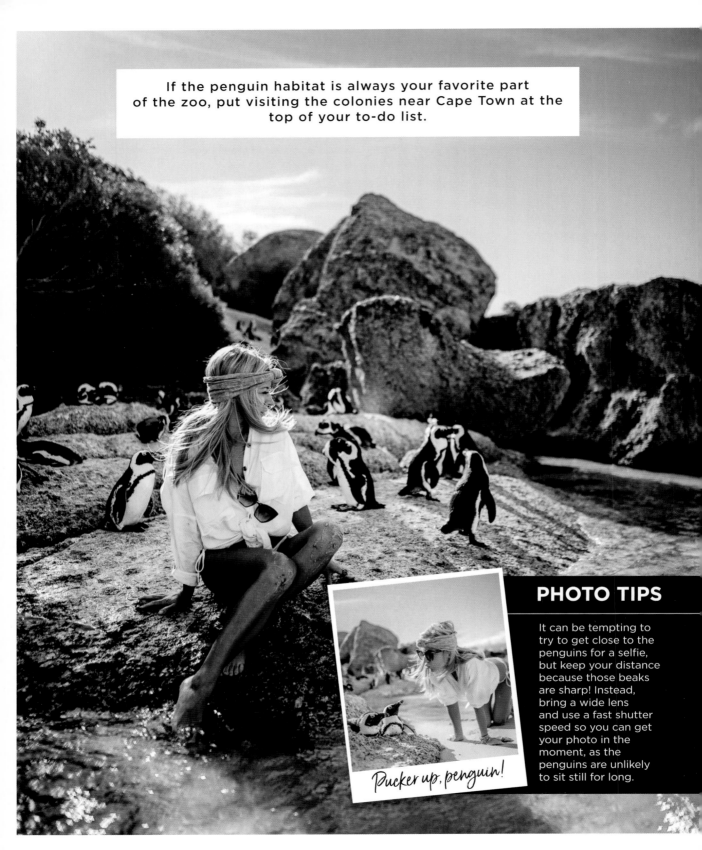

If the penguin habitat is always your favorite part of the zoo, put visiting the colonies near Cape Town at the top of your to-do list.

PHOTO TIPS

It can be tempting to try to get close to the penguins for a selfie, but keep your distance because those beaks are sharp! Instead, bring a wide lens and use a fast shutter speed so you can get your photo in the moment, as the penguins are unlikely to sit still for long.

Pucker up, penguin!

LOCATION: **BOULDERS BEACH & BETTY'S BAY**
COUNTRY: **SOUTH AFRICA**
January to May is the best time to see penguins. You can see chicks hatch in the fall, from March to May.

What to bring

Because the best time to see penguins is in late summer and into fall, be sure to pack layers, especially because there are usually more penguins on the beach in the afternoon and early evening.

Nearby places

While in Cape Town, you can stay in a **ZULU VILLAGE** (pages 112–113) or interact with elephants (pages 124–125). Don't miss the opportunity to go wine tasting in **STELLENBOSCH** and foodies will love exploring the restaurant scene. Head to **KRUGER NATIONAL PARK** or the **SERENGETI** (pages 142–145) for a safari.

Where to go

BOULDERS BEACH is just south of Cape Town, on the eastern coast of Table Mountain National Park. Here, a colony of around 3,000 African penguins nest and mate, heading out into the bay to fish and returning to shore to feed their young. This park features elevated boardwalks that allow visitors to get close to the animals (especially along Foxy Beach) without disturbing their habitat.

BETTY'S BAY is across False Bay from Boulders Beach and includes a protected marine area that opens up to the ocean from Stony Point Nature Reserve. The colony is slightly smaller than that of Boulders Beach, but the more remote location also means fewer visitors, so you just might have the boardwalk to yourself.

Get to Know The Penguins OF SOUTH AFRICA

You might think penguins stick to cold climates and icy waters, but there are actually a few species who call warmer areas home—including African penguins along the Namibian and South African coasts. At only 2 feet tall and less than 8 pounds, these endangered birds are much smaller than their Antarctic relatives. (For example, emperor penguins are 4 feet tall and can weigh 50 to 100 pounds!) They have a distinct braying call that earns them the affectionate nickname of "jackass penguins"—and it's surprisingly accurate!

When I first heard I could visit a penguin colony in South Africa, I couldn't believe it. I was shocked when I made my way down to the beach at Boulders Bay and saw hundreds of penguins around me. It was amazing to see these spirited creatures in the wild instead of behind the glass at a zoo. You really get a sense of their personalities, as some are loud and busy, while others are relaxed and can't be bothered by the humans peering at them from all directions.

These birds might be small, but they're feisty! You can see them from the boardwalk as well as from the beach, and if you get too close, they'll try to bite you and will chase you off. They hang out on the beach, building nests and laying eggs in the sand and heading into the surf to fish.

My friends and I headed farther along the beach than most visitors do, hoping to find a more secluded cove where we could see the penguins without too much distraction. We did our best to keep our distance and even swam back through the chilly water instead of walking along the beach to our car to give them an extra wide berth. So while I expected a sweet interaction with a friendly seafaring bird, I instead added "Get chased by a penguin" to my bucket list—and promptly crossed it off!

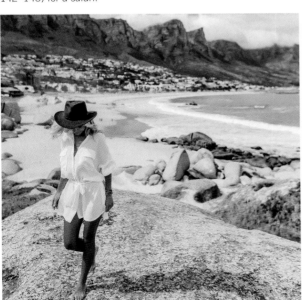

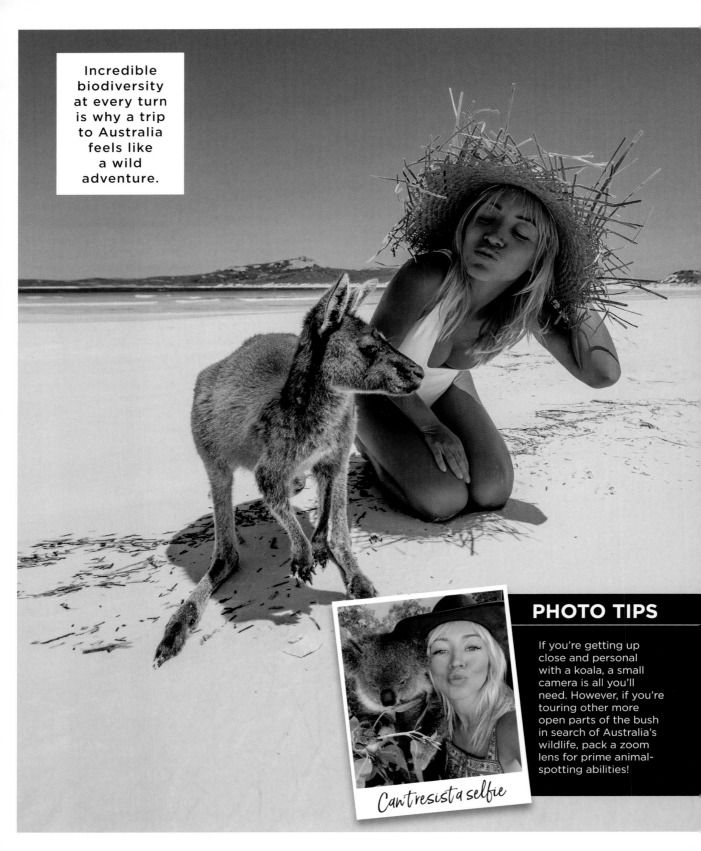

Incredible biodiversity at every turn is why a trip to Australia feels like a wild adventure.

Can't resist a selfie

PHOTO TIPS

If you're getting up close and personal with a koala, a small camera is all you'll need. However, if you're touring other more open parts of the bush in search of Australia's wildlife, pack a zoom lens for prime animal-spotting abilities!

LOCATION: **AUSTRALIA**
Seasons in Australia are the opposite of those in the Northern Hemisphere, but the continent is so large that the climate varies greatly no matter when and where you go.

Where to go

LONE PINE KOALA SANCTUARY is the place to go
if your goal is to cuddle a koala, with about 130 of the animals living on the property as part of their rescue and protection efforts. The sanctuary is also home to roughly 100 of Australia's native species, including platypuses, kangaroos, Tasmanian devils, dingoes, echidnas, and crocodiles as well as such birds as emus and kookaburras.

KANGAROO ISLAND in
southern Australia boasts five conservation parks and wildlife protection areas devoted to preserving the island's natural habitat. Head here if you'd like to see the Kangaroo Island kangaroos, bandicoots, wallabies, brushtail possums, Australian sea lions, and long-nosed fur seals.

ALICE SPRINGS DESERT PARK will give you a different
perspective on Australian wildlife. Located in central Australia, the park is all about life in the desert and is the perfect place to see thorny devils, barking spiders, wedge-tailed eagles, and other desert dwellers.

PHILLIP ISLAND NATURE PARK near Melbourne is home
to an animal you might not expect to see in Australia: penguins! Phillip Island is home to a colony of little, or fairy, penguins, averaging 13 to 17 inches in height. Every evening at sunset, they return to shore and the safety of their burrows, putting on an absolutely adorable parade!

What to bring

Most animal sanctuaries are funded by visitors, so consider bringing extra money to make a donation in addition to the cost of entry. You'll be helping to preserve Australia's native wildlife and protect the animals from hunting and invasive species.

Nearby places

Australia is massive and one of the best ways to see it is by car. See pages 90–91 for one of my favorite road trip itineraries! Once you've made your way up to Queensland, get out on the water and go snorkeling or scuba diving on the **GREAT BARRIER REEF** (pages 26–27). Or if you're in the mood for a little more time in a big city, be sure to visit **SYDNEY** and **PERTH**. They have two totally different vibes—Sydney is more cosmopolitan (although there's Bondi Beach; see pages 36–37), while Perth is more laid-back and outdoorsy.

See Native Wildlife
DOWN UNDER

I've taken countless photos throughout my travels, but none will ever compare with taking a selfie with a koala. While I lived in Australia for years studying in Sydney, it wasn't until a trip to the Lone Pine Koala Sanctuary in Brisbane that I got a chance to meet one of these adorable little creatures up close. The sanctuary is also home to kangaroos, dingoes, platypuses, and pythons—but what you're really there for is the koalas.

While it can be tempting to give the koalas a squeeze, listen carefully to the conservationists and instead create a cozy shelf where the koala can snuggle in and hug *you* instead of the other way around. Their bones are quite fragile, so a big hug can actually cause grave injuries to these protected animals. So open your arms, be gentle, and prepare to enjoy an experience like no other.

Koalas aren't the only animals roaming Australia—and some are doing so in huge numbers. Just like you might see deer at every turn in the United States, there are a massive number of kangaroos throughout Australia. They're everywhere—from remote habitats to populated suburbs—and they outnumber humans two to one! In fact, the population is so large that at the meat counter in grocery stores, kangaroo meat is more affordable than beef—and it's worth a taste if you have the chance. Just don't try to hug one because their reputation as excellent boxers isn't a myth.

Another animal you might be surprised to see on the sidewalk is an ostrich. Ostriches were brought to Australia from Africa and some have escaped their farms and established a feral population that spans much of the continent. During a trip to Broome on Australia's northwestern coast, I was headed to the market and felt like I was being followed by someone. When I turned around, I couldn't believe it was a massive 250-pound bird!

With Australia covering nearly 3 million square miles, it's no surprise the continent is home to a massive variety of native species—from aggressive saltwater crocodiles and deadly spiders to laughing kookaburras and petite wallabies. They're everywhere you look, so keep your eyes peeled!

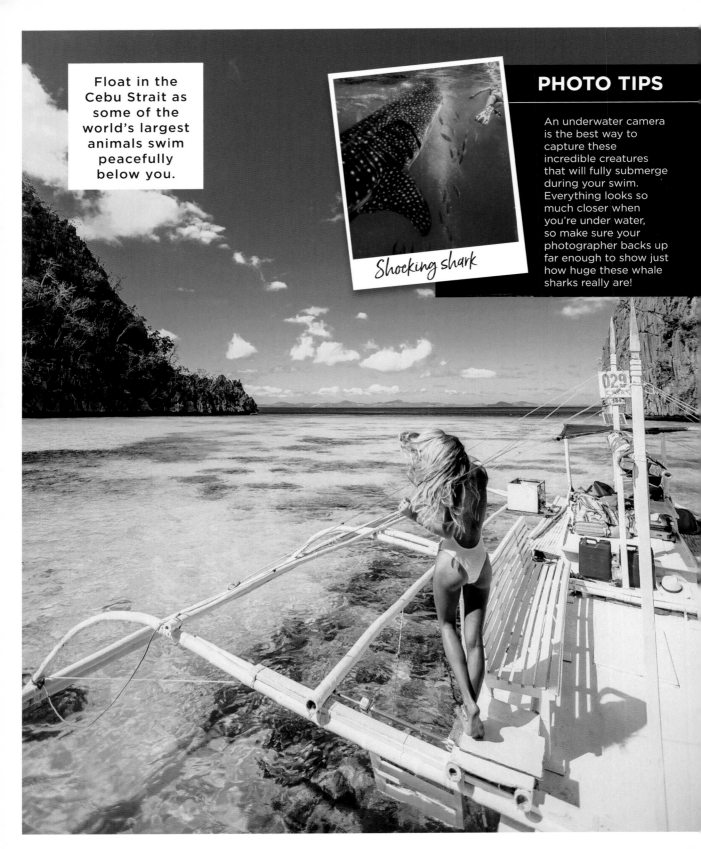

Float in the Cebu Strait as some of the world's largest animals swim peacefully below you.

Shocking shark

PHOTO TIPS

An underwater camera is the best way to capture these incredible creatures that will fully submerge during your swim. Everything looks so much closer when you're under water, so make sure your photographer backs up far enough to show just how huge these whale sharks really are!

LOCATION: **OSLOB, CEBU**
COUNTRY: **PHILIPPINES**
Whale shark migration is still a mystery, but you can spot them from November to June, with peak sightings from February to April.

Swim with Whale Sharks
IN THE PHILIPPINES

Where to go

OSLOB is on the island of Cebu, centrally located in the island chain. Here, a community-based dive company partners with the local government to get tourists near the whale sharks while also helping protect local aquatic life (including, of course, the endangered whale sharks) and lift the community out of poverty. If the idea of swimming with an animal that's on average 32 feet in length is a little intimidating, head to Barangay Tan-awan to watch the whale sharks from the fishing village's shore.
DONSOL BAY on southwestern Luzon is another leader in sustainable ecotourism. Snorkeling tours here are strictly regulated, meaning you'll have less of an impact on the whale sharks while still getting to see them up close.

Whale sharks are filter-feeding sharks with hundreds of tiny teeth that are much less ferocious than their hunting cousins and they're the largest living nonmammalian vertebrate at an average 32 feet in length. Small groups of swimmers can join tours around the Philippines for the opportunity to swim with these incredible creatures, floating and snorkeling in the water as the whale sharks socialize and eat below you.

I couldn't believe just how massive these animals are in person and was blown away by how stunning their speckled markings are through the clear blue water. I was also moved by how gentle and graceful whale sharks are, especially for their size. In fact, they might even investigate you and your companions while you're in the water! Don't be afraid—just keep your arms and legs to yourself and let them continue on their way.

Swimming with whale sharks has had a significant impact on the conservation of these animals, but the jury is still out on whether it's the best way to prevent them from going extinct, so do your research and use your best judgment. And if you do find yourself in the Philippines surrounded by some of the largest animals on Earth, admire them from afar and follow the rules!

What to bring

Preserving these endangered whales is of the utmost importance, so sunscreen isn't allowed. Wear a rashguard or long sleeves to protect yourself from getting a sunburn! I'd also recommend bringing snorkel gear, as some of the dive companies don't have the newer, higher-quality equipment.

Nearby places

Swimming with whale sharks might just inspire you to do a little more scuba diving. Head to **MANTA BOWL** in Donsol to see another incredible underwater creature: the manta ray, which gives the area its name. (They can also be seen in **MOOREA**. See pages 138–139 for more.) The area around **LUZON** is also home to amazing wreck dives, where fish gather around wrecked ships and planes from World War II. The Philippines is made up of thousands of islands and they each have their own distinct feel. So if you're looking for amazing diving or the most laid-back beach, do a little island-hopping (pages 48–51)!

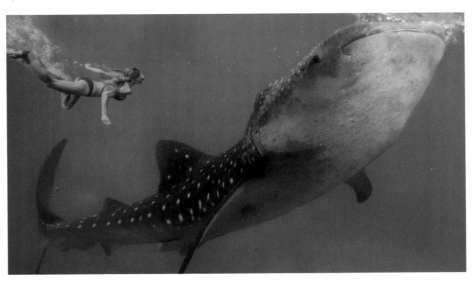

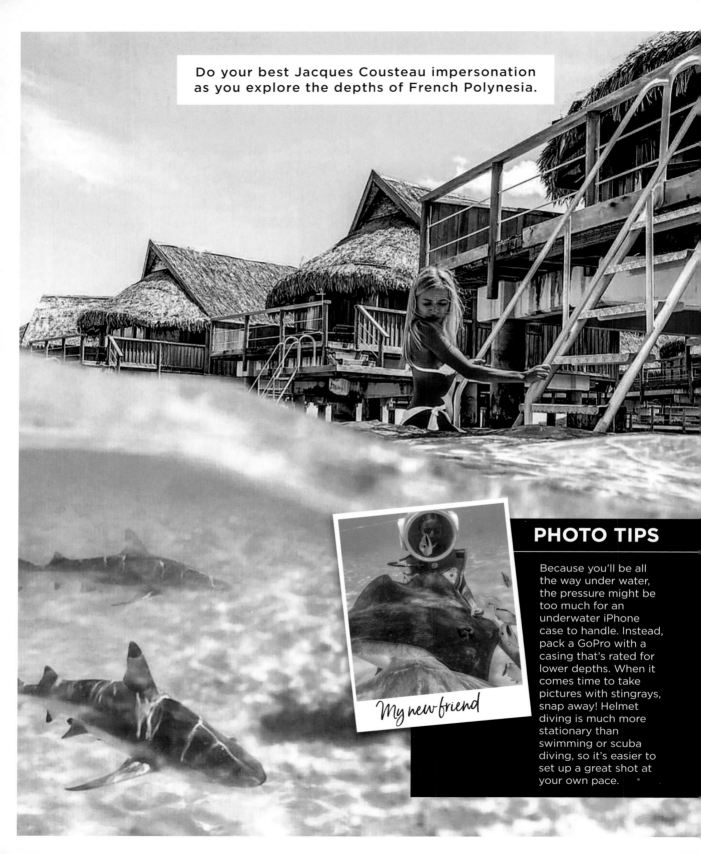

Do your best Jacques Cousteau impersonation as you explore the depths of French Polynesia.

My new friend

PHOTO TIPS

Because you'll be all the way under water, the pressure might be too much for an underwater iPhone case to handle. Instead, pack a GoPro with a casing that's rated for lower depths. When it comes time to take pictures with stingrays, snap away! Helmet diving is much more stationary than swimming or scuba diving, so it's easier to set up a great shot at your own pace.

What to bring

If you're planning to go helmet diving, all you need is a little bit of courage and your bathing suit! It's incredibly safe—our guide had recently taken an 88-year-old on a dive!—and it's the perfect way for those who don't love to swim to experience life at the bottom of the ocean.

Nearby places

Once you're in French Polynesia, paradise is at your fingertips. While on Moorea, learn about local culture at the **TIKI VILLAGE** and hike through the jungle for an incredible view at **BELVEDERE LOOKOUT**. On Tahiti, hike to the **THREE WATERFALLS** or watch expert surfers navigate incredible waves at **TEAHUPO'O**. In Bora Bora? Embrace the romance and check into an overwater bungalow with your significant other (see pages 46–47). No matter which island you choose, keep an eye out for some of my favorite **BLACK SAND BEACHES** (see pages 44–45)!

LOCATION: **TAHITI, MOOREA & BORA BORA**
COUNTRY: **FRENCH POLYNESIA**
April to October is the best time for diving: Dry weather means calm waters and smaller waves.

Where to go

An island nation in the South Pacific, French Polynesia is a must-visit destination for anyone curious about the mysteries of the oceans that surround us. The 118 islands and atolls stretch across more than 1,000 miles, with volcanic coastlines, coral reefs, and white sand lagoons inviting all sorts of ocean life to make themselves at home.

TAHITI is a diver's paradise, where excursions frequently lead to sightings of hawksbill and loggerhead sea turtles, stingrays, eagle rays, and several species of sharks. If you'd rather stay on the boat than get in the water, visit from mid-August to the end of October to see pods of migrating humpback whales.

MOOREA is one of the best places in the region to swim and snorkel with stingrays, at Opunohu Bay and Cook's Bay. Tours range from beginner (helmet diving) to advanced (scuba), but all will get you up close and personal with these majestic creatures.

BORA BORA is just 45 minutes by plane from Moorea and it's worth a flight if you want to see large and dramatic manta rays, which can reach around 20 feet in width. (Stingrays, on the other hand, tend to be just a few feet wide in this part of the world.)

Enjoy the Life Aquatic
IN THE SOUTH PACIFIC

In some of my scuba and snorkeling adventures, I'd spotted visitors going helmet diving and had to try it for myself. Instead of a scuba tank or a mask, you put on a bubble-shaped helmet that's connected to an above-water air supply. You can breathe normally and your hair even stays dry and the weight of the helmet helps you sink to the bottom so you can walk along the sand.

In Moorea, we had a chance to interact with stingrays as they rubbed up against our legs. They're curious animals, so our guide didn't even have to feed them to get them to come investigate us—a humane alternative that I was happy to support. With our helmets on, we were able to get that same immersion you get from scuba diving but without the training or extra work. Even my mom, who isn't much of a swimmer, loved being able to feel comfortable under the surface. Moving through the water felt like a slow and deliberate pace. The stingrays didn't seem to mind—and as long as you remember to let them come to you instead of going after them, it's incredibly safe!

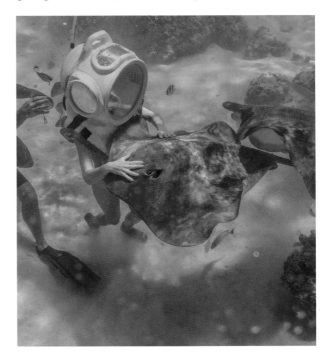

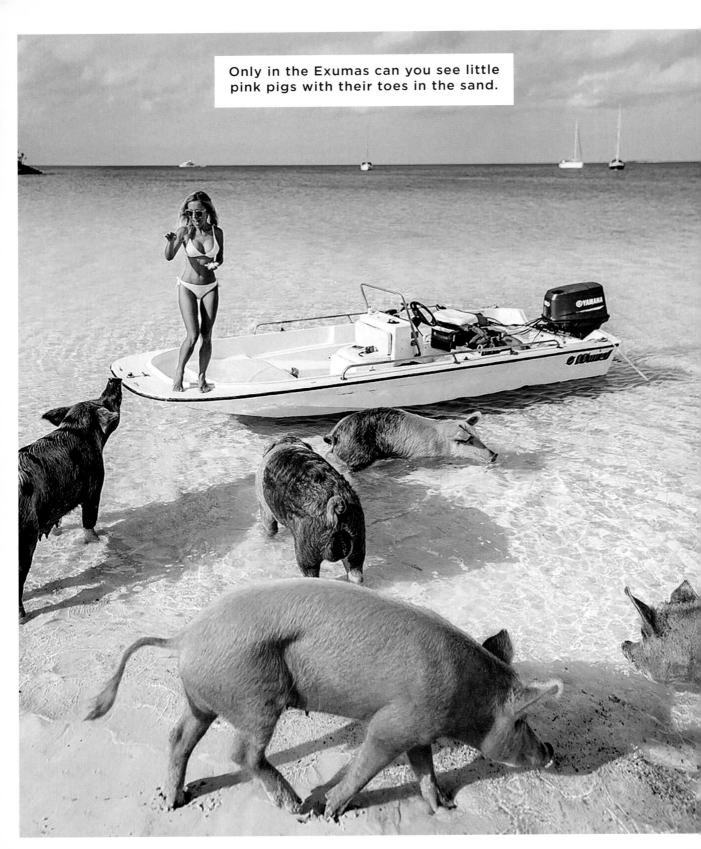

Only in the Exumas can you see little pink pigs with their toes in the sand.

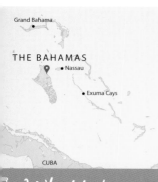

THE BAHAMAS
• Nassau
• Exuma Cays

CUBA

Spend a Day at the Beach with Pigs IN THE BAHAMAS

LOCATION: **THE EXUMAS**
COUNTRY: **THE BAHAMAS**

The Exumas welcome visitors year-round, but November to April are most popular. Avoid the rainy hurricane season from June to November.

Where to go

BIG MAJOR CAY, also known as Pig Beach, is one of the 365 islands that make up the district of Exuma. This uninhabited island is home to an adorable clan of feral pigs (including the cutest swimming piglets you've ever seen!). Tours tend to run from around 9 a.m. to sunset—but arrive early to beat the rush!

WHITE BAY CAY is also home to feral pigs, and while it might not be the original Pig Beach, you won't know the difference once you're in the water! This beach is said to be less crowded, most likely because it's a longer boat ride from Great Exuma.

Nearby places

If you're interested in interacting with actual seafaring creatures—and are feeling brave!—head to **COMPASS CAY** or **TIGER BEACH** to swim with sharks (pages 130–131). Rather keep your feet on dry land? Book a tour to Pig Beach that also includes a stop at **ALLEN'S CAY** to see the Bahamian rock iguanas. The Exumas aren't all the Bahamas have to offer either! **HOPE TOWN**, in the Abacos, is home to the Elbow Cay Lighthouse and streets lined with pastel-hued historic homes, while nearby **FIDDLE CAY** hosts the annual Cheeseburger in Paradise beach party, where partygoers boat-hop and sip margaritas as an ode to Jimmy Buffett.

Pigs swimming might sound as improbable as pigs flying, but that's exactly what the piggy population of the Bahamas does—and it's just as cute as it sounds. The pigs are definitely not native, although their origins are unclear. Some say sailors left them behind, while others are sure an owner of a nearby island put them on Big Major Cay to keep the stench away from his house and the population grew from there.

The only way to visit these islands is with a tour, which helps control the number of visitors each day. The captains make sure everyone is being respectful and keep an eye out for the resident piglets. While it's tempting, you shouldn't pick them up—the babies don't like it and their mothers will let you know about it!

We arrived early in the morning and were the first boat to pull up to the beach. In fact, we were so early that most of the pigs were still fast asleep in the sand! But once they realized we'd arrived, they hightailed it into the water, knowing full well that whoever got to our boat first would get first dibs on the food. We spent a few hours on the beach, watching the pigs from the sand and snorkeling in the shallows as they swam alongside us. It was a day at the beach unlike any other and I don't think I've ever had so much fun checking something off my bucket list!

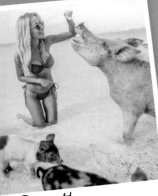

What to bring

It might be tempting to bring treats for the pigs, but leave the snacks at home! The captains of each tour bring fruits, vegetables, and other treats to keep the pigs well fed. However, you might want to bring a snorkel so you can get a peek at their little hooves paddling under the surface!

Pig out!

PHOTO TIPS

A bubble lens is the best way to get a photograph of the pigs as they swim toward you in the shallow waters, capturing their nostrils above the surface searching for snacks and their hooves below.

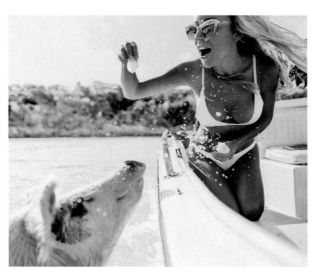

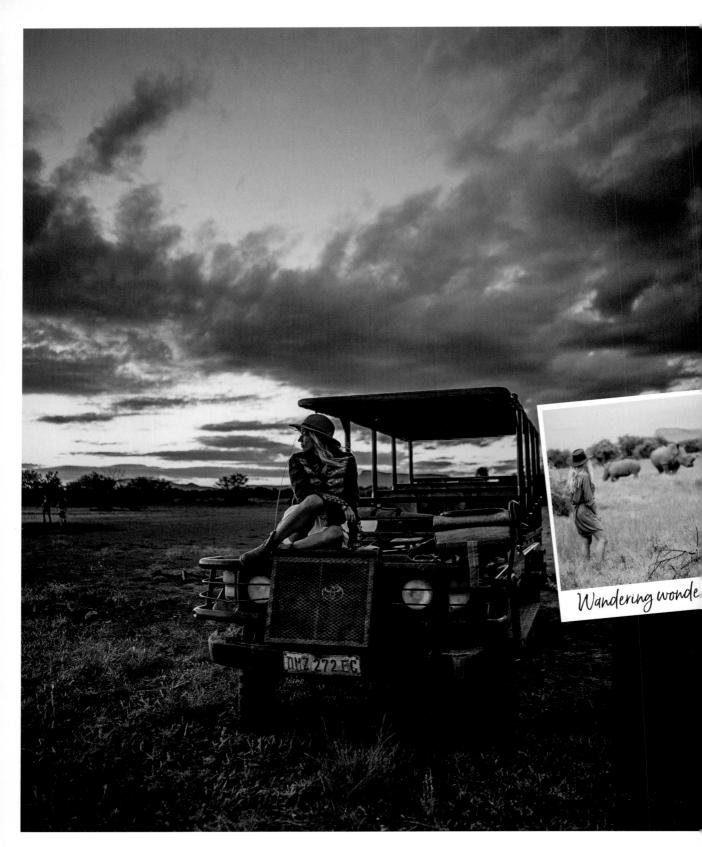

Wandering wonde

What to bring

You'll want to wear neutral colors so you don't stand out against the plains—but leave the camouflage at home, as this print is actually illegal in some areas! Game drives take place in the early morning and late afternoon, so lots of layers (and even a hat and jacket!) are a must as temperatures rise and fall.

PHOTO TIPS

Bring your best zoom lens as you search for animals along the plains. It can be useful for photos, of course, but also as binoculars. The animals blend in with their surroundings (it's how they survive, after all!), so getting your images focused is of the utmost importance. Embrace the fact that you won't be getting a selfie with an elephant. Instead, snap a few good photos and then put down your camera and just look around—it's so much more impressive in person that it is on a screen, even if there are tens of thousands of animals migrating past you!

LOCATION: **SERENGETI NATIONAL PARK**
COUNTRY: **TANZANIA**
The Great Migration is millions of animals making their annual journey in search of food, water, and survival.

Where to go

While the exact timing varies every year, you'll find the massive herds in northern Tanzania from December to March as babies are born, in the southern Serengeti in June during mating season, and in the Mara Plains of Kenya from September to November before they head back to Tanzania to give birth after the rains begin.

NGORONGORO CRATER is where to be from January to March, especially if you'd like to see baby zebras. It's peak foaling season and the southern Serengeti's short grass plains are ideal habitats.

SERONERA RIVER VALLEY in the central Serengeti is full of life in April and May, when floodwaters and animals alike pour into the region.

GRUMETI RIVER VALLEY is an amazing place to watch the herds cross the river in the western corridor and head north as the dry season begins. The timing of the migration's arrival can be iffy (although it's often around June), but you'll also see crocodiles, hippos, and elephants that call this area home year-round.

LOBO VALLEY in the northern Serengeti is where you'll see the herds from July to October before they head into the Mara in Kenya. Animals will cluster around water sources, making them easy targets for big cats, such as lions, cheetahs, and leopards, so this season can be particularly gory.

Go on a Safari to See the
Great Migration
IN TANZANIA

Nothing comes close to seeing the animals of Africa in their natural habitat. Can it be scary? Of course it can—especially when there's a herd of buffalo outside of your tent at 1 a.m. or a lion napping under your vehicle and preventing you from moving until he wakes up. But we as humans *should* be the ones who are scared! These incredible creatures occupy a grand and immense part of our planet, and we should be the ones to journey to see them. It's a humbling experience that reminds you just how vulnerable we are as well as how hard we need to work to protect the life that surrounds us.

The Great Migration across the Serengeti is that iconic safari experience—and with good reason: Millions of animals make their way through northern Tanzania and southern Kenya every year in search of a safe place to birth their young as they follow changing food and water sources. It's a massive open plain, and if you can time it right, those barren grasses might instead be filled with more animals than you've seen in your entire life.

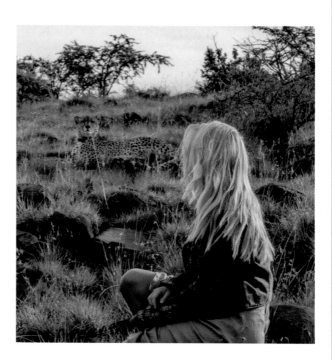

There are so many ways to experience the power of the Serengeti on a safari—whether you're taking a bush walk behind a guide in search of a family of warthogs or camping along the rim of the Ngorongoro Crater so you can watch one of the most incredible sunrises you'll ever see. Do your research to find a talented guide and a reputable agency that are devoted to the well-being of this complex ecosystem and its animal inhabitants. You'll be rewarded with spectacular memories, insightful knowledge, and a sense of fulfillment that comes along with both understanding just how vast and mighty our world is and knowing you've played a part in protecting it.

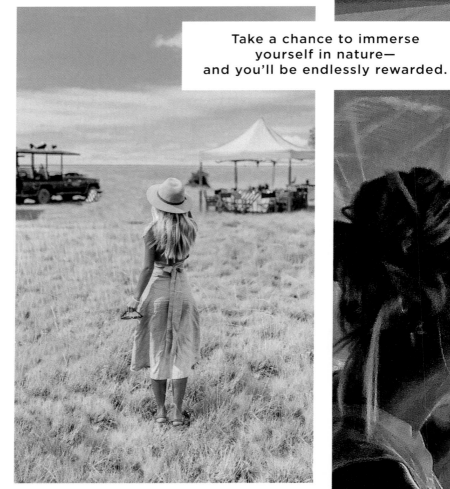

Take a chance to immerse yourself in nature— and you'll be endlessly rewarded.

Nearby places

A visit to the **ORIGINAL MAASAI HOTEL** (pages 106–109) is an amazing addition to a trip to Tanzania. If you're looking to test yourself physically and mentally, spend a week climbing **MOUNT KILIMANJARO** (pages 62–67) before indulging in some R&R on the beach in **ZANZIBAR**. For an up-close-and-personal animal experience, head north from the Serengeti to Giraffe Manor in **NAIROBI** (pages 120–121) or journey west to **UGANDA** to track mountain gorillas (pages 122–123). Africa is a vast continent, so flying from place to place is your best bet.

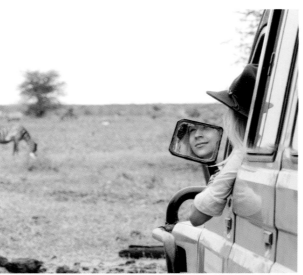

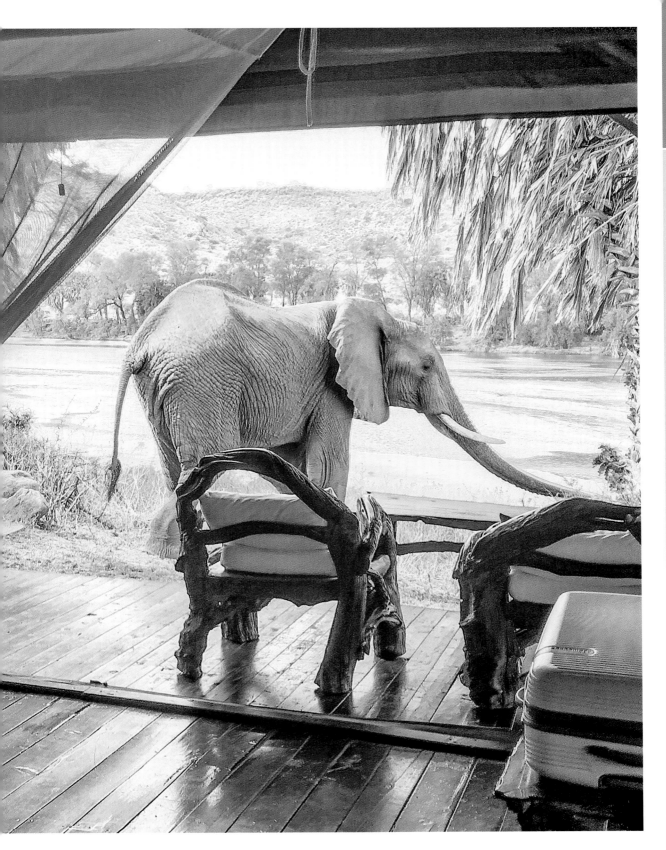

city
experiences

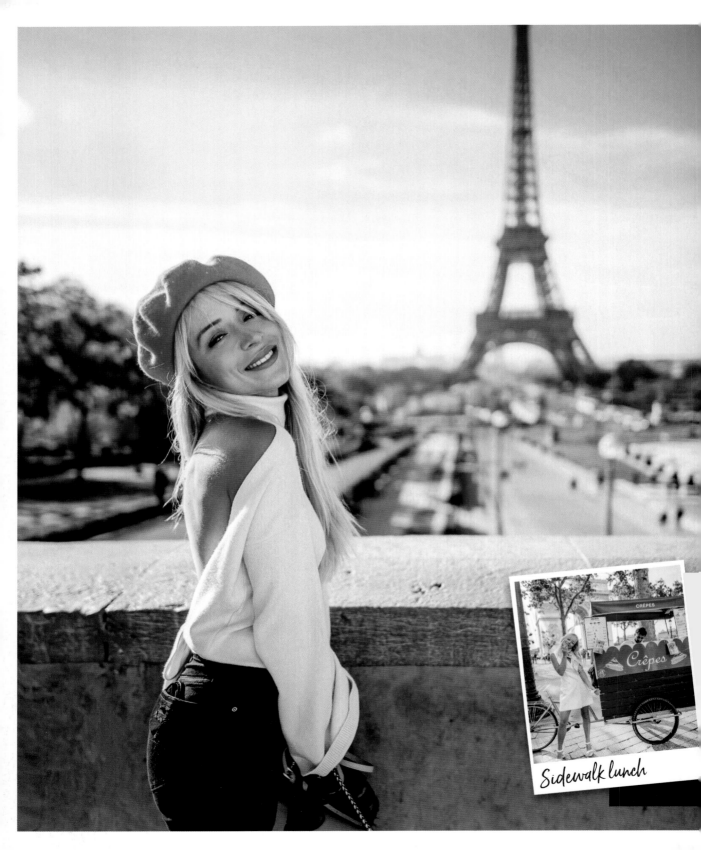

Sidewalk lunch

BELGIUM
GERMANY

PARIS
Giverny
Versailles
Champagne

Loire
Valley
SWITZERLAND

FRANCE
ITALY

Paris when it sizzles (summer) isn't as ideal as Paris in the springtime. But you'll always remember Paris no matter when you go.

Where to go

More than the capital of France, Paris is a global epicenter of art, fashion, food, and culture—not to mention romance! These places spotlight the diversity of the city—and how beautiful it is.
CHAMPS-ÉLYSÉES is where window shopping is the best way to get a feel for the city's sense of fashion. Nothing beats peeking in the high-end boutiques along the avenue, with the Arc de Triomphe sitting proudly at the northeastern end.
MONTMARTRE is a haven for artists and tourists alike and this hilly district is perfect for wandering and exploring. Climb the steps to the Sacré-Coeur or pop into Café des Deux Moulins, where they filmed *Amélie*, for un café.
MUSÉE DU LOUVRE is a spectacular Parisian landmark and I.M. Pei's glass pyramids shouldn't be missed. But don't forget to go inside! I'm not a museum person, but the Louvre will convert you. They say that if you looked at every piece in the collection for 60 seconds each, it would take seventy-five 8-hour days to see it all!

🧳 What to bring

You must pack red lipstick, heels, and an outfit that makes you feel incredible. Paris is one of the world's fashion capitals, so it's a great excuse to bring out your inner fashionista. I never pass up the opportunity to get dressed up! For daytime, dress casual-chic in tailored jeans, a crisp top, ballet flats, and a blazer. At night, pair a flowy dress with heels and bright lipstick, even if you're sipping wine at the bar while dining solo.

PHOTO TIPS

When I'm traveling by myself, I love to get in touch with local photographers and buy them lunch or dinner in exchange for a few hours of photographing and exploring. They know all the best spots—whether a secluded garden or a rooftop with Eiffel Tower views like you've never seen before.

Take a Solo Trip
TO PARIS

Paris. Is there anything more romantic? The name alone makes me think of couples embracing in front of the Eiffel Tower, but the City of Love isn't just for lovers—it can also be the City of Self-Love. It's worth a visit on its own, but if you're heading to other parts of Europe, you should absolutely extend your stay for two or three days and get lost in the meandering cobblestone streets. That's my favorite way to go—and it means I get to spend a little "me" time in Paris even more often!

There's so much to explore—from shops and museums to quaint cafés and pristine parks. Start your day with a café au lait and a croissant, sip a chilled glass of wine as you spend the afternoon people-watching, or enjoy a picnic for one with a baguette and cheese in the Luxembourg Gardens. My best advice, though, is to just get lost. Meditate and reflect wherever your feet take you—and don't forget your camera! Paris is full of spectacular views, ornate details, and sweet and sleepy corners you'll want to document and savor.

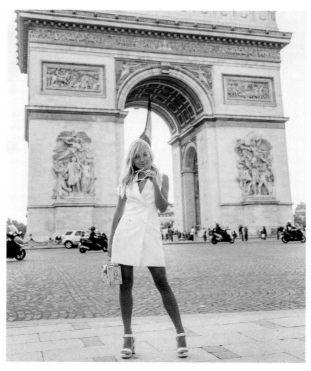

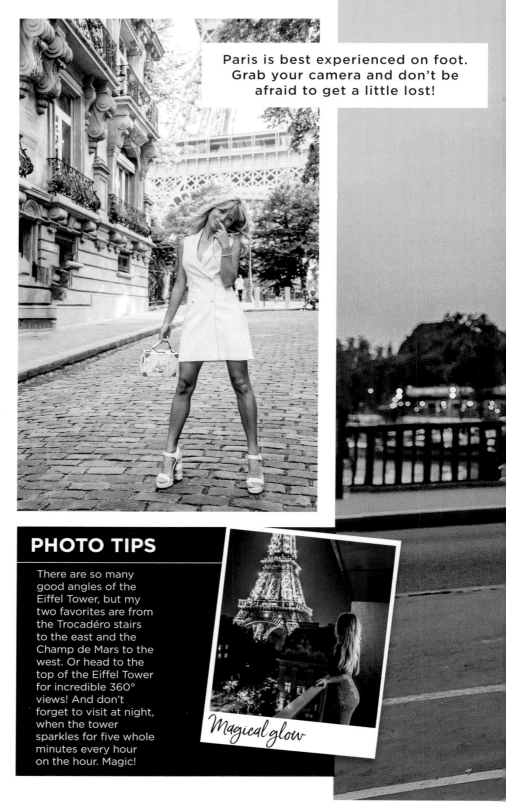

For me, every trip to Paris is different. I might squeeze into a tiny room in the rafters of a historic building one time and lounge in the lap of luxury at the Plaza Athénée the next. You'll find the city's cool and romantic vibe no matter where you stay. Treat yourself as you explore. I especially love bouncing from one patisserie to the next and sampling éclairs and macarons (hello, Ladurée!) at each stop. Calories in Paris don't count!

Nearby places

Paris is the perfect starting point for a number of day trips to get a feel for France and the high-speed train system makes it easy. Take the 45-minute train ride to **VERSAILLES** to see the Hall of Mirrors, Le Petit Trianon, and other aspects of the Palace of Versailles. Or head a little farther away to the **LOIRE VALLEY** to surround yourself with chateaux and picturesque grounds. Art lovers will fall head over heels wandering among Monet's gardens at **GIVERNY,** where there's a photo op around every corner. In the mood for a bit of bubbly? Spend the day in **CHAMPAGNE** tasting the best sparkling wines in the world. You can even do a tasting of Veuve Clicquot!

Paris is best experienced on foot. Grab your camera and don't be afraid to get a little lost!

PHOTO TIPS

There are so many good angles of the Eiffel Tower, but my two favorites are from the Trocadéro stairs to the east and the Champ de Mars to the west. Or head to the top of the Eiffel Tower for incredible 360° views! And don't forget to visit at night, when the tower sparkles for five whole minutes every hour on the hour. Magic!

Magical glow

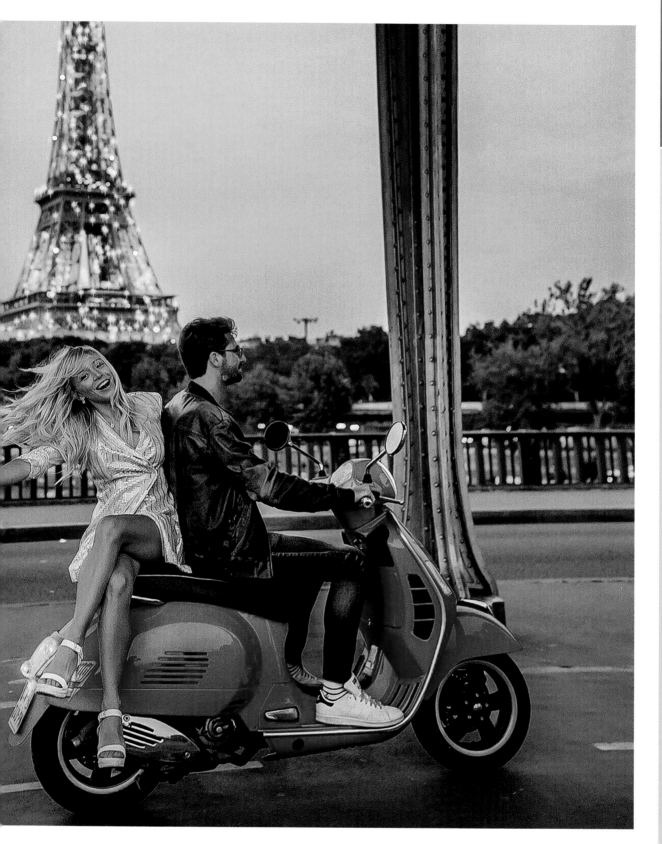

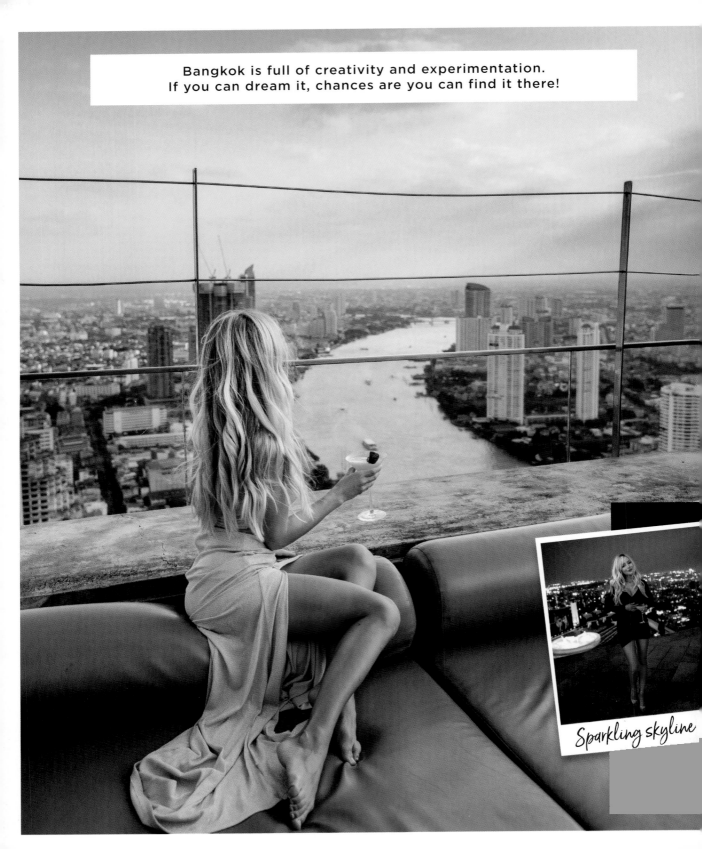

Bangkok is full of creativity and experimentation.
If you can dream it, chances are you can find it there!

Sparkling skyline

LOCATION: **BANGKOK**
COUNTRY: **THAILAND**
You'll be most comfortable visiting between November and March, when the heat and humidity are at their lowest after monsoon season.

Where to go

STATE TOWER is located in the Bang Rak district in western Bangkok and it's known for its golden dome. This skyscraper has apartments, offices, and retail space on its 68 floors. The Sky Bar and and Sirocco—one of the highest rooftop bars in the world and one of the highest al fresco restaurants in the world, respectively—are on the 63rd floor. The Lebua Sky Bar has amazing drinks and both offer an indulgent evening with amazing views of the city and the Chao Phraya River.

Nearby places

Thailand's small size makes everything accessible from Bangkok. **AYUTTHAYA** is a historical park featuring 67 temples dating back to the 14th century. It's the perfect place to learn more about Thai history or to just marvel at the still-standing spires. Craving the beach? **HUA HIN** is a seaside resort along the coast, where white sand beaches are studded with seafood shacks alongside high-end hotels. For an island experience, head to **KOH CHANG**. Dense jungle is surrounded by beaches and villages built on piers, with a remote vibe perfect for adventurers. The water is calm and clear, ideal for snorkeling and scuba diving. See 40–41 to learn about the floating market in **BANGKOK** and 184–185 to learn about the **CHIANG MAI** lantern festivals.

What to bring

For daytime, women should wear lightweight pants and thick-strap tops or you can wear a dress and put leggings in your purse to put on if you go into a temple. Bring a wrap to ensure your arms and shoulders are covered. Men should wear polo or collared shirts. Dressier shorts that come to the knee are okay, but if you're planning to visit temples, wear pants instead. Dress to impress in the evenings. Many of the restaurants and bars have strict dress codes.

PHOTO TIPS

Once it gets dark, avoid using your flash. Stand where you've got just enough light to see your face and then let the sparkling skyline behind you really shine through. Smog can be a big problem, but it creates some really incredible sunsets! An hour before sunset, the light and colors create dramatic backdrops and beautiful lighting. Don't be afraid to ask the Sky Bar staff to snap a photo for you—they know what they're doing!

Have a Cocktail at Lebua's Sky Bar
IN BANGKOK

Bangkok is full of contrasts, where you can get $2 pad Thai on a busy market street and then sip a $25 cocktail more than 800 feet above. It's what gives the city life and what brings me back again and again. In the heart of it all is Lebua. It's one of my favorite hotels—and it's all thanks to the bar.

If you've seen *The Hangover Part II*, you'll know the scene: As you step out of the elevator on the 64th floor, you're greeted by vertigo-inducing views and a lavish staircase that leads down to the open-air 63rd floor, encouraging you to look down and see just how high you are. At the bottom of the stairs is Sky Bar, dangling precariously above the lights of Bangkok.

Inside the glowing central bar, mixologists craft intricate specialty cocktails, including the Hangovertini (Martini Rosso and green tea liquor), as a breeze washes over the crowd and the sunset glows behind them. Because you're so close to the stars, tell the bartender your sign and enjoy a drink inspired by the solar system. There's no better place to toast to your travels and take showstopping photos of the skyline, especially as the sky goes dark and the city lights come to life.

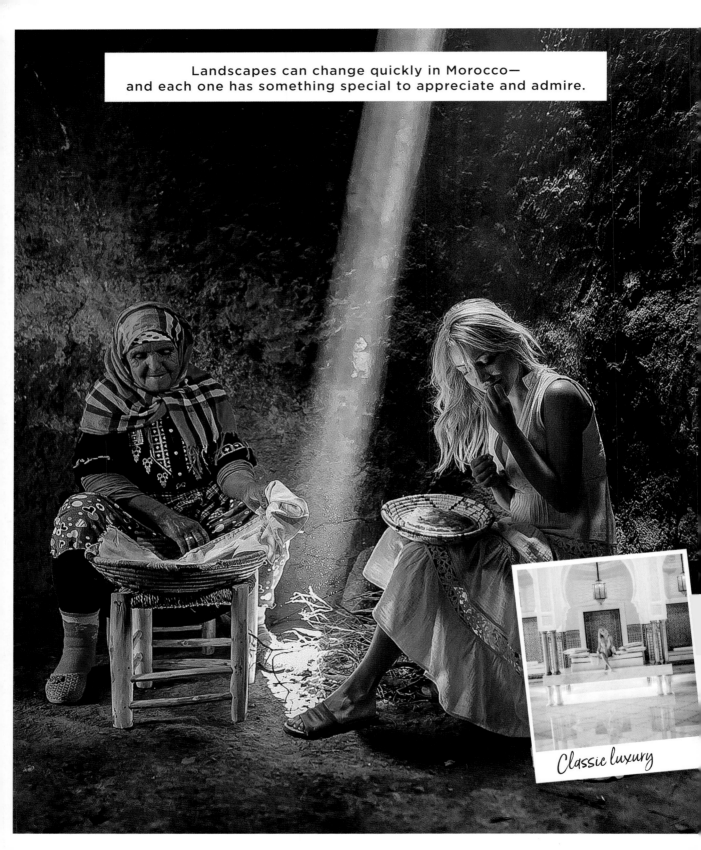

Landscapes can change quickly in Morocco—
and each one has something special to appreciate and admire.

Classic luxury

LOCATION: **MARRAKECH**
COUNTRY: **MOROCCO**
Comfy temps and affordable hotels are from March to May and September to November. Avoid June to August—when temps rise above 100°F.

Old Meets New
IN MARRAKECH

Where to go

JEMAA EL FNA is an open square in the medina, or old city. Visit during the day to see snake charmers and sip fresh orange juice. At night, magicians and storytellers entertain and food vendors serve local delicacies.
SOUK EL BAHJA is full of color and life. Meander up and down the iron stairs for a true taste of all the souk has to offer, particularly women's clothing and jewelry. In search of fragrant spices? Visit Spice Square in Souk Semmarine.
HAMMAMS are bathhouses that offer pools, scrubs, massages, and other spa treatments. Be sure to confirm whether hours are specified for certain genders—and bring your own towel!
YVES SAINT LAURENT MUSEUM displays some of the fashion designer's most iconic styles alongside his sketches and illustrations. It's a must-visit offering unique insights into the revered designer's processes.

What to bring

The challenge is balancing warm-weather clothing with conservative styles, keeping shoulders and knees covered at all times without getting too hot! Choose loose maxi dresses instead of figure-hugging styles. Bring a shawl, which will protect you from the scorching sun, help you cover up in places of worship, and keep you warm after the sun sets. And don't forget sunscreen!

PHOTO TIPS

Islam forbids images of people in most instances, so locals might get upset if they think you're taking their picture. Opt for photos of the architecture or details in the souk instead. If you want to take a picture that features a person, ask first.

Marrakech is full of hidden details and vibrant colors if you know where to look—a living and breathing treasure hunt that I wouldn't have explored if it weren't for Instagram.

Staying at a riad is a must. Ranging from intimate boutique properties with just a few rooms to luxury hotels like La Mamounia, the riads caught my eye when planning a Moroccan getaway. Tranquil courtyards, ornate archways, and spectacular tilework fill the riads with Instagram-worthy detail. Many hosts offer home-cooked meals featuring local delicacies begging to be tasted and the hospitality is truly unmatched.

On my most recent visit, I arrived in Marrakech during Ramadan. I had a fantastic guide who was eager to shared the religious, cultural, and spiritual significance of this 30-day period of fasting and prayer, and I was immediately drawn to the premise of cleansing, self-reflection, and appreciation for what we have.

My guide would tell those we met that I was also observing Ramadan and every person I spoke with was thrilled that I had taken the time to learn more about their culture. Islam is often judged unfairly, but this experience opened my eyes to the beauty, kindness, and warmth that exists in all cultures—no matter what each person believes.

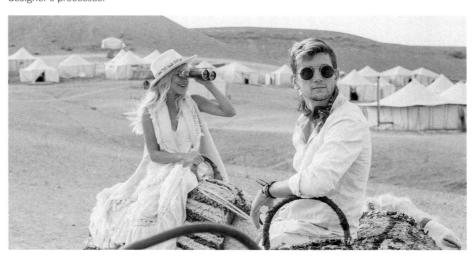

I was invited to join strangers for *iftar,* the evening meal that begins with three dates and a glass of milk and is followed by local specialties that feature fresh vegetables, vibrant herbs and spices, and sweet and savory pastries. That spirit of sharing is a cornerstone of Islam, as is the focus during Ramadan on good deeds and charity.

While the kindness and warmth of the people took the edge off, long days of fasting weren't easy, especially because Ramadan took place during the heat of the summer that year. In addition to refraining from food, you also can't drink anything—even water!—so the days can feel endless. I made the mistake of overindulging during iftar the first night and learned that stomachaches are a common symptom experienced by those fasting for Ramadan. I only fasted for a few days during my short trip and I'm in awe of those who fast on such a regular basis for their entire lives, putting their spiritual selves ahead of their physical needs for weeks at a time.

The people I met in Marrakech are some of the most lovely and hospitable in the world, eager to share a meal and open their homes to strangers. Speaking to locals, expressing genuine interest in their culture, and seeking out ways to learn and become more immersed isn't easy—you have to put your ego aside and open yourself up to whatever experience chance sends your way—but it's the best way to broaden your horizons and see even more of what the world has to offer.

Nearby places

Marrakech is a great city to visit, but Morocco has other places to see. Head to **CASABLANCA** if you're looking to travel like a local. Architecture ranges from historic mosques to luxe art deco designs to wild modern construction—a perfect fit for the city's bustling art scene. It's also the best place to sample local seafood specialties—or to grab a meal at Rick's Café that's worth the "tourist trap" designation. **FEZ** is a taste of old-world Morocco (and the entire city is a UNESCO World Heritage Site!). Fes el Bali, the walled medina, is home to ancient architecture and an unbeatable souk that's the perfect place to explore for an afternoon alongside the donkeys carrying goods through the alleys. For a photo op like no other, head to **CHEFCHAOUEN**, or the Blue City. The walls of the city are painted blue, which is said to serve as a spiritual reminder of heaven—or might simply have started to attract tourists. You'll have to decide for yourself!

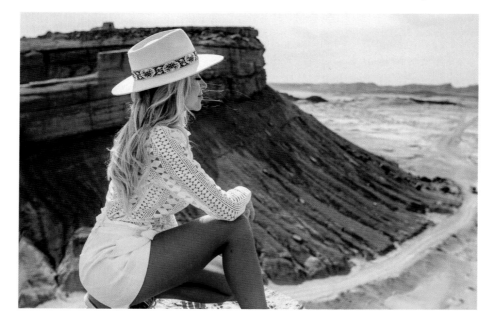

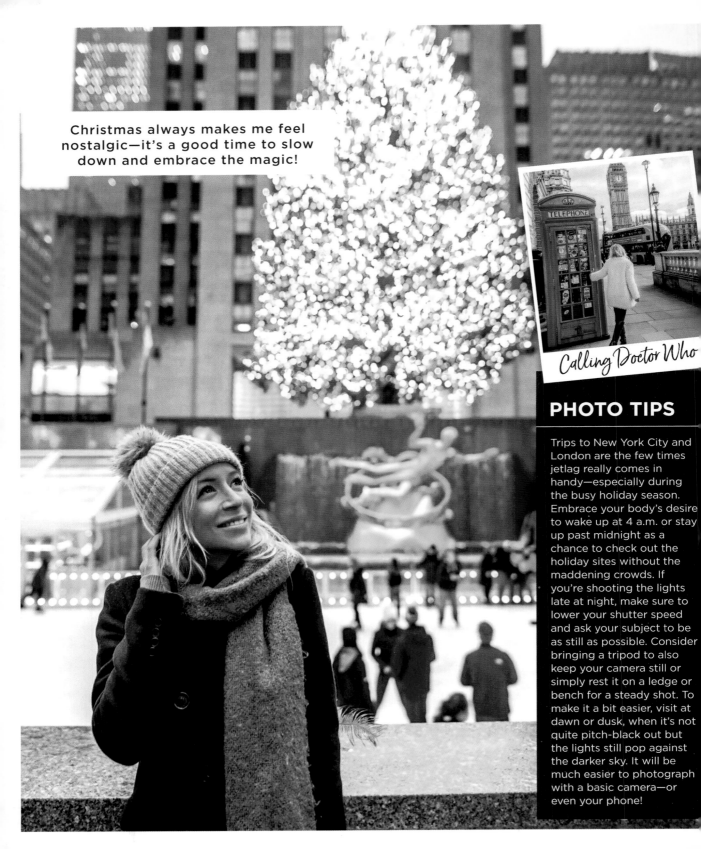

Christmas always makes me feel nostalgic—it's a good time to slow down and embrace the magic!

Calling Doctor Who

PHOTO TIPS

Trips to New York City and London are the few times jetlag really comes in handy—especially during the busy holiday season. Embrace your body's desire to wake up at 4 a.m. or stay up past midnight as a chance to check out the holiday sites without the maddening crowds. If you're shooting the lights late at night, make sure to lower your shutter speed and ask your subject to be as still as possible. Consider bringing a tripod to also keep your camera still or simply rest it on a ledge or bench for a steady shot. To make it a bit easier, visit at dawn or dusk, when it's not quite pitch-black out but the lights still pop against the darker sky. It will be much easier to photograph with a basic camera—or even your phone!

What to bring

New York and London can get quite chilly in winter and snow is a regular occurance. Because these cities were designed for walking, wear comfy weatherproof shoes (and save the chic heels for the cab ride to dinner!). Don't forget a hat, scarf, and gloves as well as a coat and sweater. Wearing layers is key so you can peel things off once you head inside from the cold!

Nearby places

New York City and London are amazing starting points for visiting other equally amazing destinations. From NYC, you can take an Amtrak train up or down the East Coast to **BOSTON**, **PHILADELPHIA**, or **WASHINGTON, DC**. Or rent a car and head to **UPSTATE NEW YORK** to really enjoy the snow with a bit of skiing at Hunter Mountain or Thunder Ridge. From London, head across the English Channel for a Christmas experience in **PARIS**. (You can learn more about my favorite spots in Paris on pages 148–151!) Smaller English towns are quaint year-round but even more charming when dusted with snow. Head to **RYE** in East Sussex for a pub crawl—nothing takes the chill off like a pint by the fire!—or trek out to **WAKEHURST** to tour the snowy illuminated gardens.

LOCATION: **NEW YORK CITY & LONDON**
COUNTRIES: **UNITED STATES & UNITED KINGDOM**
Although they're great cities year-round, they come to life in new ways in December.

Where to go

NEW YORK CITY
ROCKEFELLER CENTER is the epicenter of Christmas in the Big Apple. It's home to two holiday traditions I absolutely adore: the Rockefeller Center Christmas Tree and the ice rink at Rockefeller Center. The tree towers high above the skaters below, lit with thousands of lights that twinkle day and night.
5TH AVENUE gets all dressed up for the holidays—just like the shoppers wandering in and out of the high-end boutiques. Devote a few hours to the holiday windows, which are incredible feats of art and engineering that change dramatically every season.
COLUMBUS CIRCLE is in Central Park, and every holiday season, it plays host to a sprawling outdoor market inspired by those of Europe. Artisans sell everything from handmade ornaments to clothing, plus rich cocoa and gingerbread cookies!

LONDON
TRAFALGAR SQUARE is home to London's largest Christmas tree, a gift from the city of Oslo. Groups gather around the tree for caroling and the lights at night are the perfect holiday photo op!
HYDE PARK hosts Winter Wonderland—full of activities and attractions for visitors of all ages: the UK's largest outdoor skating rink, a Christmas circus, the towering Ferris wheel, and two sprawling markets featuring arts, crafts, and unique gifts alongside delicious seasonal treats.

Christmas
IN THE BIG CITY

In New York, the heart of the Christmas season is Rockefeller Center. The skating rink and towering tree, paired with thousands of lights, create a magical ambiance that makes the throngs of visitors and honking taxis seem charming. If you plan to hit the rink, be sure to reserve a spot online in advance. It costs a bit more than general admission, but you'll skip the line with a specified skate time and you can enjoy complimentary cocoa and cookies. Plus, skate rentals are included, making it absolutely worth the splurge.

London during Christmas is enchanting and nostalgic. The city slows down as holiday music jingles from shop speakers, carolers wander the streets in period garb, and everything from major thoroughfares to tiny alleys are draped in lights. Pubs are cozy by default. The addition of some mistletoe and a roaring fire make braised meats and traditional puddings taste even better.

My favorite thing about Christmas in London is that everyone just seems jolly, inspired by the impending arrival of St. Nick! Head to the Christmas grotto at Harrods to watch children's eyes widen in wonder as they spot Father Christmas and his elves. That feeling of holiday joy makes it a romantic holiday destination, so book a flight with someone you love—and keep an eye out for mistletoe!

Dance the Flamenco IN SEVILLE
by Li-Chi Pan (@lichipan)

Officially known as *Feria de Abril de Sevilla* in Spanish, the Seville Fair is a weeklong event filled with all-night partying, dancing, drinking, food, and all the delights of an amusement park. Like most things in Spain, though, it's steeped in a distinct tradition all its own. What began as a livestock fair quickly developed into a party where people dress up in traditional clothes and basically have an excuse to have a great time!

To get into the festive spirit, I'd suggest buying a flamenco gown *(traje de flamenca)*. You can opt to have one made or purchase one in the town center of Seville. I'd be lying if I didn't say the *traje* is a significant part of the experience! Because the dresses are quite expensive, most natives have at least two or three and rotate them throughout the week. You can also hit up Humana (the Goodwill or Salvation Army of Spain) during Feria season and you're bound to find something under $100. I got my flamenco gown made at Sibilina Flamenca. I'd highly recommend using their services because they tailor the dress to fit your body perfectly.

I'd advise going to the festival around 5 p.m. when the sun isn't at its peak. Bringing spare clothing and dancing the night away while eating local food is the absolute best! In fact, when you need something good to eat, there's seriously something magical about Spanish ham! It's one of those foods that just keeps tasting better the more you eat it. It carries an astonishing amount of flavor and history. No trip to Seville is complete without at least one tasting of top-tier *jamón ibérico de bellota.* But whether you're eating or dancing, you can't escape the history that surrounds you as you join all the revelers around you to celebrate the richness of Seville.

LOCATION: **SEVILLE**
COUNTRY: **SPAIN**
The Seville Fair usually takes place two weeks after the Easter Holy Week. Check for specific dates before going.

Where to go

SANTA CRUZ is a great cultural and historical area in Seville to go to when you're not enjoying Feria. This district offers visitors an opportunity to stroll among the charming little streets to look at the beautifully decorated façades and hidden garden spaces. This district is also where you can visit the Alcázar (from the Arabic *al-qasr*, meaning "castle"), which is a royal palace still in use; the Seville Cathedral, which began its life as a mosque; and the Giralda Tower, which is the bell tower for the Seville Cathedral.

Nearby places

AIRE ANCIENT BATHS are temples dedicated to the relaxation of body and mind in which time doesn't exist. Inspired by the tradition of baths from ancient Roman, Greek, and Ottoman civilizations, the AIRE experiences always take place in restored historical buildings in the center of cities. They're a perfect way to end your trip before heading home or to your next destination.

What to bring

A word of advice I received from locals was to bring a second outfit change, which was a clever idea because the weather can get really hot at the Feria.

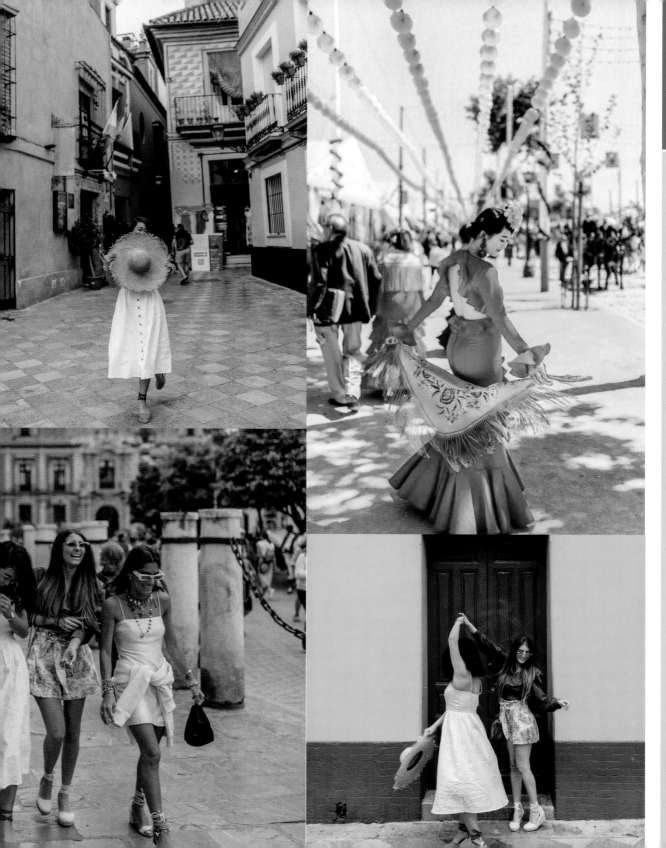

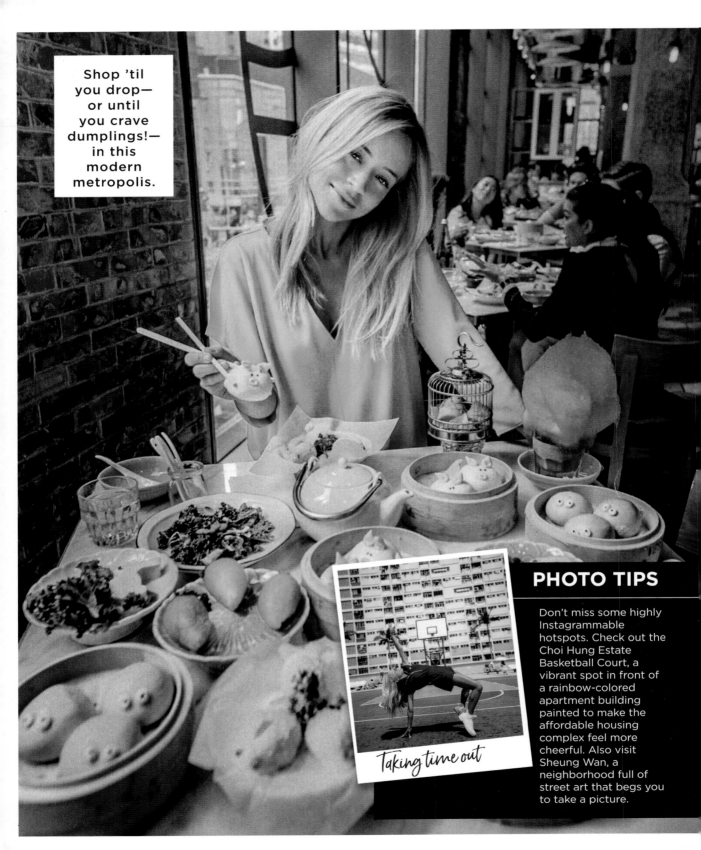

Shop 'til you drop—or until you crave dumplings!—in this modern metropolis.

Taking time out

PHOTO TIPS

Don't miss some highly Instagrammable hotspots. Check out the Choi Hung Estate Basketball Court, a vibrant spot in front of a rainbow-colored apartment building painted to make the affordable housing complex feel more cheerful. Also visit Sheung Wan, a neighborhood full of street art that begs you to take a picture.

CHINA

LOCATION: **HONG KONG**
COUNTRY: **CHINA**
October to December is the most pleasant, with temps in the 70s and smaller crowds, while January and February can be crowded but cooler.

Experience the Hustle and Bustle OF HONG KONG

What to bring

All the wealth in Hong Kong means style is a top priority. During the day, opt for chic and sophisticated outfits in light fabrics. The city is quite hilly, so comfortable flats are your friend! At night, it's all about fashion. This is a great place to wear that eye-catching piece you love that's been sitting in your closet for too long!

Nearby places

If you'll be in Hong Kong for a few days, spend some time exploring the outlying islands of Lantau, Lamma, and Cheung Chau. **LANTAU ISLAND** is home to Hong Kong Disneyland as well as lots of hiking on Lantau and Sunset peaks. **LAMMA ISLAND** has more of a hippie vibe, with age-old fishing villages that supply some of the area's most delicious seafood (to be enjoyed right on the beach, of course!). On **CHEUNG CHAU**, you can visit colorful temples, wander along the waterfront, or even explore a 19th-century pirate hideout. Looking for some glitz and glamour? Head across the bay to **MACAU**, where Chinese and Portuguese history (and some Vegas-style fun!) collide.

Where to go

VICTORIA PEAK is the highest point on Hong Kong Island and the tram ride to the top takes you to the heart of the most expensive real estate market on the planet, where you can ogle wildly expensive homes along with their multimillion-dollar views.
CANTON ROAD is Hong Kong's answer to Fifth Avenue. Luxury shops line the street, scattered between high-end malls and hotels. There's plenty of people-watching to do as well as food courts serving local and regional fare.
DIM SUM is more a way of life in Hong Kong than a place to go. It's a feast of dumplings and small plates full of flavor and Cantonese culture. Some of the best can be found at Dragon King, Yum Cha, Lin Heung Kui, and, of course, Tim Ho Wan.

Hong Kong is the perfect add-on to a trip through Southeast Asia. I had no idea what to expect when I first arrived and I quickly learned that it's incredibly cosmopolitan, with amazing restaurants, high-end shopping, and multimillion-dollar views. What's not to love?

I was lucky enough to meet up with a friend who was born in Hong Kong, so she served as our tour guide and gave us a local's perspective. We arrived during Easter, when the city's pristine streets were filled with people celebrating. Having a guide made navigating the city a breeze—from stopping at one of the delicious vegan restaurants to knowing exactly where to go for the most adorable dim sum. I'd never seen dumplings shaped like animals and it made the interactive and flavorful experience even more fun!

The main shopping areas can be crowded, but they're worth a visit. You'll find musicians and street performers on every corner and older ladies playing mahjong in parks. But stick to observing: These women have been playing their entire lives and they won't go easy on you!

From dumplings to gambling, luxe outfits, and colorful accessories, Hong Kong is full of quirks and contrasts that are begging you to explore.

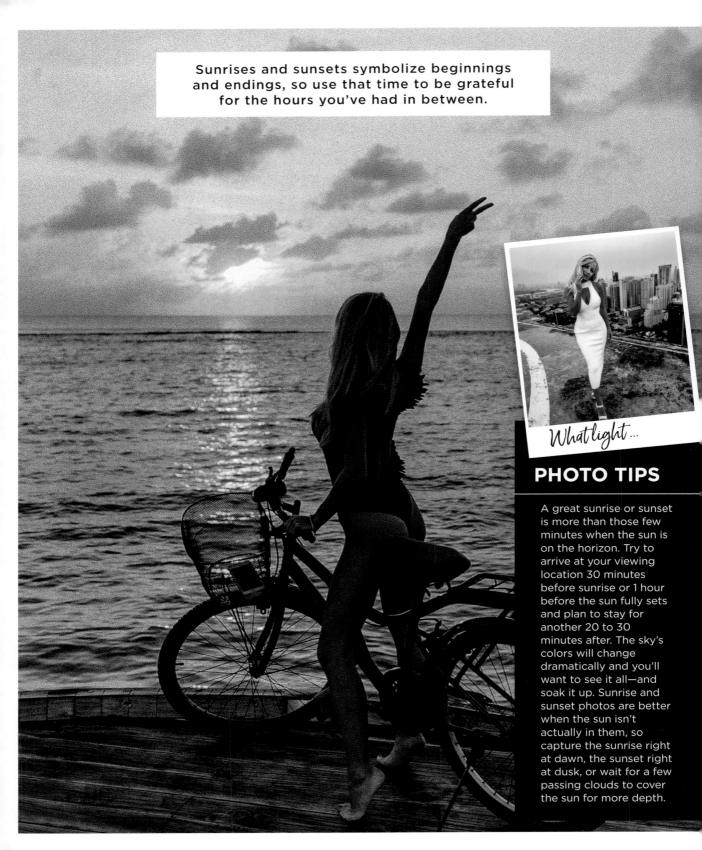

Sunrises and sunsets symbolize beginnings and endings, so use that time to be grateful for the hours you've had in between.

What light ...

PHOTO TIPS

A great sunrise or sunset is more than those few minutes when the sun is on the horizon. Try to arrive at your viewing location 30 minutes before sunrise or 1 hour before the sun fully sets and plan to stay for another 20 to 30 minutes after. The sky's colors will change dramatically and you'll want to see it all—and soak it up. Sunrise and sunset photos are better when the sun isn't actually in them, so capture the sunrise right at dawn, the sunset right at dusk, or wait for a few passing clouds to cover the sun for more depth.

🧳 What to bring

Sunsets and sunsets don't require much, but you'll want to give yourself a few hours to enjoy each and to soak up your surroundings while feeling something you don't feel during the day.

Be sure to have somewhere comfortable to sit, a snack and drinks, and clothes to accommodate the changing temps—layers to add and layers to remove depending on the experience.

And company is optional!

Where to go

SUNRISE

TULUM makes watching the sunrise easy because you'll probably have stayed up all night! After an evening of dancing on the beach, settle in on the sand and watch the sky lighten with shades of pink, orange, and blue.

SYDNEY is on the eastern coast of Australia, with nothing on the horizon for thousands of miles. It's amazing to experience the peace and quiet of a sunrise before the city has woken up around you.

MOUNT KILIMANJARO will forever be my most rewarding sunrise. After a grueling all-night climb, pausing to take it all in filled me with gratitude for what my body had done and the beauty the world around us offers. (Read more about my climb on Mount Kilimanjaro on pages 62–67.)

LOCATION: **WORLDWIDE**
If you've got a clear view of the horizon and a peaceful place to sit, you have got all you need for an amazing experience.

SUNSET

MALDIVES takes the prize for the most romantic sunset. The colors feel richer, the setting sun feels warmer, and you really feel like you and your partner are the only people on the planet experiencing this display at that moment.

HALEAKALĀ volcano is the best place to watch the sunset in Hawaii. You're high above the clouds, looking down as they change colors and dance around the sun—a completely unique way to observe the day coming to an end.

OIA is a small village in Santorini that's home to some of the world's most spectacular sunsets. The white buildings and ancient ruins are gorgeous, but what makes it really special is the town coming together every evening. Hundreds of people line the stairs to watch and appreciate the sunset, and once the sun is below the horizon, the entire town bursts into applause!

Witness the Wonder of
Sunrises and Sunsets
AROUND THE WORLD

I never realized how moving a sunrise or sunset could be until I sat down and really watched one. But over the years, I've become a connoisseur and have begun to choose destinations and scout locations in search of the very best viewing. It's a time to reflect and give gratitude—whether it's for the day that's about to begin or the one that's coming to an end.

To me, witnessing a sunrise or sunset is akin to experiencing a miracle. Nature is showing off and putting her glory on full display—why would you ever want to miss something like that?

My favorite places to watch the sunrise and sunset have one thing in common: They're quiet and peaceful, removed from large crowds. It's an experience best had in private—either on your own or with a few friends—as the profound impact of the changing colors becomes particularly striking when the world goes quiet.

Landmarks are worth a visit, but even the most ancient ruins can feel unchanging. A sunrise or sunset, though, is a new and different experience every time. One day it might be dark and stormy and the next might be the most incredible display of colors you've ever seen. You could visit the same spot every day for weeks and see something new each time—as long as you're open to whatever nature wants to offer you that day.

The way you see a sunrise or sunset says a lot about how you look at the world. The photo presets I designed for sunrises and sunsets all have a pink tone that feels a bit magical because that's how they appear to me—as though I'm viewing the world through rose-colored glasses. Taking the time to pause and truly look at the sky as it changes colors has taught me that it's not always what you see but how you see it and whether you choose to appreciate it.

Whether you're alone or with company, take time to truly enjoy the beginning and end of each day, then remember to make the most of the hours in between so those sunrises and sunsets become not just a marker of passing time but a celebration of the days you've had and the life you've yet to live.

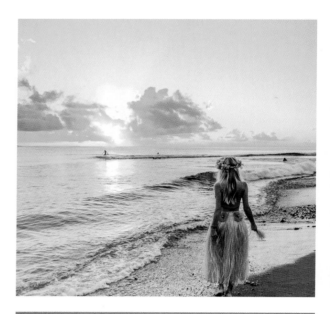

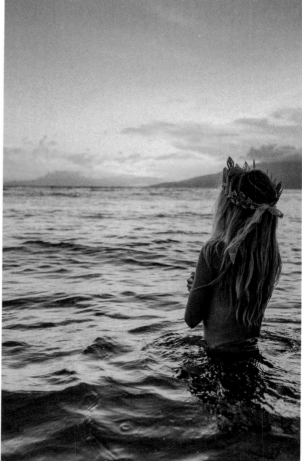

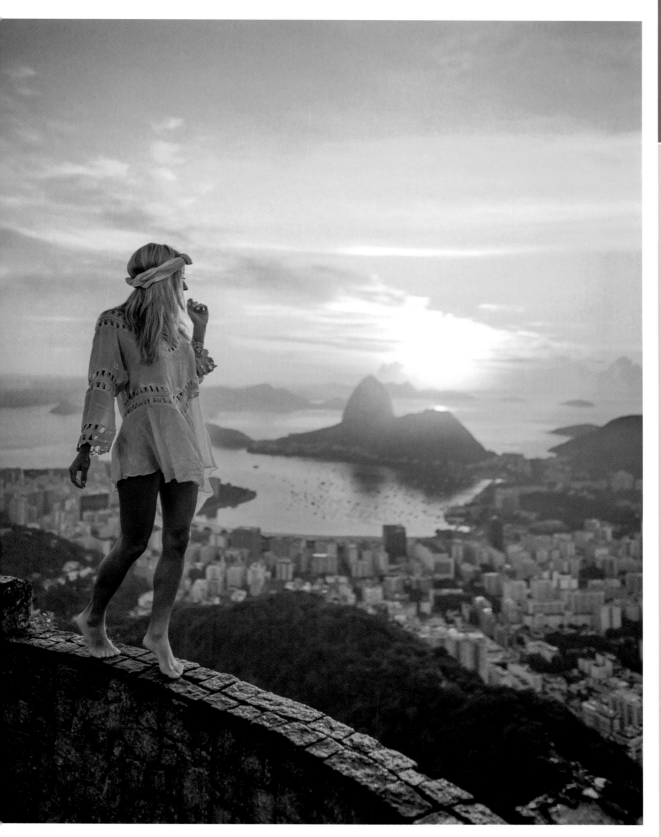

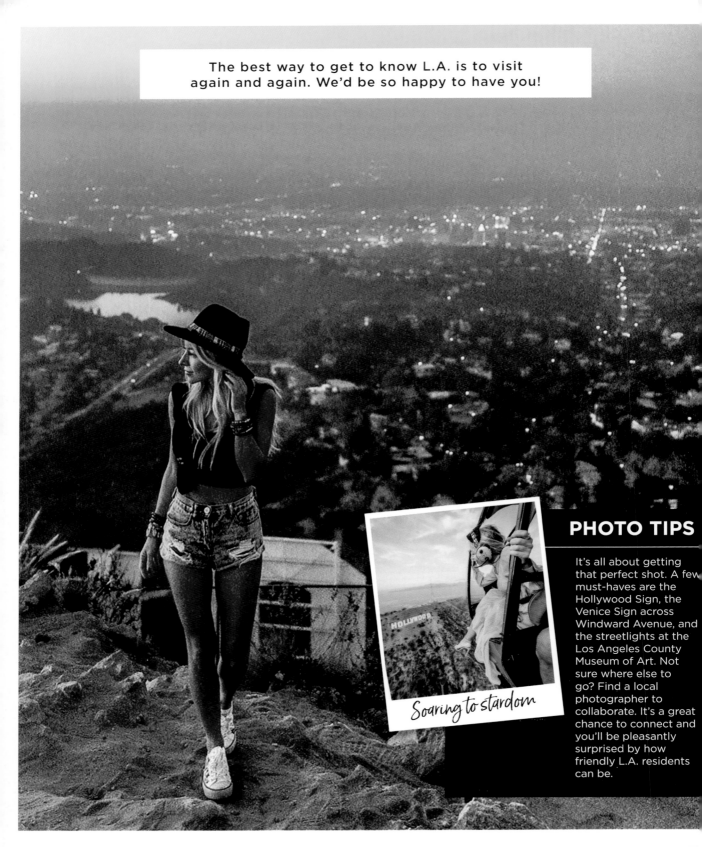

The best way to get to know L.A. is to visit again and again. We'd be so happy to have you!

Soaring to stardom

PHOTO TIPS

It's all about getting that perfect shot. A few must-haves are the Hollywood Sign, the Venice Sign across Windward Avenue, and the streetlights at the Los Angeles County Museum of Art. Not sure where else to go? Find a local photographer to collaborate. It's a great chance to connect and you'll be pleasantly surprised by how friendly L.A. residents can be.

LOCATION: **LOS ANGELES, CALIFORNIA**
COUNTRY: **UNITED STATES**
L.A. is a must-visit for its global culture and sandy beaches. And yes, that *is* an A-Lister in line behind you!

Get Discovered
IN L.A.

A trip to Los Angeles can change your life. People have been flocking to this West Coast city for decades, hoping to make it big in Hollywood. You might not catch your big break, but I guarantee you'll leave feeling like a new person.

Whenever it comes to L.A., everyone has an opinion: You either love it or you hate it. For me, it's all about finding your niche. When I first moved to L.A., I lived in Hollywood and never felt quite at home. I've since lived in Hermosa Beach and Venice, and every new area I discover makes me fall deeper and deeper in love with the city.

People in L.A. love to eat—and we love to eat very healthy. It's the mecca of amazing vegan food and we treat Erewhon as a grocery store as much as the place where you'll meet the love of your life, so don't be afraid to make eye contact over the organic produce display.

But the thing that surprises visitors the most about L.A. is how friendly people are. No one is actually from here—we've all moved to chase our dreams, so every moment is a networking opportunity and there's a feeling that we're all in it together. Chat with everyone you meet: You never know who might bring you an amazing opportunity to collaborate on something exciting and new and inspiring. Just like the people who live here, a trip to L.A. is a chance to try on any identity that tickles your fancy—and you might learn something about yourself in the process!

What to bring

It's hard to see L.A. without driving—being stuck on the 405 is part of the experience!—so make sure you bring your driver's license or consider hiring a driver to shuttle you around town. Don't forget audiobooks for the car as well as your sunglasses and a light jacket for yourself, as the temperature cools considerably at night.

Where to go

HOLLYWOOD is the place to go if you love watching movies. Pretend you're heading to the Oscars at the Dolby Theatre, compare palm sizes with your favorite stars at Grauman's Chinese Theatre, and, of course, go for a hike behind the Hollywood Sign or ride a helicopter overhead!
BEVERLY HILLS is home to Rodeo Drive, Sunset Boulevard, and Wilshire Boulevard. This area is known for its ritzy boutiques and movie landmarks. Speaking of landmarks, hop on a bus tour to ogle at celebs' sprawling mansions and daydream about your dream home. And keep your eyes open—you might just spot someone famous!
VENICE BEACH is known for its see-and-be-seen boardwalk, full of funky shops, street performers, and, yes, bodybuilders flexing in the sand. Top your wildest bathing suit with cutoff shorts and don't forget your camera!
SANTA MONICA PIER is where modern SoCal culture and charming history intersect. The historical carousel, fun-filled arcade, and thrilling roller coaster at Pacific Park are the perfect breaks from a day at the beach. And the seafood restaurants and ice cream shops will keep you more than satisfied.
LOS ANGELES COUNTY MUSEUM OF ART (LACMA) features one of the Los Angeles's Instagram landmarks: Chris Burden's "Urban Light." Visit the rows of restored 1920s and 1930s streetlights at dusk or later for a more dramatic 'gram.

Nearby places

Give yourself a few days to tick off all the tourist hotspots and spend part of your trip indulging in the global food scene, lounging on the beach, or popping from a yoga session to a juice bar to a reiki healer. You could spend your entire trip exploring L.A.'s diverse neighborhoods, but SoCal is full of things to see and do. The young at heart should set aside a day for a trip to Disneyland in **ANAHEIM**. Keep an eye out for celebs in their Mickey ears! If a laid-back beach is more your scene, head up the coast to **MALIBU** for a few days at a luxe resort and coastal fine dining. And of course, don't forget wine country! **SANTA BARBARA** is just 90 minutes up the coast and is surrounded by award-winning vineyards with picturesque views—there's no better place to sip rosé in the afternoon sun! L.A. is definitely worth more than one visit!

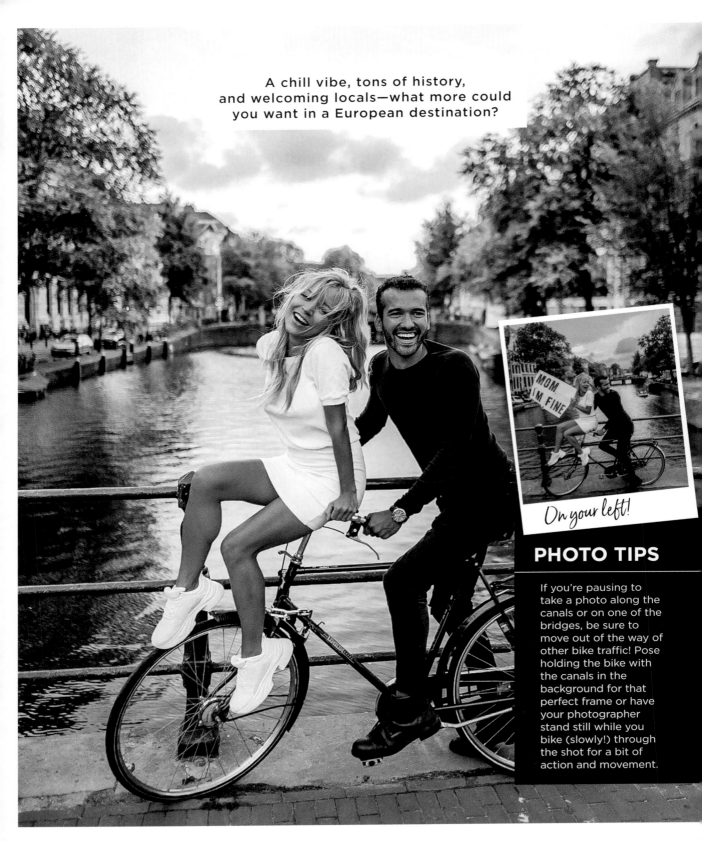

A chill vibe, tons of history, and welcoming locals—what more could you want in a European destination?

On your left!

PHOTO TIPS

If you're pausing to take a photo along the canals or on one of the bridges, be sure to move out of the way of other bike traffic! Pose holding the bike with the canals in the background for that perfect frame or have your photographer stand still while you bike (slowly!) through the shot for a bit of action and movement.

NETHERLANDS

AMSTERDAM

GERMANY

BELGIUM

🧳 What to bring

Because so much of Amsterdam's population relies on bicycles to get around, you'll want to be able to maneuver with ease. Opt for shoes that strap to your feet (no flip-flops!) and pick pants over a skirt—save that breezy "biking in a dress" photo opp for a more quiet ride through the countryside.

Nearby places

Amsterdam is one of my favorite cities in Europe and it's the perfect addition to a new traveler's European vacation. While you're on the continent, be sure to visit **LONDON** during the holidays (pages 158–159), **PARIS** for some self-discovery (pages 148–151), **MUNICH** for Oktoberfest (pages 178–179), and **ROME** for as much pizza and pasta as you can eat—or head to my home country of Poland for a hiking adventure in **ZAKOPANE** (pages 54–55)!

LOCATION: **AMSTERDAM**
COUNTRY: **NETHERLANDS**
Visit from September to November for the best ride. To see the tulips, go twhe last two weeks of April and the first two weeks of May.

Where to go

GRACHTENGORDEL, or the Canal Belt, is the best place to hop on a bike. This is where you'll see all those iconic canals and bridges—perfect for a photo op! Whether you're touring the neighborhood by bike or by boat, remember to take in all the history and 17th-century architecture that flank the waterways.

THE KEUKENHOF is your destination for incredible tulip sightings. Also known as the Garden of Europe, it's located southwest of Amsterdam and is only open in the spring—prime tulip season! Seven million bulbs are planted in the garden every year, with layouts ranging from meandering English gardens to more organic Japanese gardens. While the park itself doesn't contain those color-blocked rows of tulips you've seen in photos, it's surrounded by private farms where the vibrant blooms seem to go on forever.

MUSEUMPLEIN is a can't-miss stop for art lovers. Dutch art is some of the best in the world, from classic masters like Vermeer to the unmistakable Van Gogh. Visit the Rijksmuseum, the Van Gogh Museum, and the Stedelijk Museum, then meander in the park or hit the nearby couture and diamond boutiques for retail therapy.

Bike the Canals
IN AMSTERDAM

Whether you're an experienced traveler or are leaving your home country for the first time, I always recommend Amsterdam as a can't-miss destination. This northern European city has a cool, welcoming vibe that combines European history (hello, art museums and architecture!) with modern touches (including some really amazing restaurants!).

Like Paris, I love adding Amsterdam to my trip as a two- to three-day layover. It's the perfect amount of time to unwind and explore for a few days while also giving you plenty of reasons to come back again and again. Visit in the spring to see the tulips in all their colorful glory or plan a trip in the winter to wander through the charming holiday markets and see the historic buildings dusted in snow.

Amsterdam is very much a pedestrian city—whether you choose to walk, boat, or ride a bike. I love being up close and personal with a city's sights and sounds, and traveling this way also gives you more chances to stumble upon an adorable bakery or get to chatting with locals while you ask for directions. Everyone I've met in Amsterdam is incredibly friendly and welcoming, quick to switch into English to recommend their favorite local spots. So get out of your comfort zone and start exploring!

festivals

Brush off your dance moves and make your way to the world's biggest dance floor.

Street dancing

What to bring

Pack for the weather and don't forget to register with a samba school before you arrive so you can join their party! You'll head to a designated area to pick up your T-shirt and then volunteers will decorate it for you so you'll fit right in with the thousands of others joining the school to dance and celebrate.

Nearby places

Spend a little time exploring the city, especially the iconic **IPANEMA**, **COPACABANA**, and **LEBLON** beaches. They're vast and bustling beaches perfect for working on your tan. To get a taste of the other wild side of Brazil, visit the **AMAZON RAINFOREST** (pages 68–71) to paddle the Amazon River, explore the jungle, and learn about indigenous and tribal cultures.

PHOTO TIPS

Crowds and expensive cameras don't mix, so leave your DSLR at home and snap your shots with your phone.

At street parades, don't shy away from the crowds in your photos! Showing that other people are having as much fun as you are is what enjoying Carnival is all about.

LOCATION: **RIO DE JANEIRO**
COUNTRY: **BRAZIL**
Carnival in Rio began in 1723. Check the specific dates before traveling, then get ready to party with more than 2 million people each day!

Where to go

SAMBADROME MARQUÊS DE SAPUCAÍ is a massive parade area that was built in 1984 to showcase the thousands of dancers who compete as part of a samba school during Carnival. With space for 90,000 spectators, it's *the* place to see the top samba schools perform! It's also home to the Champions Parade, a showcase of the winning schools.
BELMOND COPACABANA PALACE hosts the other end of the Carnival spectrum: a black-tie ball overlooking Copacabana Beach. Tickets are pricey, but this luxe celebration is the perfect combination of Carnival revelry and sophistication.

Party at Carnival
IN BRAZIL

If there's one place in the world where you can dance like nobody's watching, it's in Rio during Carnival. This five-day celebration might take place before Lent, but music and dance moves are at the heart of this wild and raucous festival.

There are two ways to experience Carnival: at a street party and at the Sambadrome. Street parties take place wherever you can find them, with locals and visitors alike mingling in the heat of the night as the music blasts. The Sambadrome is like being on another planet, with tens of thousands of spectators and performers gathering to see the best samba schools on parade. The costumes and floats are full of color, sequins, and gems glistening beneath the lights.

My favorite way to enjoy Carnival is at the Sambadrome as part of a samba school. Make your way to the street to join your school in their 75-minute parade and performance. The competition begins at 8 p.m. and lasts all night, with the final school finishing their performance around 5 a.m.—but you'll be so into the music that time will fly by. On the Saturday after Carnival ends, the winning samba school and five runners-up gather for the Champions Parade—a showcase of the top samba talent in Brazil—so be prepared to be amazed!

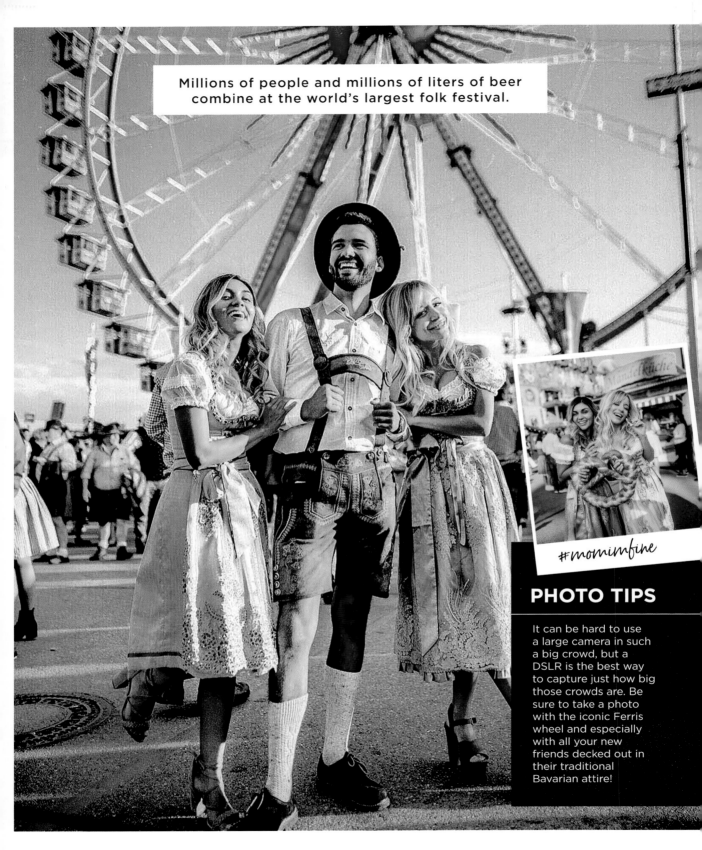

Millions of people and millions of liters of beer combine at the world's largest folk festival.

#momimfine

PHOTO TIPS

It can be hard to use a large camera in such a big crowd, but a DSLR is the best way to capture just how big those crowds are. Be sure to take a photo with the iconic Ferris wheel and especially with all your new friends decked out in their traditional Bavarian attire!

Show Off Your Dirndl
AT OKTOBERFEST

LOCATION: **MUNICH**
COUNTRY: **GERMANY**
Oktoberfest takes place from late September to early October, giving you plenty of chances to wear your Tracht garments (folk costumes).

GERMANY

Berlin •

CZECHIA

CE

MUNICH
Neuschwanstein
Castle

AUSTRIA

What to bring

Everyone wears lederhosen and dirndls during Oktoberfest, so don't forget yours! The costumes are beautiful and they create a real sense of unity among the revelers. Try to source one before you go so you're not stuck scouring local shops at the last minute.

Nearby places

Art lovers should visit Munich's **ALTE PINAKOTHEK**, one of the world's oldest art galleries. Those in search of charming architecture will love **MARIENPLATZ**, a can't-miss site if you're in Munich during the Christmas season! Head north to **BERLIN** to tour the remains of the Berlin Wall and immerse yourself in the country's storied past. In southwest Bavaria, **NEUSCHWANSTEIN CASTLE** is a monument to King Ludwig II, who commissioned the palace as a private retreat. Its spires are the inspiration for Sleeping Beauty's castle at Disneyland! Looking for a place to get outdoors and see more of Eastern Europe? Visit **ZAKOPENE** (pages 54–55) in my home country of Poland for a gorgeous hike!

Where to go

THERESIENWIESE (Theresa's Meadow) is the heart of Oktoberfest. In 1810, the meadow was the venue for the marriage of Princess Therese of Saxe-Hildburghausen and Crown Prince Ludwig I, and Oktoberfest has been held on that spot every year since to commemorate their marriage. Theresienwiese is big enough to hold 100,000 people at a time—more than 6 million visitors over 3 weeks!

THE BAVARIA is a 60-foot statue of the patroness of Bavaria. She towers over the meadow and a staircase inside leads up to her head, where there are openings from which you can view Oktoberfest from above.

ST. PAUL'S CHURCH offers another epic view of Oktoberfest—this time with the Alps rising in the background. Just head to the north end of the meadow and climb the tower at St. Paul's Church. It's not to be missed, especially because the viewing platform is only open during the festival.

Whether you're a beer connoisseur or don't drink, a trip to Oktoberfest should absolutely be on your bucket list. During this massive September festival, more than 6 million visitors descend on Munich to don traditional Bavarian clothing, enjoy regional foods, visit the carnival, and, of course, drink beer—more than 7 million liters worth!

The first time I went to Oktoberfest, I was 19 and didn't like beer (I still don't!), but I was introduced to radlers—a 50-50 combo of a helles (light beer) and lemon-lime soda. It's light and refreshing and also lower in alcohol. But Oktoberfest it's all about the booze. During my second visit to Oktoberfest a decade later, my friends and I didn't touch a drop of alcohol and we still had an absolute blast.

From the Ferris wheel and mega go-karts to live music in every tent, there's such a friendly, lively atmosphere. The feeling of unity is infectious: Everyone is an instant friend, throwing arms around one another to belt out the lyrics to their favorite songs (in German, of course!) or share classic eats like pretzels, currywurst, sugar-roasted almonds, and spiced lebkuchen cookies. No matter where you're from, at Oktoberfest, everyone is an honorary Bavarian.

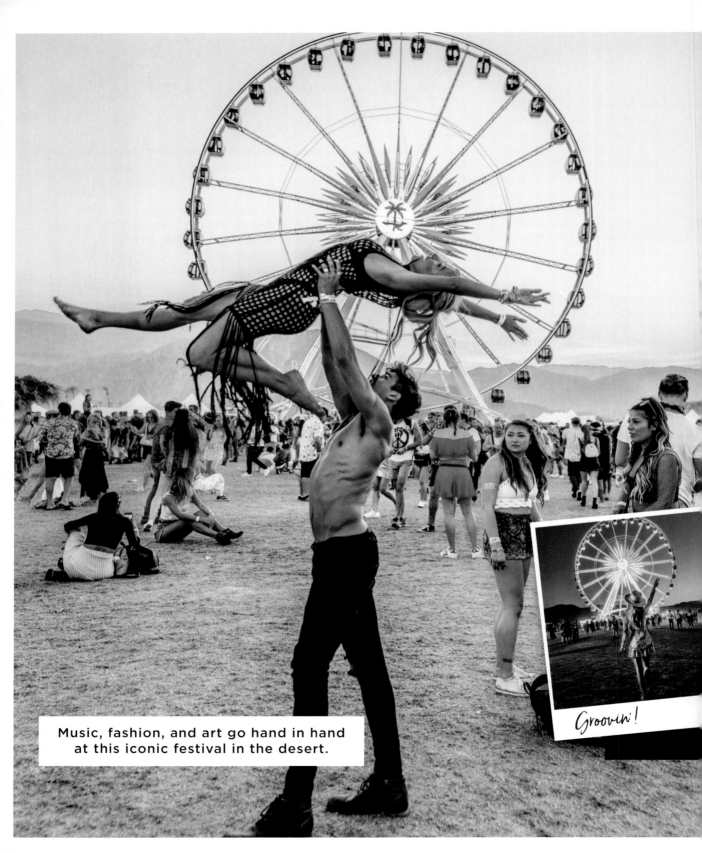

Music, fashion, and art go hand in hand at this iconic festival in the desert.

Groovin'!

Immerse Yourself in Music
AT COACHELLA

UNITED STATES

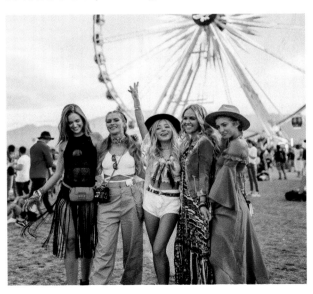

LOCATION: **INDIO, CALIFORNIA**
COUNTRY: **UNITED STATES**
Coachella takes place in April on back-to-back three-day weekends—and yes, you'll want to go both weekends! Check for specific dates.

Los Angeles • **INDIO**
• Palm Springs • Salvation Mountain

What to bring

A trip to Coachella is whatever you make of it. Some people pack their best festival attire and change five times a day, while others will wear the same shorts and T-shirt all weekend and focus on the music. Whatever your style, remember that Coachella takes place in a desert. Bring a bandanna to protect your nose and mouth from the dust, and remember to bring sunscreen and a hat for hot days and warm layers for cool nights.

PHOTO TIPS

Professional cameras (those with detachable lenses) aren't allowed, so it's best to leave your DSLR at home. Instead, snap a few pictures with your phone and focus on enjoying the music and the people around you! And remember, there will be people in your photos no matter what—it's part of the fun!

Where to go

Coachella features five main stages and a number of smaller performance areas, each drawing different acts and different crowds.
COACHELLA STAGE is home to the headliners. (Think Beyoncé and Childish Gambino.) This central stage draws the largest crowds.
OUTDOOR THEATRE is adjacent to the Coachella Stage and is a great place to see smaller acts while you're waiting for the headliners.
MOJAVE is a tent that showcases a variety of musical genres and performers ranging from established artists to up-and-comers.
GOBI is next to Mojave and also showcases a variety of new and established artists.
SAHARA is the place to go if you're looking for EDM acts. This hangar-like tent is the largest covered performance space and the stage has seen the likes of such artists as Migos and French Montana.

Nearby places

PALM SPRINGS is an iconic desert town to visit between the two weekends of shows. Hotel prices soar (and rooms book up fast!), so be sure to reserve early. Once the festival ends, head out to **JOSHUA TREE NATIONAL PARK** for some much-needed solitude. For a colorful and spiritual experience, head south to **SALVATION MOUNTAIN**, a massive piece of American folk art in the desert. Or check out my favorite things to do in **LOS ANGELES** on pages 168–171!

At Coachella, there's something for everyone. It's where music and fashion go hand in hand and everyone's there to express themselves and have a good time. It's really whatever you make of it—whether you're there for Beyoncé or are planning a weekend full of indie bands you've never heard of. One moment you might feel like you're in a club while Israeli DJ Guy Gerber spins and the next you might be bopping to Ariana Grande or attending Kanye's Easter Sunday service.

My trips to Coachella have taught me two things: First, make plans in advance. There's no service (especially with almost 100,000 people trying to use their phones!), so make sure your friends all know when and where to meet—and have a backup plan in case someone gets lost! Second, comfort is key. You're in the desert after all, so comfortable shoes and something to protect your nose and mouth from the dust should be at the top of your packing list. Yes, you'll be happier with eye drops than with dry shampoo!

Make time to explore all the arts and activities that surround the musical acts—from games at the Camp Lounge to massive art installations to, of course, the unmistakable Ferris wheel towering above the desert. Coachella is a festival at its best, so make the experience your own!

Camp Out in the Desert at AfrikaBurn
IN SOUTH AFRICA

by Chelsea Yamase (@chelseakauai)

Like the global Burning Man events, AfrikaBurn brings together incredible art, nonstop music, and performance (although on a smaller scale of 11,000 participants). From the moment I arrived, I was struck by the colors. People are dressed in all sorts of random, awesome, sexy, strange outfits. Cars (a.k.a. "mutant vehicles") are also decorated. Everywhere there's art—beautiful art—and the installations tell a story. We would bike around in the quieter midday moments and check out each piece. One of my favorites was a structure that reminded me of a treehouse. After climbing into the top, there was a cozy area to sit with pillows and photos of past AfrikaBurn events. Every year, the art structures are different and that made me really take extra moments of appreciation.

I don't drink or do drugs, so I had the unique experience of being sober at this festival. I had heard stories about Burning Man, so I thought I might feel uncomfortable or out of place. But I didn't feel this way at all! I really do think it's an event where you can have a whole range of experiences depending on what you're looking for. Some people even brought their whole families!

Everyone sets up camp for the week (no modern showers or toilets!), so all in all, expect it to be an experience close to wilderness camping. One camp typically offers a communal hosing off as their gift to the event. Other camps offered everything from fresh-baked bread to meditation space to raucous dance parties.

AfrikaBurn is a very open and friendly community—a super unique way to connect and make some South African friends.

LOCATION: **TANKWA KAROO, NORTHERN CAPE**
COUNTRY: **SOUTH AFRICA**
The festival is in late April or early May every year.

Where to go

TANKWA KAROO is about a four-hour drive north from Cape Town. It's a semi-arid desert land, with the campsite situated around a central playa (a dried-up desert basin). The playa is just outside the Tankwa Karoo National Park.

The drive itself from Cape Town to Tankwa Karoo is glorious and takes you through beautiful mountain landscapes before becoming drier and flatter in the desert. You'll pass a few small towns, but I'd recommend getting the majority of your supplies and groceries in Cape Town before you leave. It's a long drive on a very, very bumpy, dusty dirt road without a phone signal, gas stations, or nearby assistance. So essentially you want to be prepared, know how to change your own tires, and drive slowly. We luckily didn't encounter any issues besides inhaling a ton of dust!

Nearby places

After the event, you'll be somewhat close to another scenic area called the **CEDARBERG.** Unlike the flat expanse of the Tankwa Karoo, the Cedarberg takes you up into a mountain pass. At the higher elevation, the landscape changes to red sandstone archways and rocky monoliths. I went here on a separate trip after hearing about it and fell in love with the solitude, the deep-red dusty roads, and the otherworldly structures that go for miles. It's world renowned for its rock climbing. For more adventurous humans, they even host a slackline and highline festival here! We stayed in villas built into the rocks at a place called Kagga Kamma. Their pool area and rooms are unique and so much fun to shoot, plus the stars and Milky Way were some of the brightest I've ever seen.

What to bring

In late April or early May when the festival is held, South Africa is heading into late fall, so it can get quite chilly at night. I brought a large down jacket to throw over my outfits and I'd definitely recommend having that and a pair of sturdy boots.

Bikes are essential and so much fun. The playa is walkable, but it's much better to have a bike to ride around and look at the art cars, installations, and different camps. I recommend a company called Pedals for Peace, which transports bikes to the festival for you and gives you the option to donate your bike to rural communities in need once the event is over.

Also, be prepared with a good pair of earplugs if you're wanting a decent night of sleep.

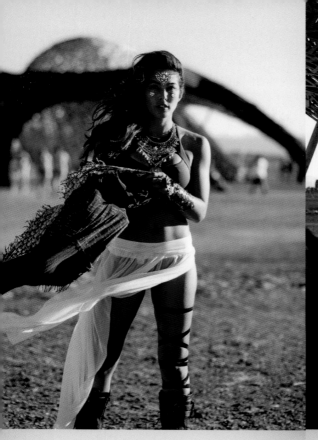
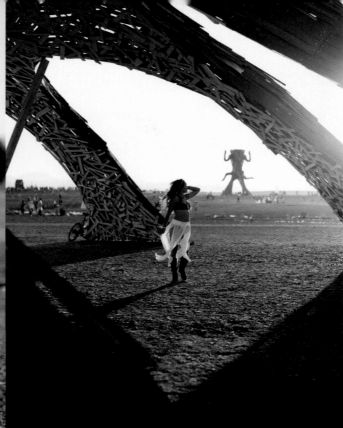
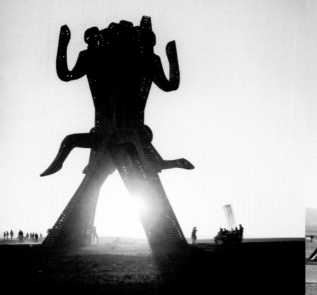

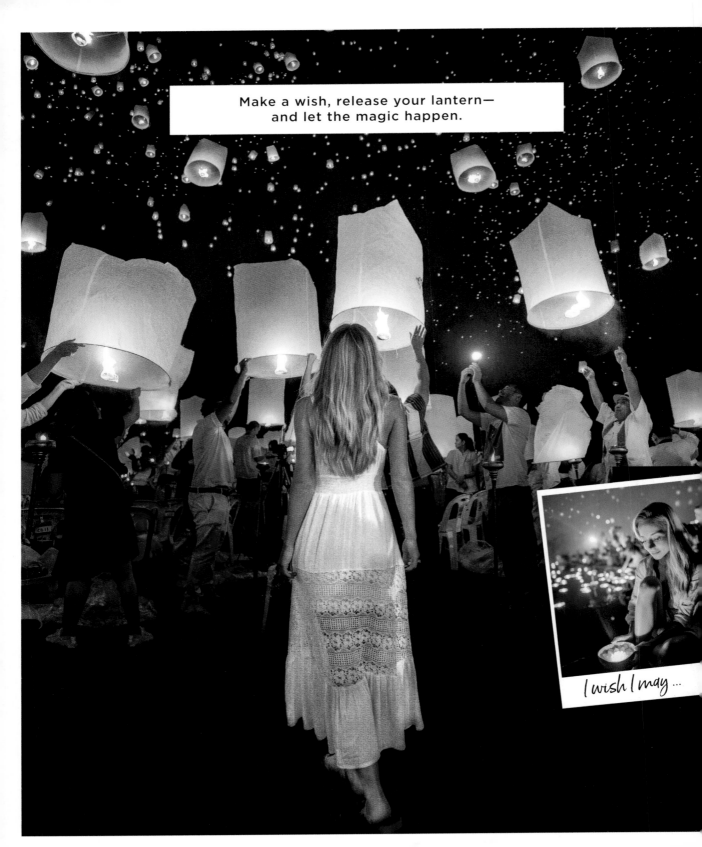

Make a wish, release your lantern—
and let the magic happen.

I wish I may ...

What to bring

Because these are religious festivals, make sure to dress conservatively and cover your shoulders and knees. Bring a sweater because the mountainous city of Chiang Mai can get chilly at night, especially in November. These lantern festivals are two of the most romantic events I've ever experienced, so you might also want to bring someone special with you!

PHOTO TIPS

This festival is one of the hardest things to shoot. It's difficult to predict the exposure before everyone lights up their lanterns, and once they're lit, they move quickly up into the sky. A faster shutter speed will help you capture the lanterns instead of just blurs of light—I'd recommend to focus on the lanterns instead of taking pictures of people.

LOCATION: **CHIANG MAI**
COUNTRY: **THAILAND**
Yi Peng and Loi Krathong take place during the full moon of the 12th Thai lunar month, which is usually in November, but check for specific dates.

Where to go

MAEJO UNIVERSITY is north of Chiang Mai and is the center of the largest sky lantern release during Yi Peng. Buddhist monks gather here to pray for hours before releasing lanterns into the sky. Arrive early to get a good seat!
THREE KINGS MONUMENT is located in the Old City and also features a sky lantern release later during the festival as well as traditional Lanna performances.
OLD CITY MOAT surrounds central Chiang Mai and is a popular place to release floating lanterns for Loi Krathong. You'll also spot locals releasing these lanterns into rivers and other waterways throughout Thailand.

Nearby places

Chiang Mai is famous for its food, especially a coconut curry noodle soup called *khao soi*. This is absolutely my favorite Thai dish and it can only be found in northern Thailand, so be sure to seek it out as many times as you can during your visit! While you're in Thailand, head south to **BANGKOK** to visit the city's famous floating markets (pages 40–41), then travel east to **CAMBODIA** to visit the temples at Angkor (pages 110–111). Southeast Asia is also full of incredible island destinations—from **BALI** (pages 22–23) to the **PHILIPPINES** (pages 48–51).

See the Lights

AT CHIANG MAI'S LANTERN FESTIVALS

As the full moon rises over Thailand every November, the sky suddenly transforms, lit by thousands of paper lanterns lifting gently toward the heavens while others float by on rivers and streams. Known as *Yi Peng* (the sky lantern festival) and *Loi Krathong* (the floating basket festival), these two lantern festivals coincide in Chiang Mai for a magical and deeply spiritual moment that will take your breath away.

In anticipation of the sky lantern release for Yi Peng, Buddhist monks pray for hours as the sun begins to set, helping believers release the things that aren't serving them so they can welcome new blessings into their lives. As the moon starts to rise, they begin a ceremony that culminates with the midnight release of thousands of rice paper lanterns into the night sky.

It's hard to describe how breathtaking this moment is. Floating lanterns stretch for miles— they even close the airport for a few hours!—and candles glow all over the city. Whether you've joined the masses to release lanterns at Maejo University or you're standing in a dark street with the person you love, make a wish and release your lantern as the clock strikes 12. Filled with a feeling of love and reverence for the rituals being practiced around me, I wished for happiness for the people I care about most. In that moment, as the sky glows and lanterns softly float around you, there's an intense feeling that your deepest and most heartfelt wishes will actually come true.

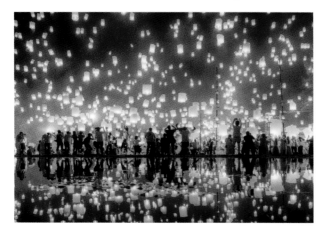

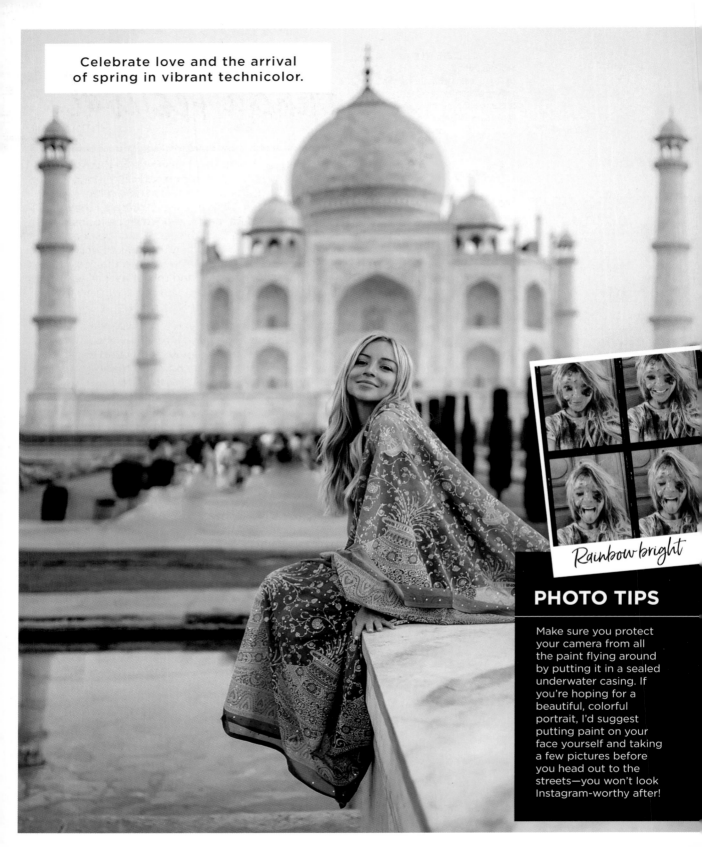

Celebrate love and the arrival of spring in vibrant technicolor.

Rainbow bright

PHOTO TIPS

Make sure you protect your camera from all the paint flying around by putting it in a sealed underwater casing. If you're hoping for a beautiful, colorful portrait, I'd suggest putting paint on your face yourself and taking a few pictures before you head out to the streets—you won't look Instagram-worthy after!

LOCATION: INDIA, NEPAL & WORLDWIDE

Holi is a festival marking the arrival of spring and takes place around the spring equinox in March. Check the specific dates before going.

Celebrating Spring at the
Hindu Festival
OF HOLI

Holi brings together three of my favorite things in one holiday: the arrival of spring, vibrant colors, and a celebration of love! Revelers take to the streets, celebrating, singing, and dancing as they toss colored powders, paint, and water balloons. A number of legends give this festival of color a religious significance, including Vishnu's triumph over evil and Krishna's deep love for Radha. It's marked as a day to forgive and forget as well as to honor the arrival of spring and the changing of seasons with a fresh (and colorful!) start.

Street celebrations range from playful on the fringes to more crowded and intense as you approach the temples. The crowds covered in paint are incredible to see but can be quite overwhelming. I was happy to retreat to a quieter celebration that was equally beautiful and exactly as fun as you'd imagine! Many hotels offer Holi experiences, which are more lighthearted and are safer than the throngs on the streets—a particularly good choice for groups of women traveling to participate in Holi. However you choose to participate, you'll feel the sense of unity that's woven through this celebration of love and renewal, tinted with every color of the rainbow.

What to bring

Warning: These tinted powders stain! Pack coconut oil to prevent it from penetrating into your skin and hair, and wear clothes you won't mind throwing away. Protective eyewear is also a good idea!

Where to go

AGRA in northern India is home to the Taj Mahal. There's nothing quite like celebrating Holi near this shrine. If you're planning to visit this immense monument to love and loss, schedule your trip during Holi to add another layer of cultural significance.

MATHURA is between New Delhi and Agra, and it's the birthplace of Krishna, a major deity in the Hindu religion. The festival here is one of spring and also one of love, and it lasts for more than a week.

KATHMANDU is the capital of Nepal and Holi is also celebrated by Hindus in this city and country. Concerts are held throughout the country and revelers are known to throw balloons filled with colored water in addition to paint and powders.

Nearby places

The Indian subcontinent covers 1.7 million square miles and boasts 30,000 years of history, so you don't have to look too hard to find amazing places to visit. Be sure to tour both **OLD DELHI** and **NEW DELHI**. In Old Delhi, hire a guide to lead you through **KHARI BAOLI**, one of Asia's largest spice markets. Head through the gate at the Red Fort into New Delhi, then wander around **LODHI GARDEN** for a lush and green escape from the bustle of the city. Visit **YAMUNA GHAT**, on the banks of the Yamuna River, at sunrise to watch massive flocks of seagulls take flight in the mist. Most travelers devote a few weeks to their trip to India and you should do the same. From Delhi, head south to **AGRA** to see the Taj Mahal, tour the lavish palaces in **JAIPUR**, or take a ferry out to the Elephanta Caves in the coastal city of **MUMBAI**.

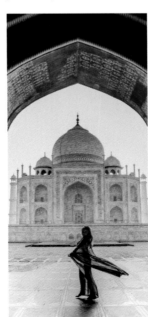

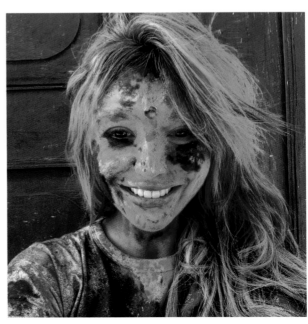

Index

About the Author

Aggie Lal's passion for travel and finding beauty in the world has shaped her career as an Instagram travel influencer. Born in Poland and currently residing in Los Angeles, Aggie is a global citizen who loves spending time in nature and chasing adventure while seeking inner peace and self-fulfillment. Although she originally called her Instagram "Travel in Her Shoes," the name was born out of her passion for learning about the peoples and cultures that make up our planet. Aggie not only shows the beauty of the world to her Instagram followers, but she also champions causes such as the better treatment of animals, more respect for indigenous people, and a kinder, gentler approach to sharing life together on our incredible planet. With her charitable work, recyclable swimwear line, and a photo editing app, Aggie has shown that being an influencer is just one of many adventures of her globetrotting life.

Acknowledgments

PUBLISHER'S ACKNOWLEDGMENTS
The publisher wishes to thank Jaimie Schoen Mackey, Michael Moretti, Claudia Padgett, Li-Chi Pan, Chelsea Yamase, and Jacob Riglin for their writing contributions to this book. The publisher also wishes to thank Anondra Williams for reviewing the text and photos for potential issues with inclusion, diversity, and sensitivity.

AUTHOR'S ACKNOWLEDGMENTS
The author wishes to thank Michael Moretti for taking the majority of the photos for this book.

Her family: Anna, Krzysztof, and Magdalena Lal, Elzbieta and Reginald Szumski, as well as her chosen family, Roland Peralta and Magdalena Pyzowska, for their support during the writing of this book.

The contributors: Claudia Padgett, Li-Chi Pan, Chelsea Yamase, and Jacob Riglin. As well as others for their help on this book: Polina Burashnikova, Anna Mioduszewska, Morgan Oliver-Allen, Jonathan Kubben, Jessica Mercedes-Kirschner, Krzysztof Piechocki, Jakob Burkhardt, Lisa Homsy, Raya Encheva, Gavin Velasco, and Christine Tran.

Publisher Mike Sanders
Editor Christopher Stolle
Senior Designer Rebecca Batchelor
Proofreader Georgette Beatty
Indexer Celia McCoy

First American Edition, 2020
Published in the United States by DK Publishing
6081 E. 82nd Street, Indianapolis, Indiana 46250
Copyright © 2020 Aggie Lal

20 21 22 23 24 10 9 8 7 6 5 4 3 2 1
001-316438-FEBUARY2020

DK would like to thank the following for their kind permission to use their photographs:
Jacob Riglin: 34–35
Michael Moretti: 104–105
Claudia Padgett: 128–129
Li-Chi Pan: 160–161
Polina Burashnikova: 173
Chelsea Yamase: 182–183

Library of Congress Catalog Number: 2019945957
ISBN 978-1-4654-9010-0

DK books are available at special discounts when purchased in bulk for sales promotions, premiums, fund-raising, or educational use. For details, contact: SpecialSales@dk.com

Printed and bound in U.S.A.

A WORLD OF IDEAS:
SEE ALL THERE IS TO KNOW

www.dk.com